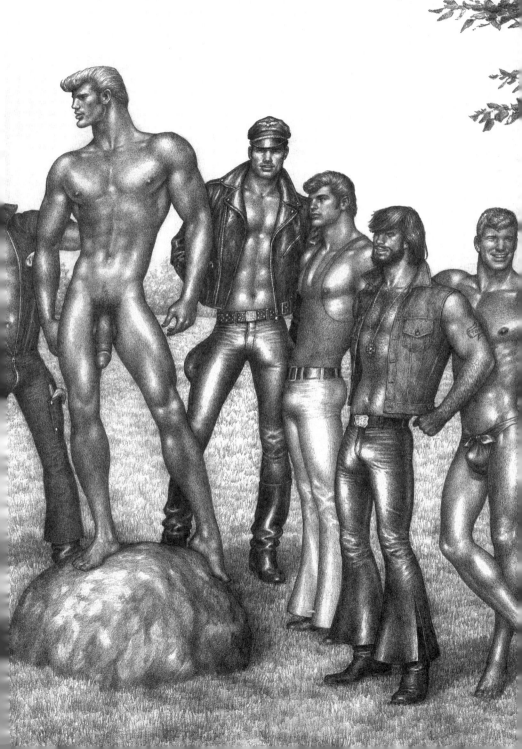

Bikers

TOM OF FINLAND

VOLUME II

Bikers

TASCHEN

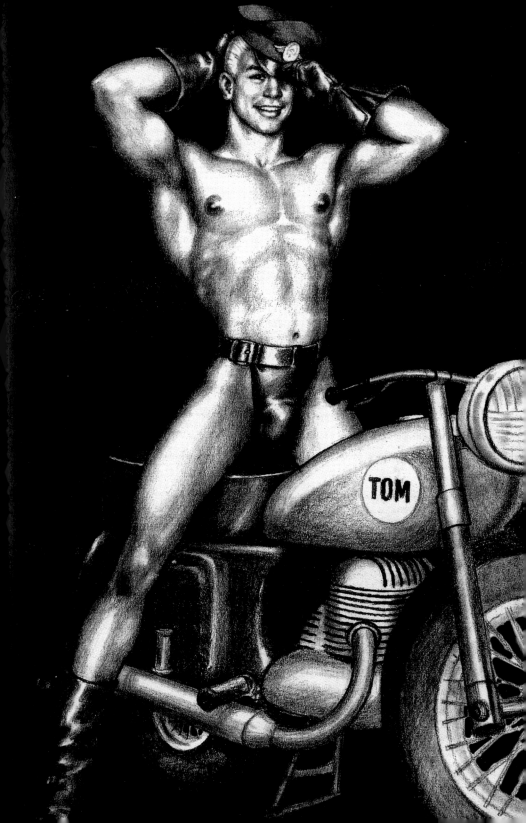

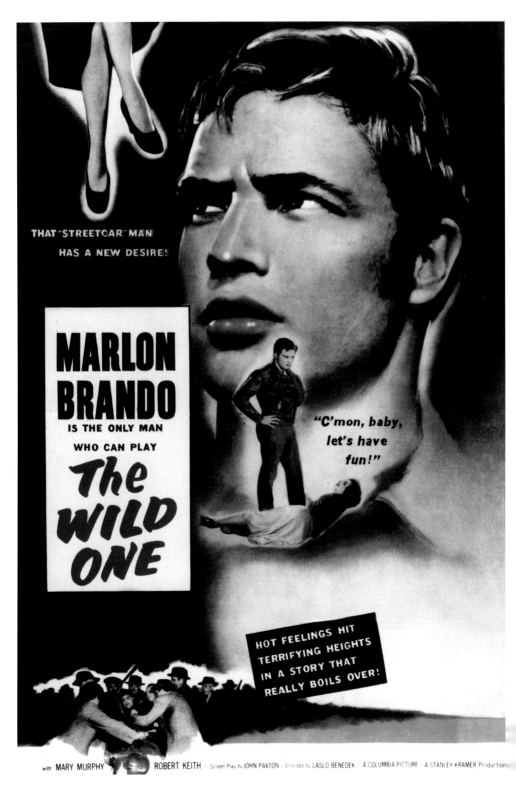

KNIGHTS IN BLACK LEATHER

By Dian Hanson

In 1953 *The Wild One*, starring Marlon Brando as Johnny, leader of the Black Rebels Motorcycle Club, was released worldwide. In 1954 Tom of Finland, previously known for his military and blue collar subjects, drew his first civilian motorcyclist dressed in black leather. Coincidence? Hardly.

The Wild One—originally marketed to a female audience with a poster featuring a close-up of Brando's face sans leather cap, hair tousled, cheeks and pout tinted pink, with the tagline "That 'Streetcar' Man Has a New Desire!"—resonated far more with gay audiences, who took Brando's character as a template for the first leatherman.

Of course, the look wasn't new. Brando's Perfecto motorcycle jacket had been made by the Schott company since 1928 with few design changes. The zippers, the belt, the epaulets, and the studded snaps all served a purpose for the serious biker, but Brando wasn't a serious biker: He was a bisexual Hollywood hunk wrapped in sensual black leather, and that made all the difference. One look at the real biker pictured in the July 21, 1947, issue of *Life* magazine accompanying coverage of the so-called Hollister riot, the biker weekend gone wild in a small California town that inspired *The Wild One*, makes clear what Brando brought to the role. And to male libidos. Tom of Finland was first attracted to German military bikers, and rendered a few in

their brown leather boots and jackets during the 1940s. After seeing *The Wild One* he never drew brown leather again; black leather now dominated his fantasies, and his art.

That Brando's black leather had such a powerful effect had something to do with the war. Many men came to terms with their homosexuality during WWII, thrown together in barracks far from home, emboldened to experiment with previously suppressed desires under the ever-present threat of death. These men didn't have the time, circumstance, or inclination to cultivate the effeminacy displayed by most out gays before the war. They weren't looking for a new lifestyle, just fast, exciting sex, often with their equally masculine military buddies. Once back home, some played it straight, becoming furtive married men perusing *Physique Pictorial* in parked cars. Others, like Tom, couldn't settle. They yearned to replicate the buddies-with-benefits camaraderie of the war. Straight vets who missed wartime camaraderie, if not the sexual benefits, formed motorcycle clubs. *The Wild One* suggested the same option to their gay counterparts.

In 1954 a group of Los Angeles friends formed the Satyrs, the world's first gay motorcycle club. Brando was an obvious inspiration, and leather a given on their runs and camping trips, but their sexual orientation, by

"Brando wasn't a serious biker: He was a bisexual Hollywood hunk wrapped in sensual black leather."

necessity, was kept strictly secret. This wasn't hard, because *The Wild One* taught the public to accept a fetishy ensemble of boots, Levi's, and black leather as straight motorcycle garb. Dressing like Brando — which is to say, like a Tom of Finland sex fantasy — allowed the Satyrs, and the Oedipus Rex Motorcycle Club, which split off in 1958, and all the gay motorcycle clubs that followed in the '60s, to hide in plain sight. It was only after the Stonewall riots in 1969, when police realized that this new generation of queers wouldn't accept the harassment and beatings they'd endured in the past, that clubs like the Satyrs dared admit that their leather jackets, caps, and boots meant more than protection from road rash. Leather became a lifestyle, and went looking for a home.

There were bars in LA that catered to gay bikers from the mid-'50s, including The Club, and the Cinema Bar, now a run-down straight dive where the only sign of its original clientele is a framed photo of Marlon Brando in among the beer lights, but these were not true leather bars. The first leather bar was Chicago's Gold Coast, opened in 1958 by Chuck Renslow, a biker, photographer, and gay activist. Renslow's lover was the artist Etienne, whose work for *Physique Pictorial* inspired Tom's own. When tolerance increased, and leathermen could live openly, the Gold Coast became a gallery for Etienne's paintings of hyper-

masculine bikers. To one-up the Gold Coast, Tom's Saloon in Hamburg hired Tom of Finland to cover its walls with his leathermen. Tom and Etienne were never competitors, though. Tom may have missed the Gold Coast's first leather-man contest in 1972, where John Lunning was crowned by an enthusiastic mob in black leather boots, caps, jackets, pants, and the ubiquitous chaps, but he enjoyed the International Mr. Leather contests that followed in 1979. Tom's personal style mixed elements of his favorite uniforms, notably jodhpurs and riding boots, but a black biker jacket was always included. As he spent ever more time in the United States, indulging every fantasy he'd ever drawn, the leather Perfecto jacket, white T-shirt, Levi's, and high boots became his signature look.

It was this same look that Tom selected for Kake, his confident, ever-horny hero of 26-panel stories. There is no doubt that Kake was Tom's fearless, outgoing alter ego, though there is far more id than ego in Kake's personality. Freud could have been reading a Tom comic when he called the id "...a cauldron full of seething excitations..." Kake doesn't just seethe; he regularly boils over, sharing his "excitations" with all in range.

At first glance it seems curious that Tom, whose first sexual experience was with a man in military uniform, whose first erotic drawings were of military

> ## *"What a wild dream this must have seemed to the shy Finn, the ultimate fantasy of natural, untamed masculinity."*

men and whose last drawing was of a military officer, would choose a biker as his avatar. And yet...Tom's personality was controlled and emotionally reserved. His approach to life and work was neat, orderly, and conscientious. He was an artist, but he could just as easily have been a career military man. The life presented by Marlon Brando in *The Wild One* was just the opposite. He and his gang of rough young hoodlums roamed freely, impulsively. They took what they wanted, and did as they pleased, with no concern for legal consequence or societal convention. What a wild dream this must have seemed to

the shy Finn, the ultimate fantasy of natural, untamed masculinity. And how enduring the dream has proven — outlasting Brando, and Tom, while the Satyrs, and the Perfecto jacket, go on and on.

In this volume we've mixed Kake's adventures with the best of Tom's single panel drawings portraying bikers and leathermen, as well as Tom's reference photos of men in black leather. All together they give a pretty good idea of what this fantasy meant to Tom. More of Tom's fantasies will be showcased in succeeding volumes, but for now, it's all about the leather.

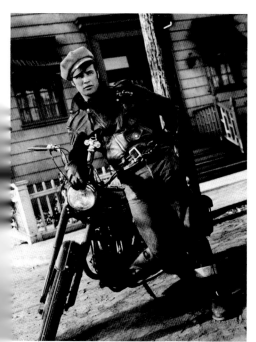
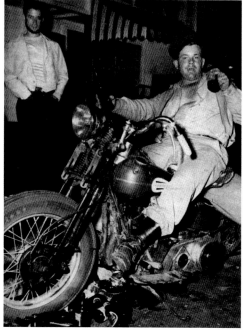

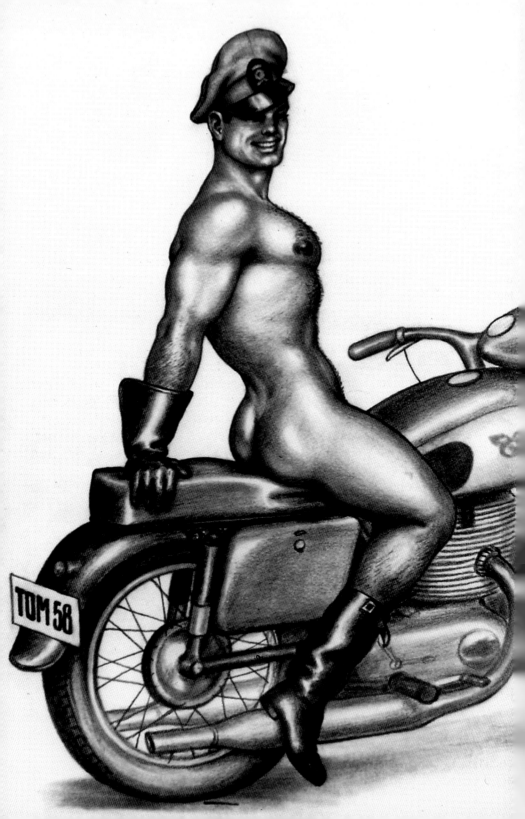

RECKEN IN SCHWARZEM LEDER

Von Dian Hanson

1953 kam weltweit *Der Wilde* (*The Wild One*) mit Marlon Brando als Johnny, Kopf der Motorrad-Bande „Black Rebels Motorcycle Club", in die Kinos. 1954 zeichnete Tom of Finland, zuvor bereits für seine Figuren in Militäruniformen und Arbeiterdress bekannt, zum ersten Mal einen zivilen, in schwarzes Leder gekleideten Motorradfahrer. Zufall? Kaum.

Die Werbung für *Der Wilde* richtete sich eigentlich eher an ein weibliches Publikum, mit einem Plakat, das eine Nahansicht von Brandos Kopf ohne Ledermütze, mit zerzaustem Haar und rosa getöntem Schmollmund samt einem Slogan „Seine Endstation ist eine ganz andere Sehnsucht!" zeigte. Doch der Film sprach sehr viel stärker Schwule an, die die von Brando verkörperte Figur als Prototyp für den ersten Lederkerl nahmen.

Dieser Look war natürlich nichts Neues. Brandos Perfecto-Motorradjacke wurde vom Hersteller Schott mit nur wenigen stilistischen Veränderungen bereits seit 1928 produziert. Die Reißverschlüsse, der Gurt, die Achselstücke und die überall verteilten Druckknöpfe erfüllten für den seriösen Motorradfahrer allesamt einen Zweck. Brando jedoch war kein seriöser Motorradfahrer: Er war ein in sinnlich wirkendes schwarzes Leder gehüllter bisexueller Hollywood-Adonis, und das war der entscheidende Unterschied. Ein Blick auf den im *Life*-Magazin vom 21. Juli

1947 abgebildeten echten Biker aus der Berichterstattung zum sogenannten „Hollister-Aufruhr" – einem außer Kontrolle geratenen Motorradfahrer-Wochenendtreff in einer kleinen kalifornischen Stadt, das die Story zu *Der Wilde* inspirierte – verdeutlicht, was Brando in seine Rolle einbrachte... und männliche Gelüste beflügelte. Anfangs fühlte sich Tom of Finland zu Motorradfahrern in deutschen Militäruniformen hingezogen und stellte während der 1940er Jahre ein paar dieser Männer in ihren braunen Stiefeln und Jacken dar. Nachdem er *Der Wilde* gesehen hatte, zeichnete er nie wieder braunes Leder; von nun an dominierte schwarzes Leder seine Fantasien und seine Kunst.

Dass Brandos schwarzes Leder eine so mächtige Wirkung ausübte, hatte mit dem Krieg zu tun. Viele Männer kamen, in Kasernen weit weg von zu Hause zusammengepfercht, während des Zweiten Weltkriegs mit ihrer Homosexualität ins Reine – den Tod stets vor Augen, fühlten sie sich ermutigt, mit zuvor unterdrückten Sehnsüchten zu experimentieren. Diese Männer hatten weder die Zeit noch die Gelegenheiten oder die Neigung, das von den meisten bekennenden Gays vor dem Krieg zur Schau getragene unmännliche Verhalten zu kultivieren. Sie waren nicht auf einen neuen Lebenstil aus, sondern schlicht auf schnellen, lustvollen Sex, oft mit ihren gleichermaßen maskulinen Ar-

„Brando war kein seriöser Motorradfahrer. Er war ein in sinnlich wirkendes schwarzes Leder gehüllter bisexueller Hollywood-Adonis."

meekameraden. Wieder in der Heimat, spielten manche den Hetero, waren diskret verheiratet, blätterten aber im geparkten Wagen *Physique Pictorial* durch. Andere, wie Tom, konnten sich nicht arrangieren. Sie verzehrten sich danach, die Kumpelsex-Kameradschaft der Kriegszeiten wiederaufleben zu lassen. Hetero-Kriegsheimkehrer, die den Kameradschaftsgeist jener Tage, wenn auch nicht die sexuellen Vorteile, vermissten, fanden sich in Motorrad-Clubs zusammen. *Der Wilde* legte ihren schwulen Gegenparts die gleiche Möglichkeit nahe.

1954 gründete eine Gruppe von Freunden aus Los Angeles die „Satyrs", den ersten schwulen Motorradclub der Welt. Ganz offensichtlich waren sie von Brando inspiriert, und Leder gehörte bei ihren Touren und Camping-Ausflügen dazu. Ihre sexuelle Orientierung hielten sie jedoch, notgedrungen, strikt geheim. Das war, nachdem *Der Wilde* dem Publikum vermittelt hatte, dass Stiefel, Levi's und schwarzes Leder als Motorrad-Kleidung von Heteros als kultige Tracht akzeptabel ist, nicht allzu schwierig. Sich wie Brando zu kleiden – will sagen, wie eine Tom of Finland-Sexfantasie – ermöglichte den „Satyrs" wie auch dem „Oedipus Rex Motorcycle Club", der sich 1958 aus einer Abspaltung konstituierte, und schließlich allen schwulen Motorradclubs, die in den 1960er-Jahren folgten, sich in aller Öffentlichkeit

verborgen zu halten. Erst nach dem „Stonewall"-Aufruhr (in der New Yorker Christopher Street) 1969, bei dem die Polizei feststellen musste, dass diese neue Generation von Schwulen die Schikanen und Prügel, die sie in der Vergangenheit zu ertragen hatten, nicht mehr akzeptierten, wagten Clubs wie die „Satyrs" zuzugeben, dass ihre Lederjacken, Mützen und Stiefel mehr zu bedeuten hatten, als nur Schutz vor den Risiken der Straße zu sein. Lederklamotten gehörten fortan zu einem Lebenstil, der sich ein Zuhause suchte.

Die erste Bar für die Leder-Szene hieß „Gold Coast" und wurde 1958 von Chuck Renslow, einem Biker, Fotografen und schwulen Aktivisten, in Chicago eröffnet. Den ersten Lederkerle-Wettbewerb, den das „Gold Coast" 1972 veranstaltete und bei dem John Lunning von einer begeisterte Menge in Stiefeln, Mützen, Jacken und Hosen aus schwarzem Leder und den allgegenwärtigen Cowboy-Beinkleidern gekürt wurde, hat Tom wohl verpasst. Doch er genoss den Wettbewerb um den Titel eines „International Mr. Leather", der 1979 am gleichen Ort abgehalten wurde. Für seinen persönlichen Stil mischte Tom Elemente seiner Lieblingsuniformen, insbesondere Jodhpur-Hosen und Reitstiefel, eine schwarze Biker-Jacke gehörte jedoch stets dazu. Je öfter und länger er sich in den USA aufhielt und jeder Fantasie, die er je gezeichnet

„Dem schüchternen Finnen muss das wie ein wilder Traum vorgekommen sein, das Äußerste einer Fantasie über unbefangene, ungezähmte Männlichkeit."

hatte, frönte, desto klarer entwickelte sich eine Kluft aus Perfecto-Lederjacke, weißem T-Shirt, Levi's und Schaftstiefeln zu seinem Markenzeichen.

Genau diesen Look verpasste Tom seinem Vertrauten Kake, dem dauergeilen Helden in 26 Bildgeschichten. Zweifellos war Kake Toms furchtloses, kontaktfreudiges Alter ego, auch wenn Kakes Persönlichkeit weit mehr an Es als an Ich offenbart. Es scheint, als hätte Freud einen Comic von Tom gelesen, wenn er das Es „...einen Kessel voll brodelnder Erregungen..." nennt. Kake brodelt nicht nur, er kocht regelmäßig über und lässt jeden, den er zu fassen kriegt, an seinen „Erregungen" teilhaben.

Auf den ersten Blick mag es seltsam erscheinen, dass sich Tom, der seine erste sexuelle Erfahrung mit einem Mann in Militäruniform erlebte, dessen erste erotische Zeichnungen uniformierte Soldaten zeigten und auf dessen letzter Zeichnung ein Militäroffizier zu sehen war, ausgerechnet für einen Biker als Avatar entschied. Zudem hatte Toms Persönlichkeit einen kontrollierten und emotional zurückhaltenden Charakter. Sein Leben und seine Arbeit ging er akkurat, planmäßig und gewissenhaft an. Er war Künstler, aber ebenso gut hätte er in der Armee Karriere machen können. Das Leben, das Marlon Brando in *Der Wilde* vorführte, war das genaue Gegenteil. Er und seine Gang rüder,

junger Strolche streunten nach Belieben und spontan umher. Sie nahmen sich, was sie wollten, und machten das, wozu sie Lust hatten, rechtliche Folgen oder gesellschaftliche Konventionen kümmerten sie nicht. Dem schüchternen Finnen muss das wie ein wilder Traum vorgekommen sein, das Äußerste einer Fantasie über unbefangene, ungezähmte Männlichkeit. Und dieser Traum hat sich als ungewöhnlich beständig erwiesen – er hat Brando überdauert, auch Tom, während es die Satyrs und die Perfecto-Jacken immer noch gibt.

Für diesen Band haben wir Kakes Abenteuer und die besten Einzelblätter Toms mit Zeichnungen von Bikern und Lederkerlen zusammengestellt, dazu Fotos von Männern in schwarzem Leder, die Tom als Vorlagen nutzte. Alles in allem vermitteln diese Materialien eine gute Vorstellung von dem, was diese Fantasie für Tom bedeutete. Mehr von Toms Fantasien werden wir in Folgebänden präsentieren, doch zunächst dreht sich alles um Leder.

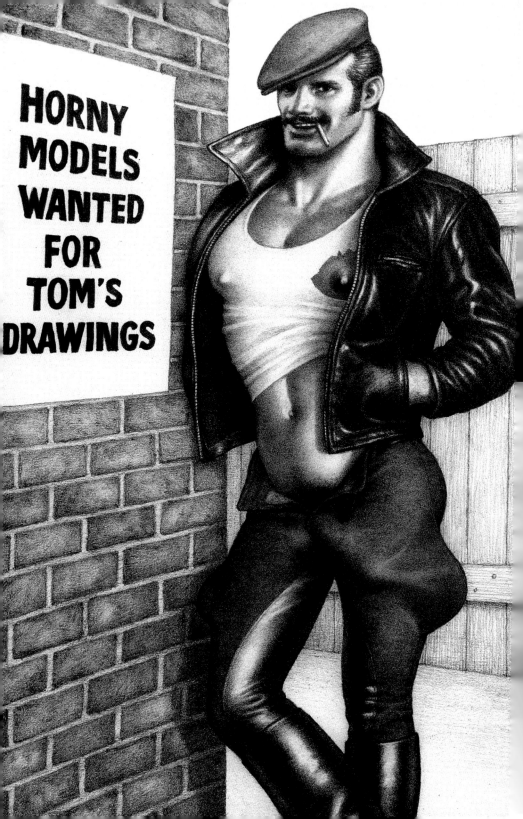

LES CHEVALIERS DU BLOUSON NOIR

Par Dian Hanson

En 1953, le film *L'Équipée sauvage* sortit sur les écrans du monde entier. Marlon Brando y incarnait Johnny, chef d'un groupe de motards baptisés les Rebelles noirs. En 1954, Tom of Finland, jusqu'alors surtout connu pour croquer des ouvriers ou des militaires, dessina son premier motard tout vêtu de cuir noir. Une coïncidence ? Pensez-vous !

L'Équipée sauvage ciblait initialement un public féminin, comme en atteste son affiche originale montrant un gros plan du visage de Marlon Brando, tête nue, ébouriffé, ses joues et ses lèvres boudeuses teintées de rose, accompagné de la légende : *L'homme du «Tramway» a un nouveau désir !*. En fait, le film fit un tabac auprès des spectateurs homosexuels qui virent en Johnny / Brando le prototype du premier Cuir gay.

Ce look n'avait pourtant rien de nouveau. Le Perfecto en cuir que portait Brando était commercialisé par la maison Schott depuis 1928, avec quelques variations de style. Les fermetures à glissière, la ceinture, les épaulettes et les boutons-pression avaient tous une fonction pratique pour le vrai motard, ce que Brando n'était pas : c'était un beau gosse bisexuel qu'Hollywood avait drapé dans un cuir noir sensuel ; toute la différence était là. *L'Equipée sauvage* s'inspirait d'un fait divers : un rassemblement de motards qui avait dégénéré en une bagarre monstre à

Hollister, une petite ville de Californie. Il suffit de regarder la photographie d'un vrai participant à cette fameuse «émeute de Hollister», publiée dans le numéro du 21 juillet 1947 du magazine *Life*, pour comprendre ce que Brando a apporté au rôle. Et à la libido masculine. Au début de sa carrière, dans les années quarante, Tom of Finland était principalement attiré par les motards de l'armée allemande qu'il dessinait avec leurs bottes et leur blouson en cuir brun. Après avoir vu *L'Équipée sauvage*, le cuir brun disparut définitivement de ses créations ; ses fantasmes et son art étant désormais dominés par le cuir noir.

Le formidable impact du blouson noir de Brando s'explique en partie par la guerre. Au cours de la seconde guerre mondiale, de nombreux soldats entassés dans des baraquements loin de chez eux, prompts à explorer des désirs inassouvis face à la menace omniprésente de la mort, donnèrent libre cours à leurs pulsions homosexuelles jusque-là refoulées. Ces hommes n'avaient pas le temps, la possibilité ni l'envie de cultiver les manières efféminées qu'affectaient la plupart des homosexuels d'avant-guerre. Ils ne cherchaient pas un nouveau mode de vie mais uniquement des rapports sexuels faciles et excitants, le plus souvent avec des camarades de régiment tout aussi masculins qu'eux. De retour

«Brando n'était pas un vrai motard : il était un beau gosse bisexuel qu'Hollywood avait drapé dans un cuir noir sensuel.»

au pays, certains reprirent leur vie hétérosexuelle, se mariant et menant furtivement une double vie. C'était eux qui dévoraient *Physique Pictorial* à l'abri, dans leur voiture. D'autres, comme Tom, ne purent se réadapter. Ils aspiraient à reproduire leurs amitiés du front «avec un plus». Les vétérans hétérosexuels qui regrettaient la camaraderie guerrière, avec ou sans bonus sexuel, formèrent des clubs de moto. *L'Equipée sauvage* suggéra aux anciens combattants homosexuels d'en faire autant.

En 1945, un groupe d'amis de Los Angeles fondèrent les Satyrs, le premier moto-club gay. Brando était leur inspiration et le cuir un accessoire indispensable de leurs virées et de leurs week-ends de camping. Néanmoins, leurs préférences sexuelles devaient, par nécessité, rester secrètes. Ce n'était pas difficile car *L'Equipée sauvage* avait popularisé auprès du grand public la panoplie fétiche du motard hétérosexuel comprenant des bottes, un Levi's et un blouson noir. En s'habillant comme Brando, c'est-à-dire comme un fantasme sexuel de Tom of Finland, les Satyrs, les membres de l'Oedipus Rex Motorcycle Club (dissous en 1958) puis de tous les autres clubs gays qui suivirent dans les années soixante, pouvaient vivre cachés au grand jour. Ce ne fut qu'après les émeutes de Stonewall en 1969, quand la police comprit qu'elle

avait affaire à une nouvelle génération d'homosexuels qui n'acceptait plus le harcèlement et les bastonnades des décennies précédentes, que les Satyrs osèrent reconnaître que leurs blousons, leurs casquettes et leurs bottes en cuir ne servaient pas uniquement à les protéger des dangers de la route. Le cuir devint un art de vivre et se mit en quête d'un toit.

Dès le milieu des années cinquante, des bars accueillirent une clientèle de motards gays, comme le Club ou le Cinema Bar, qui est désormais un bouge hétéro où la seule trace de son ancienne clientèle est une photo encadrée de Marlon Brando, une perdue entre les publicités de bières au néon. Cependant, ce n'étaient pas de vrais bars Cuir. Le premier du genre fut le Gold Coast à Chicago, ouvert en 1958 par Chuck Renslow, motard, photographe et militant de la cause homosexuelle. Si Tom n'assista pas au premier concours de monsieur Cuir au Gold Coast en 1972, où John Lunning fut couronné par une horde déchaînée vêtue de bottes, de casquettes, de blousons, de pantalons et des incontournables chaps en cuir noir, il était présent à celui de monsieur Cuir International de 1979. Le style de Tom associait divers éléments de ses uniformes favoris, notamment des jodhpur et des bottes de cheval, mais incluait invariablement un blouson noir.

> **«*Pour le timide Finlandais, cela représentait un rêve fou, le fantasme absolu d'une virilité naturelle et indomptée.*»**

Ce fut le costume qu'il choisit pour Kake, le héros à l'appétit sexuel insatiable de vingt-six bandes dessinées. Il ne fait aucun doute que Kake était l'alter ego intrépide et extraverti de Tom, bien que sa personnalité recélât beaucoup plus de ça que d'ego. On imagine que Freud, définissant le «ça» comme une «marmite pleine d'émotions bouillonnantes», aurait trouvé matière à illustrer ses propos dans un album de Kake. Kake ne fait pas que bouillonner, il déborde, partageant ses «émotions» avec tous ceux qui croisent son chemin.

A première vue, on peut s'étonner que Tom, qui connut sa première expérience sexuelle avec un militaire en uniforme, dont les premiers dessins érotiques représentaient des militaires et dont le dernier dessin fut celui d'un officier, ait choisi un motard comme avatar. Et pourtant... Tom était un être mesuré et réservé. Dans la vie comme dans son travail, il était ordonné, discipliné et consciencieux. C'était un artiste mais il aurait pu faire carrière dans l'armée. La vie incarnée par Marlon Brando dans *L'Equipée sauvage* se situait aux antipodes. Lui et sa bande de mauvais garçons menaient une existence libre et impulsive. Ils prenaient ce qu'ils voulaient et faisaient ce qui leur plaisait, sans se préoccuper des conséquences légales ni des conventions sociales. Pour le timide Finlandais, cela représentait un rêve fou, le fantasme absolu d'une virilité naturelle et indomptée. Un fantasme qui a la vie longue puisque Brando et Tom ne sont plus parmi nous mais le Satyrs Motorcycle Club et le Perfecto se portent toujours à merveille.

Dans cet album, nous avons associé les aventures de Kake, les meilleurs dessins de motards et de Cuirs de Tom, ainsi que des photos d'hommes en cuir noir qu'il utilisait comme modèles. Ainsi réunis, ils donnent une bonne idée de ce que ce fétiche représentait pour lui. D'autres fantasmes de Tom feront l'objet d'albums à venir mais, celui-ci, c'est du cent pour cent pur cuir.

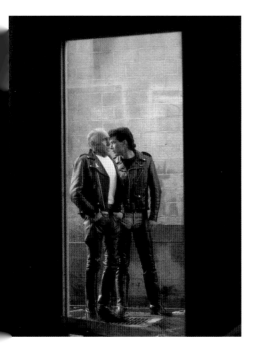

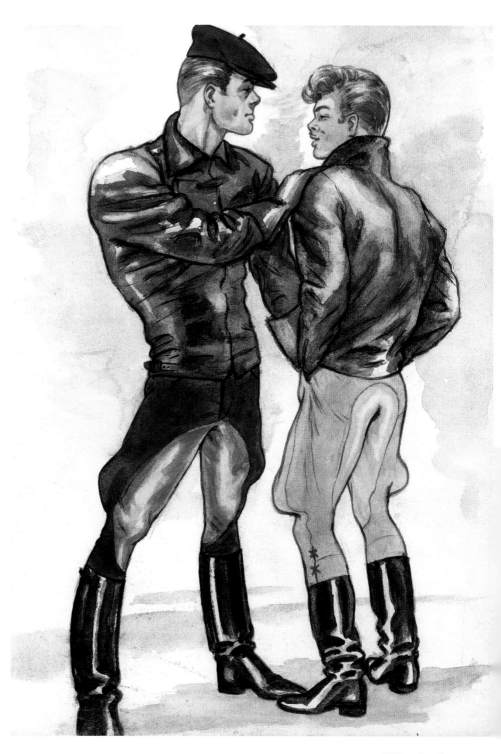

ABOVE 1947, watercolor on pape

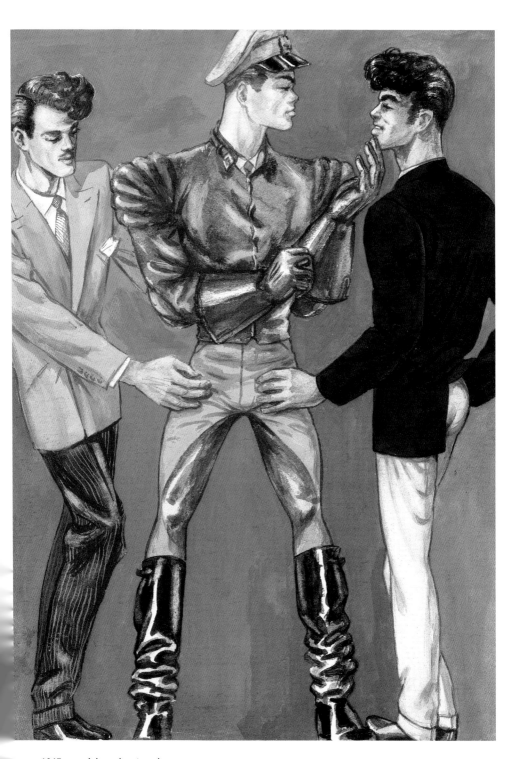

ABOVE 1947, pen, ink, and watercolor on paper

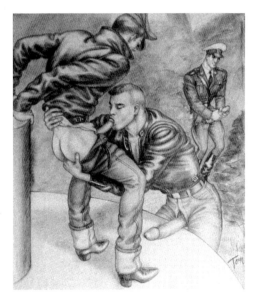
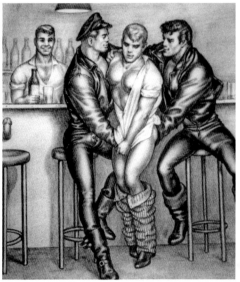

ABOVE LEFT 1954, graphite on paper
ABOVE RIGHT AND OPPOSITE 1958, graphite on paper

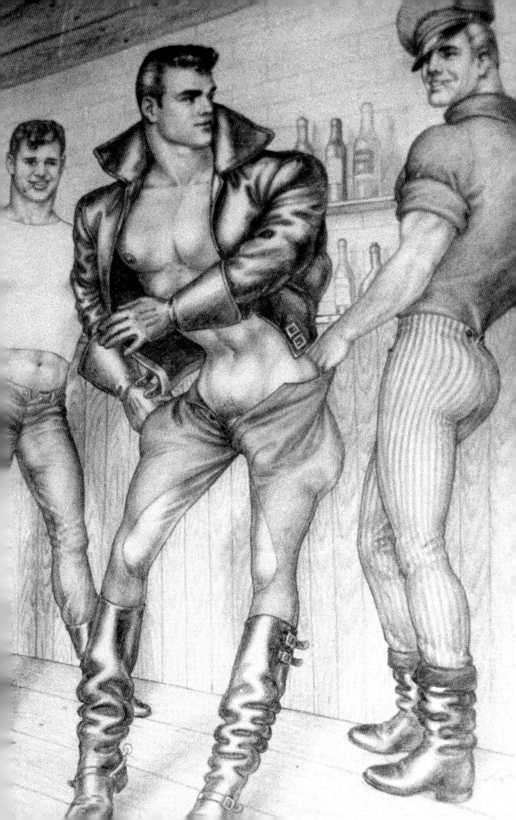

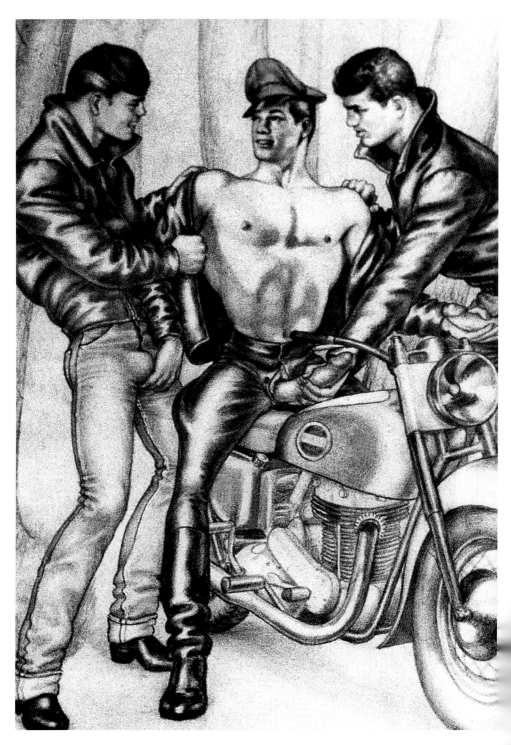

ABOVE AND OPPOSITE 1959, graphite on paper

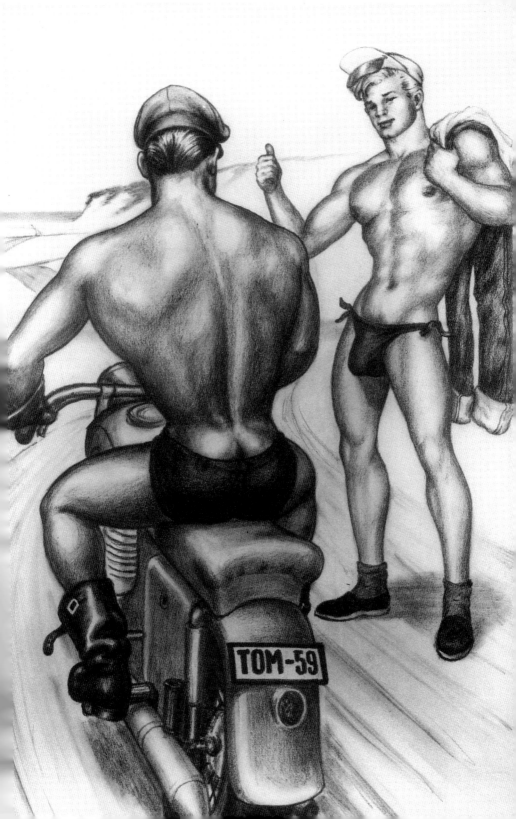

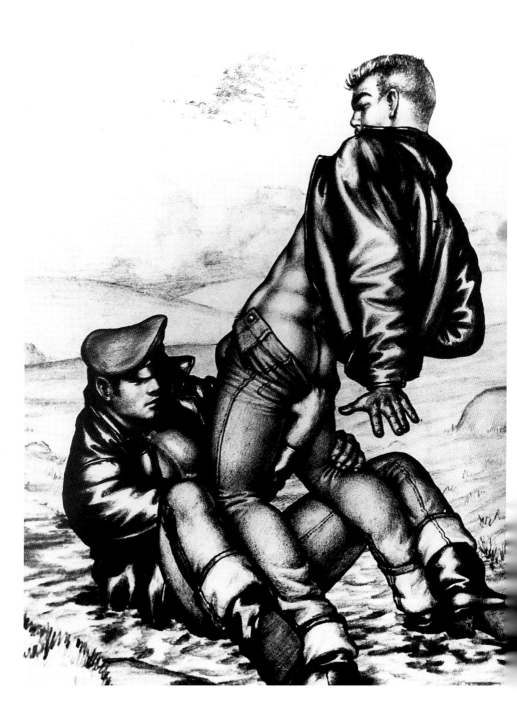

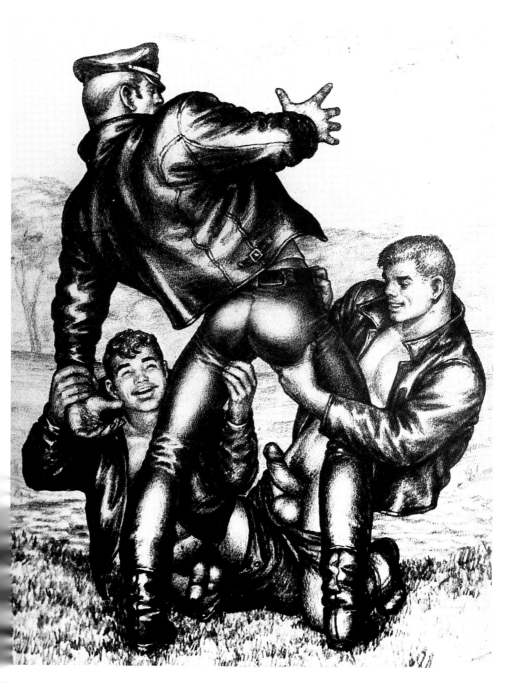

OPPOSITE AND ABOVE 1959, graphite on paper

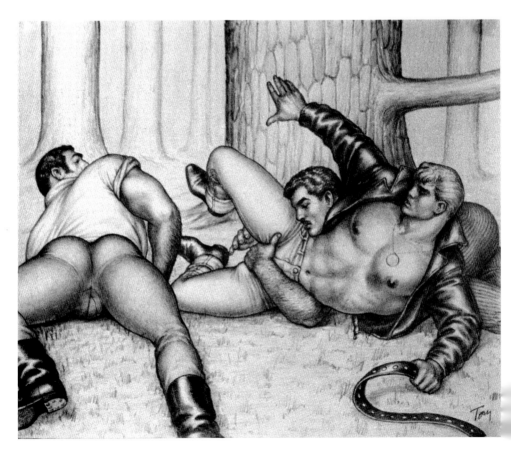

ABOVE AND OPPOSITE 1958, graphite on paper

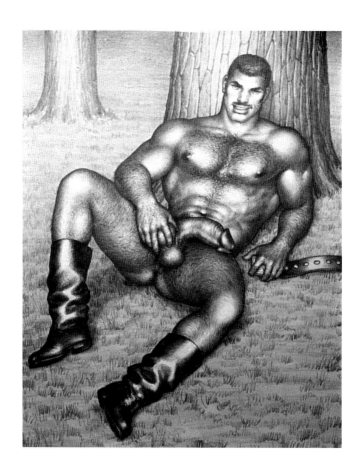

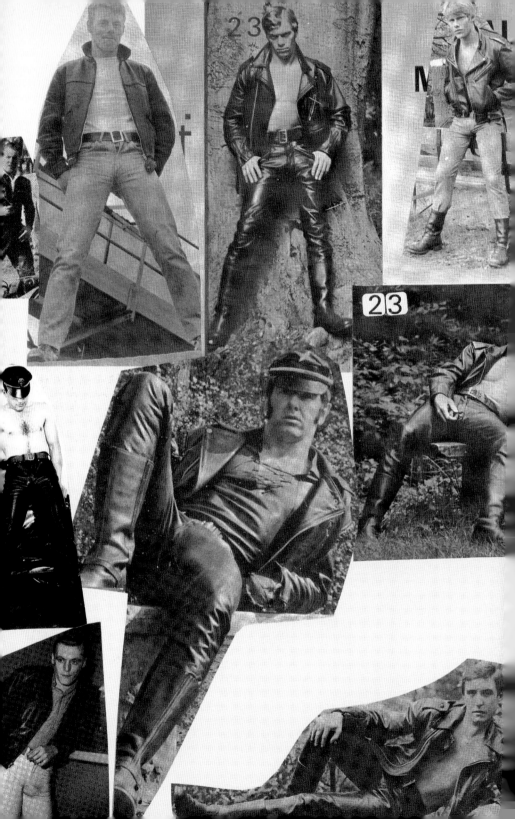

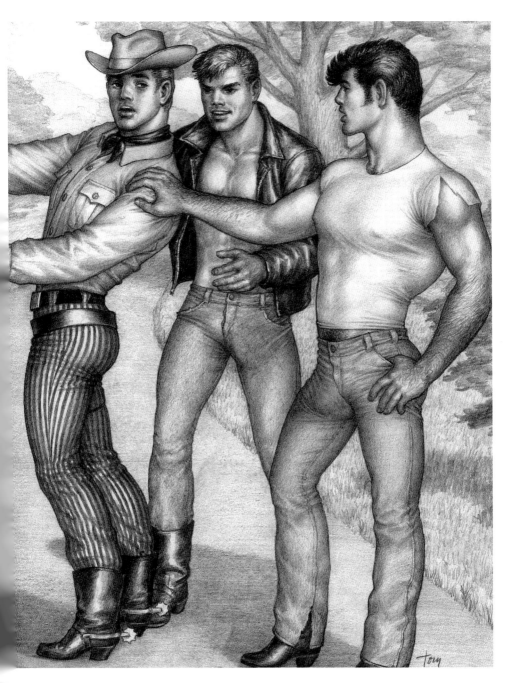

OPPOSITE Reference photo collage by Tom
ABOVE 1960, graphite on paper

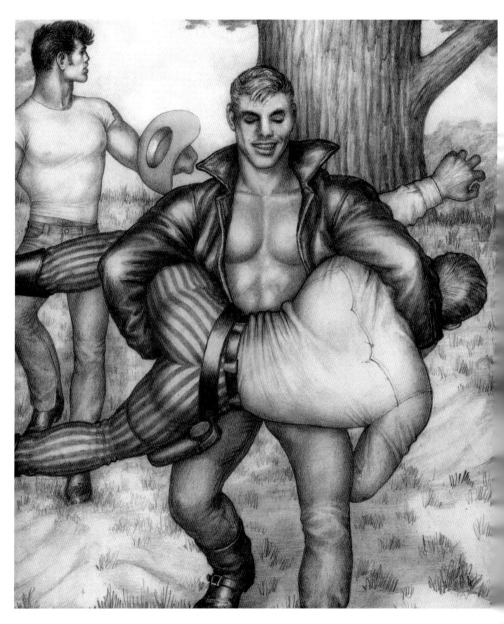

ABOVE, OPPOSITE, AND PAGES 32-33 1960, graphite on pape

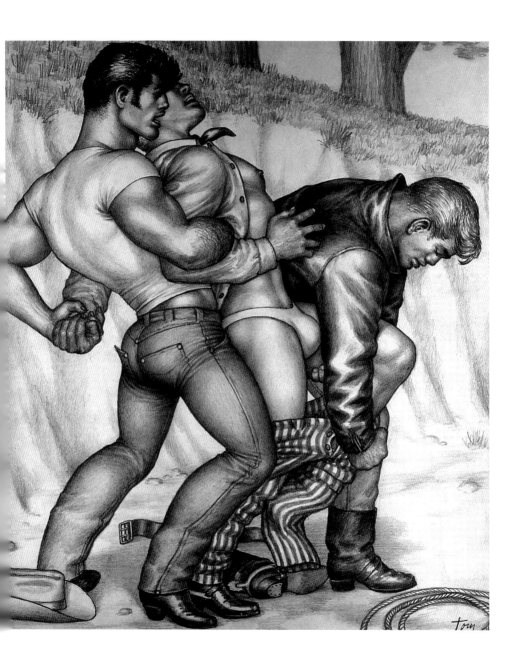

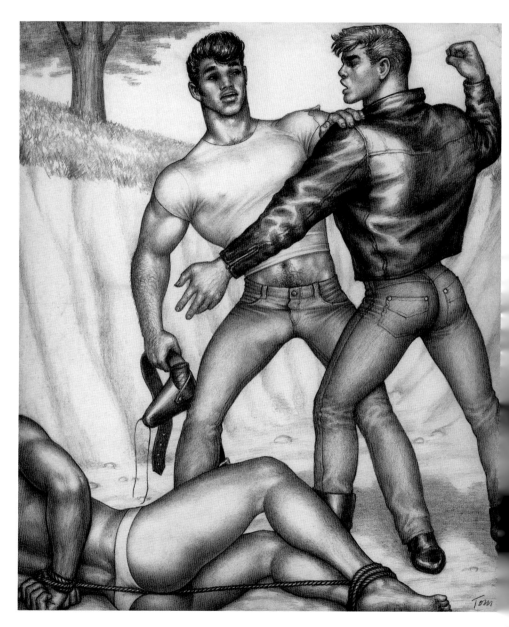

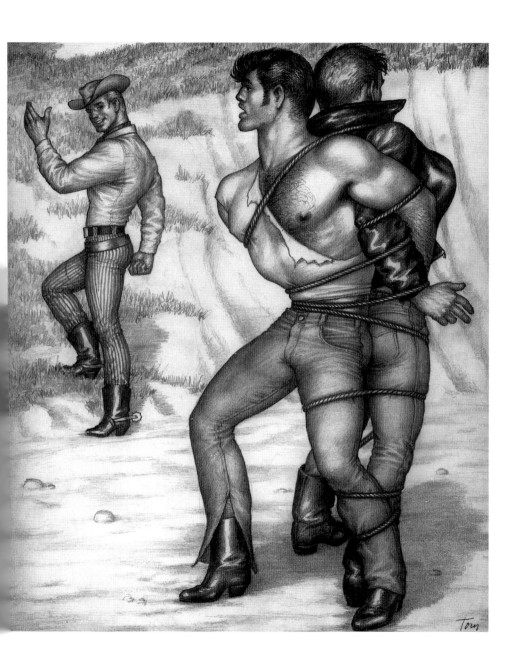

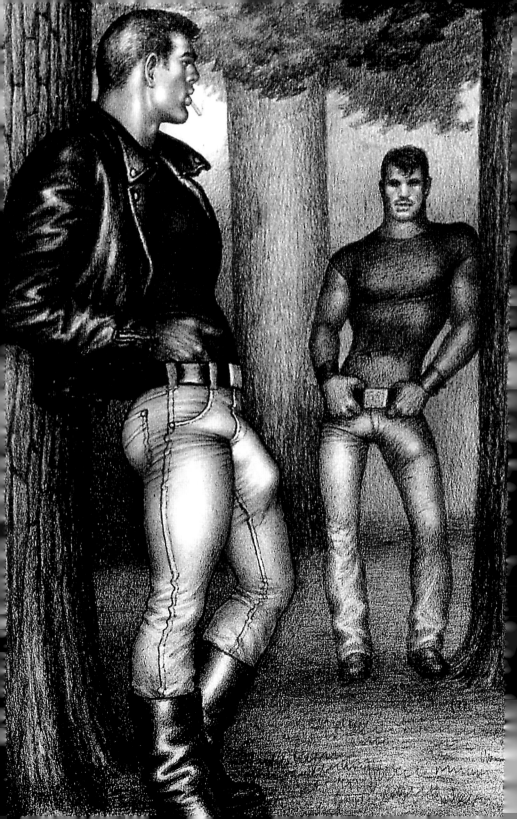

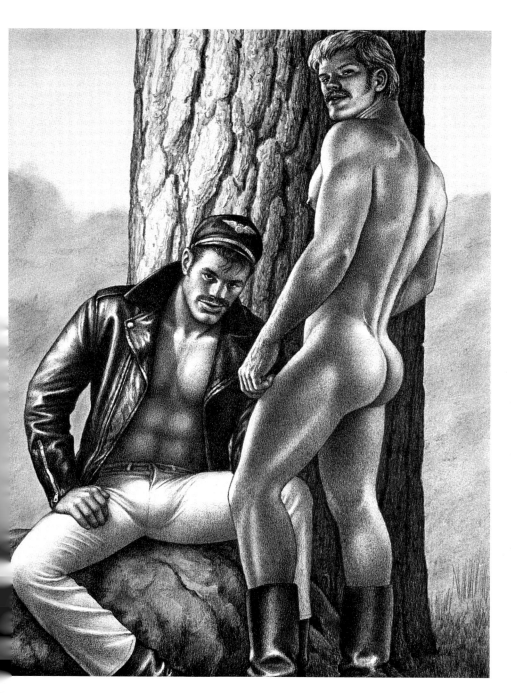

OPPOSITE 1968, graphite on paper
ABOVE 1977, graphite on paper

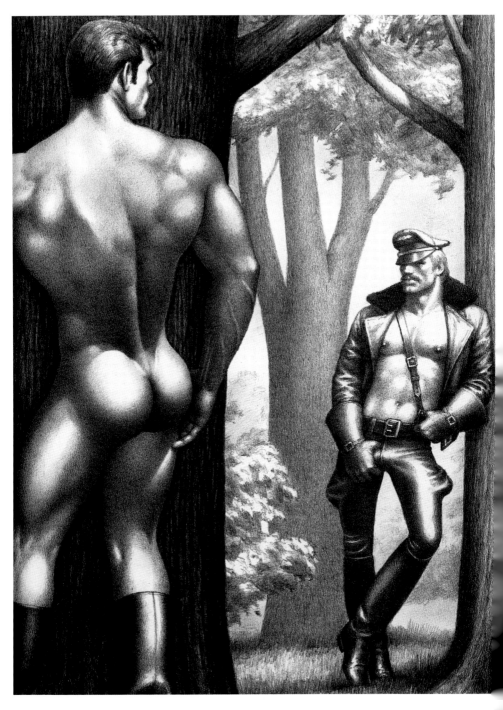

ABOVE 1978, graphite on pape
OPPOSITE 1963, graphite on pape

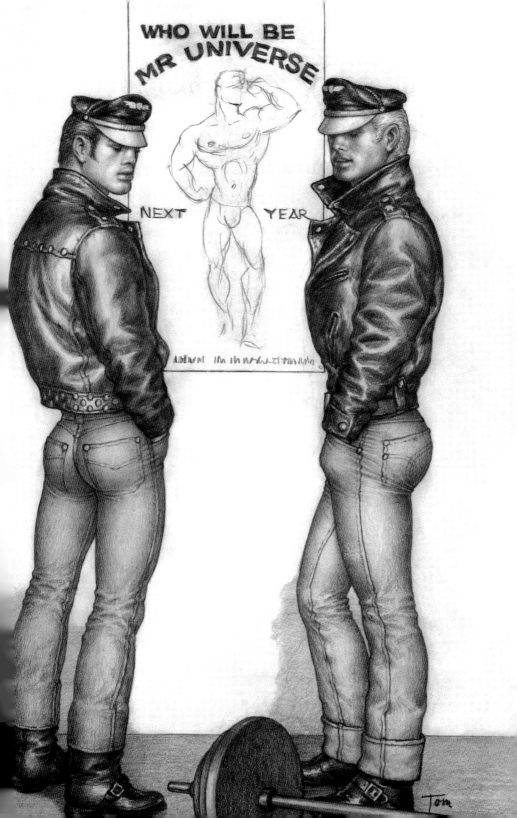

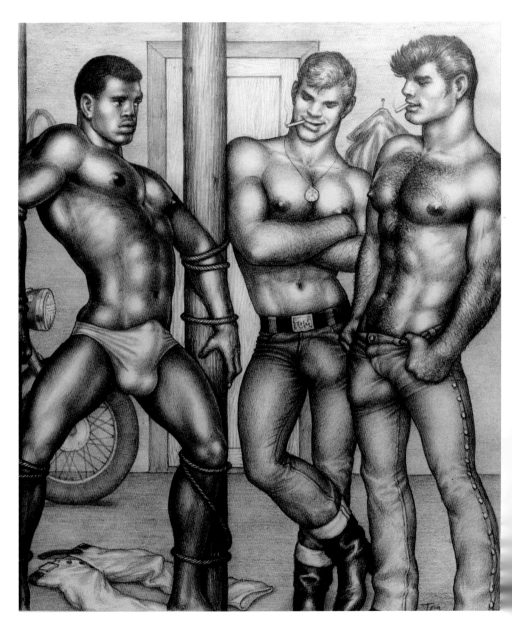

ABOVE AND OPPOSITE 1962, graphite on paper

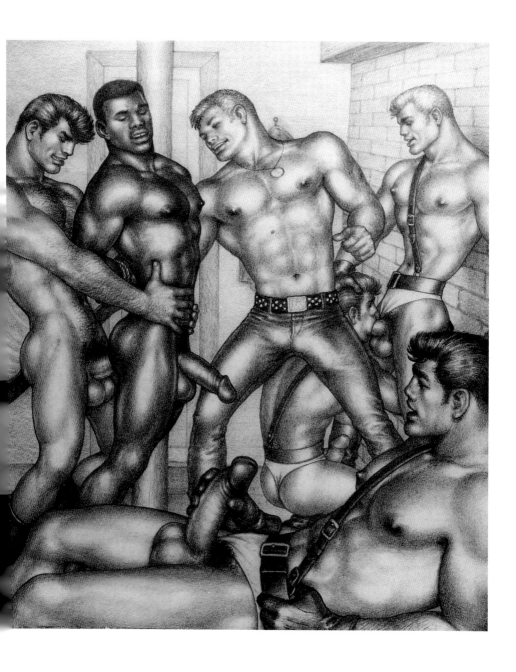

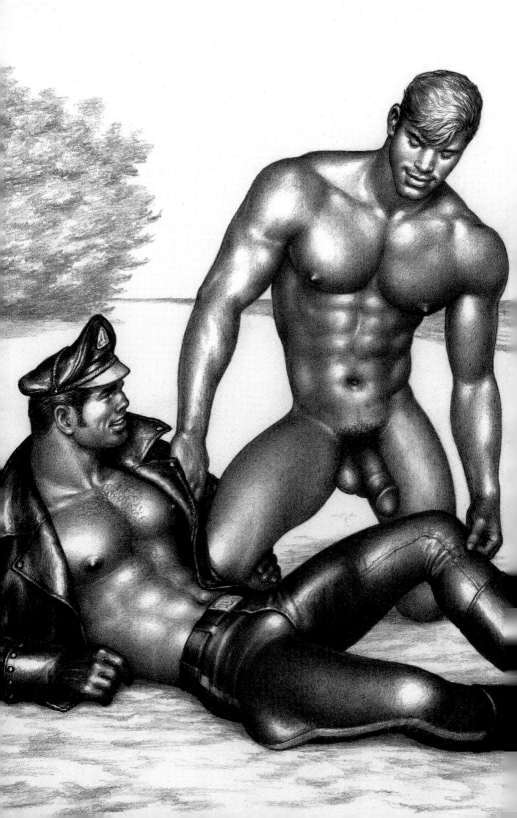

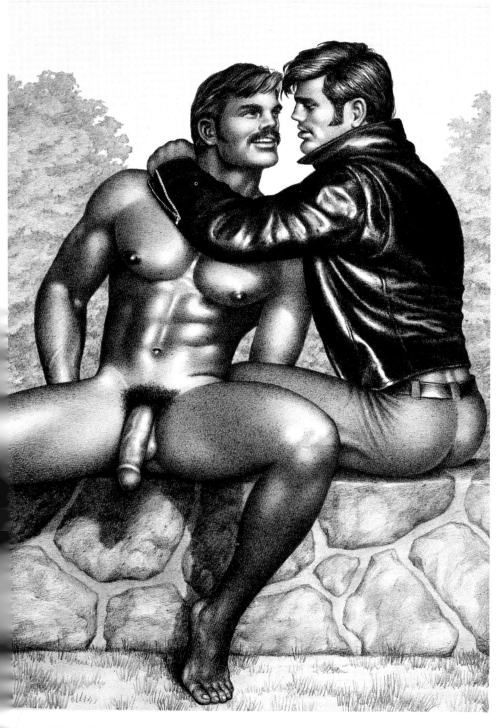

PPOSITE 1968, graphite on paper
BOVE 1976, graphite on paper

"I almost never draw a completely naked man. A naked man is, of course, beautiful, but dress him in black leather or a uniform — ah...then he is sexy!"

— Tom of Finland

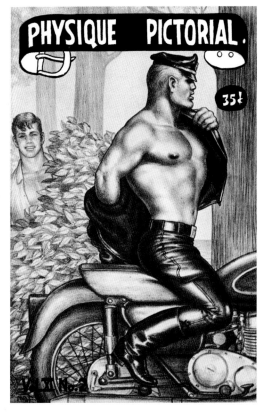

LEFT *Physique Pictorial*, Vol. 11, No. 2
OPPOSITE 1961, graphite on paper

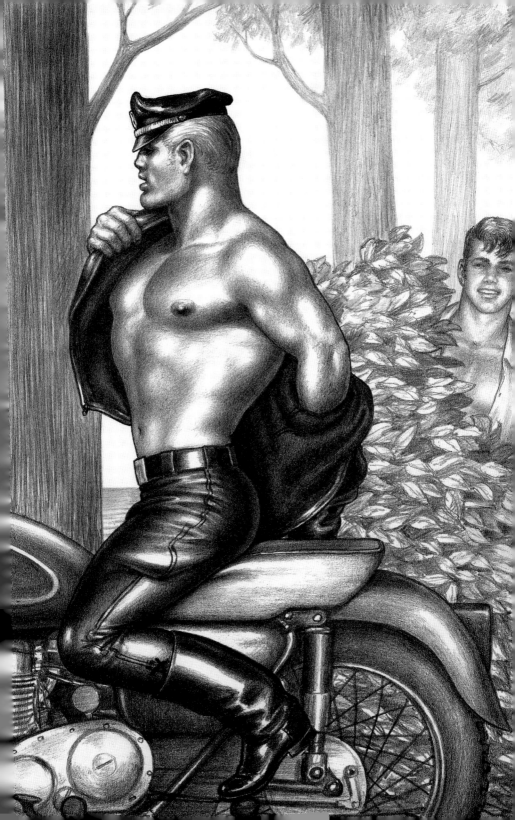

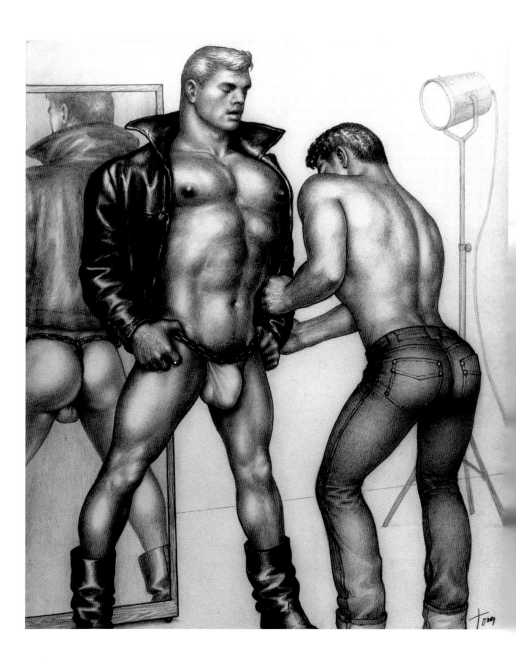

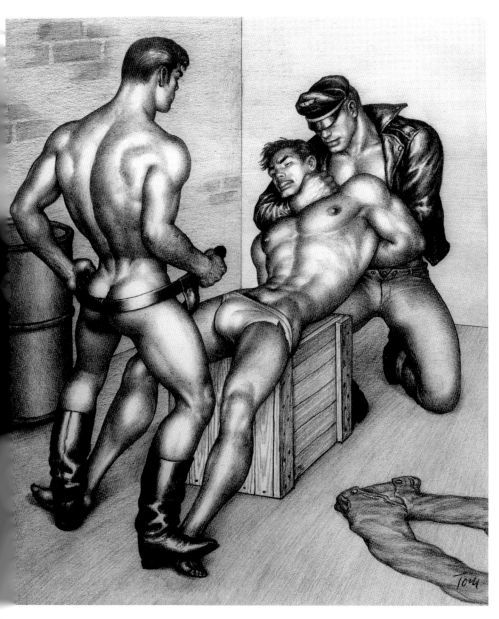

POSITE AND ABOVE 1963, graphite on paper
GES 48-49 1961, graphite on paper

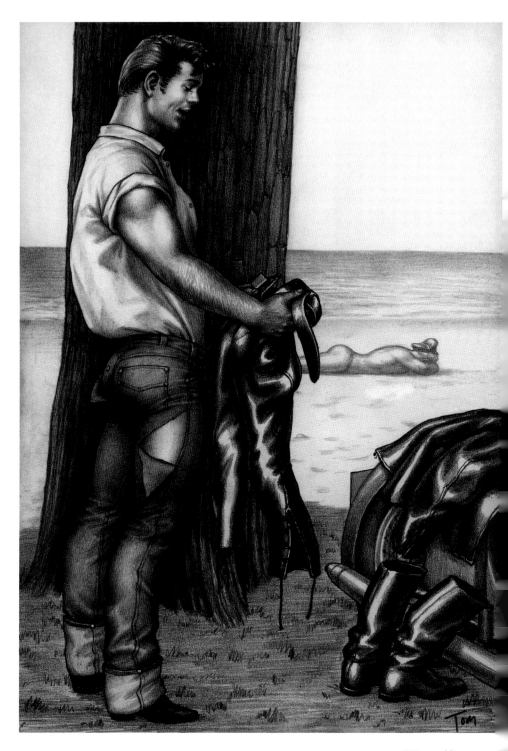

ABOVE AND OPPOSITE 1961, graphite on pap

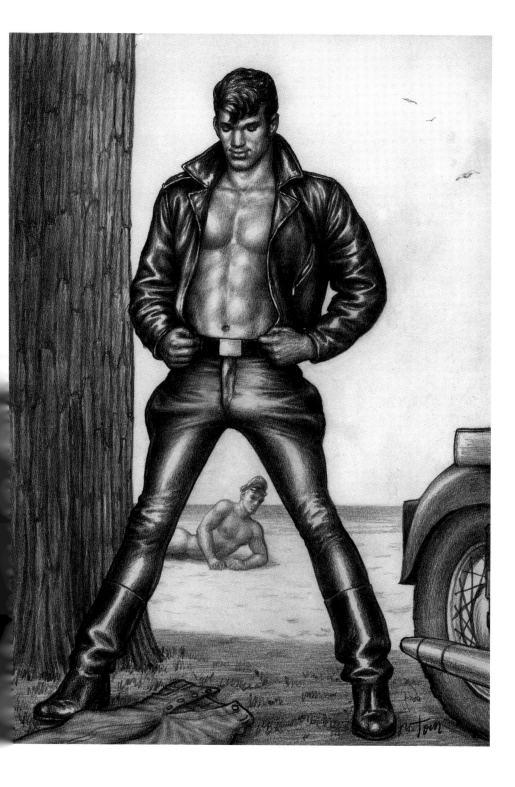

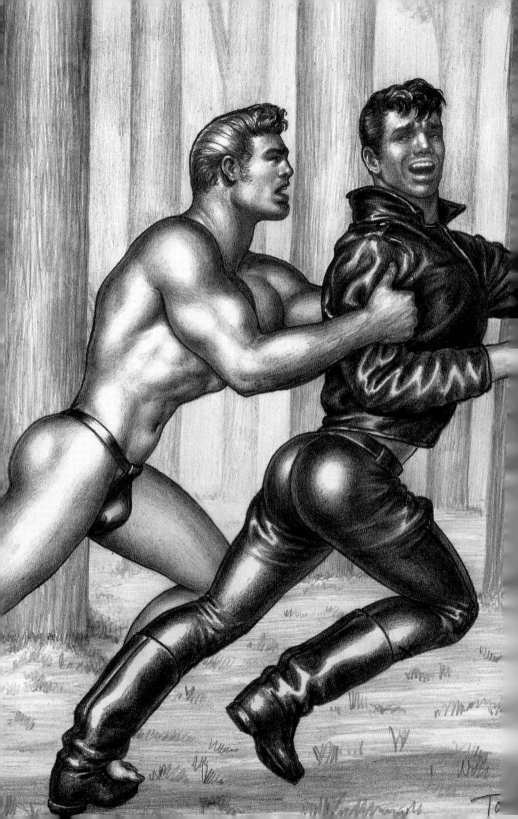

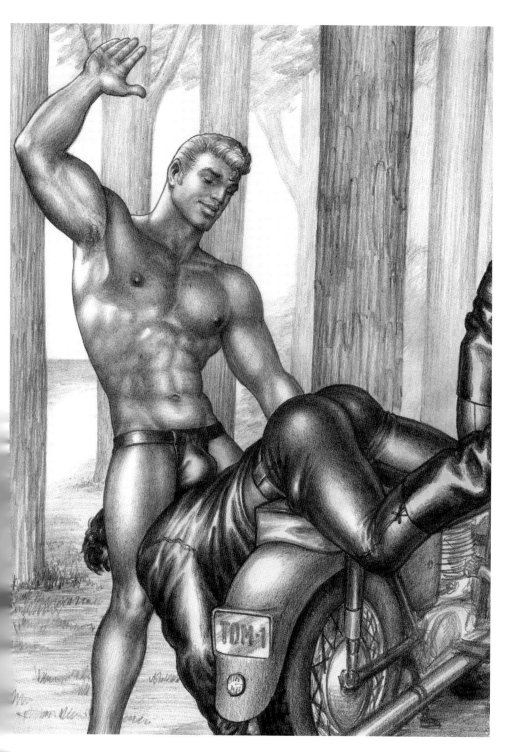

OPPOSITE AND ABOVE 1961, graphite on paper

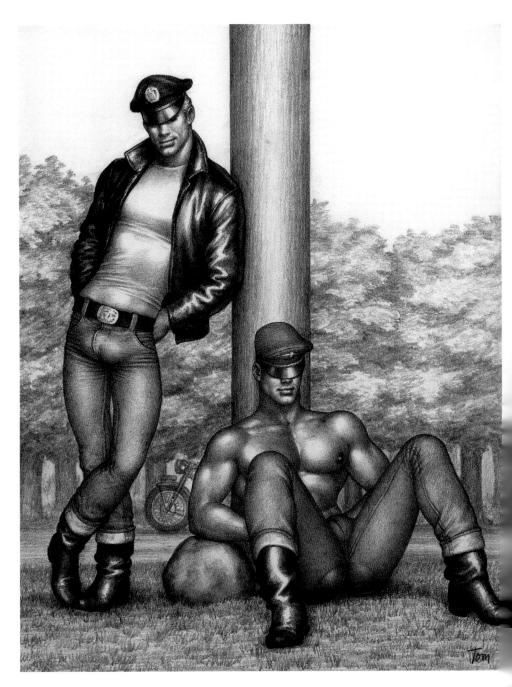

ABOVE AND OPPOSITE 1962, graphite on pape

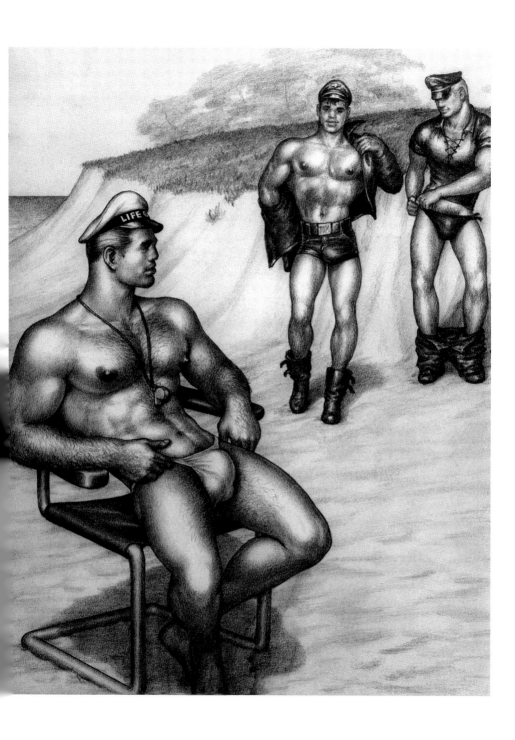

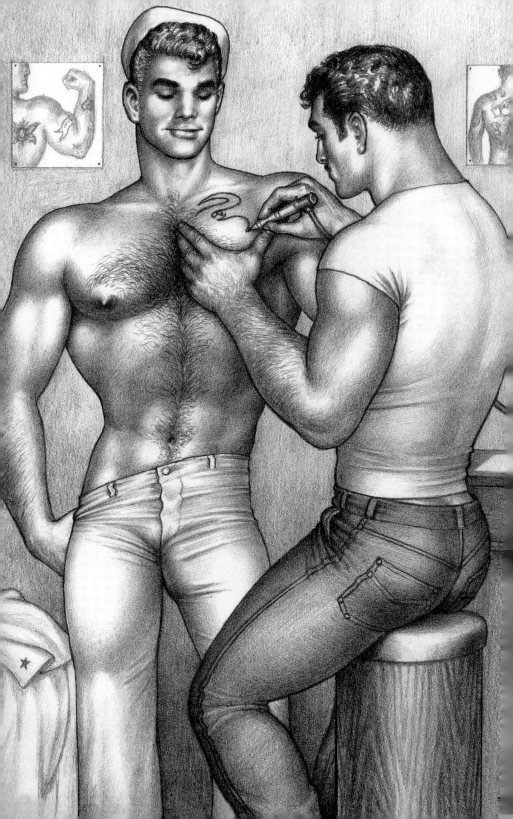

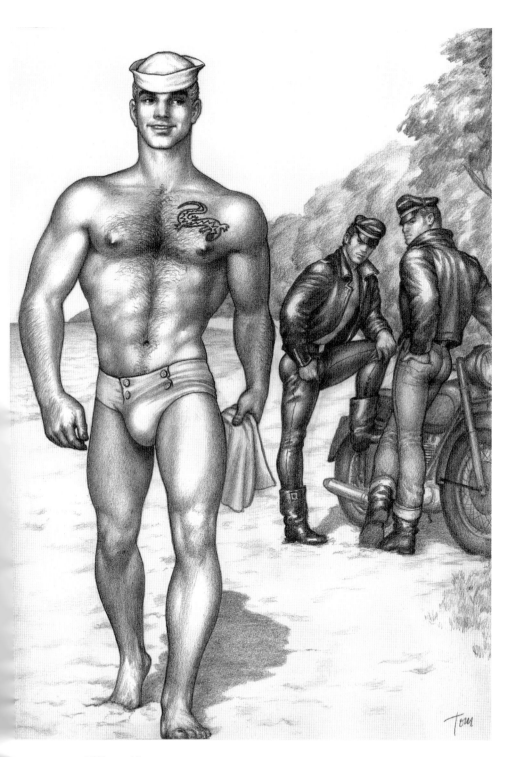

OPPOSITE AND ABOVE 1962, graphite on paper

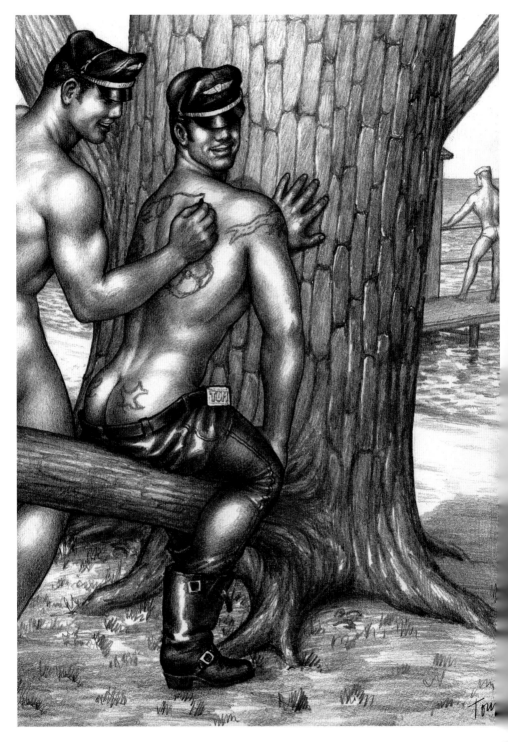

ABOVE AND OPPOSITE 1962, graphite on pape

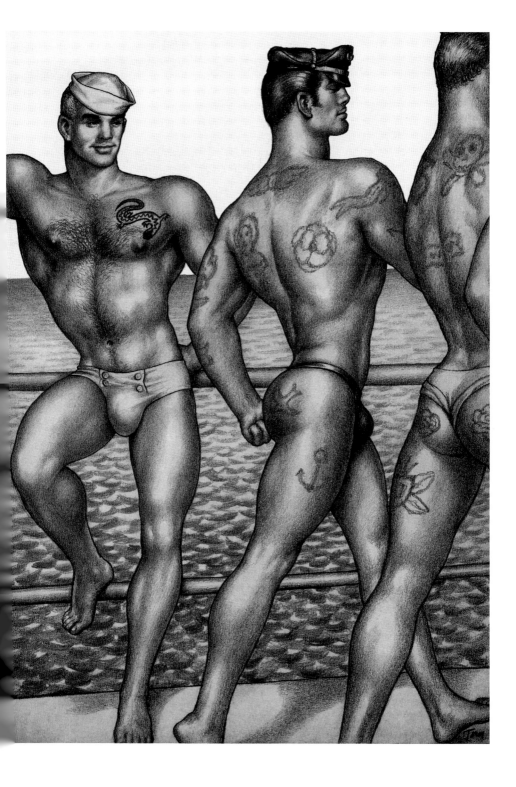

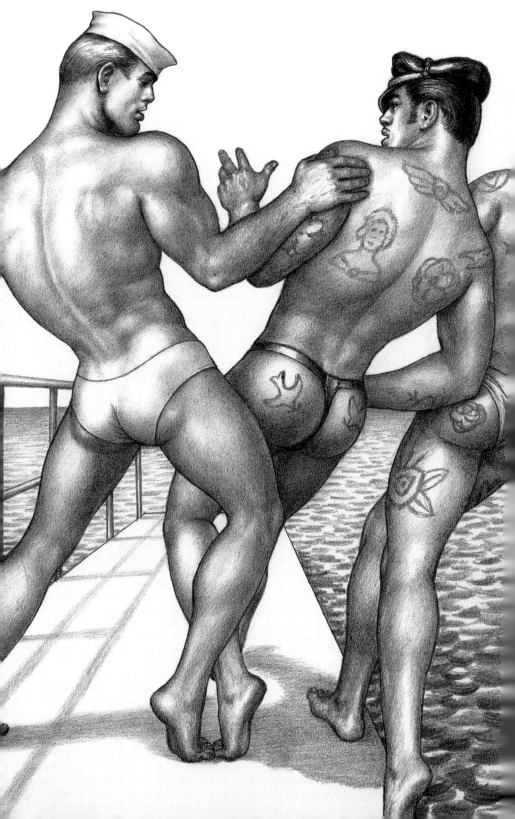

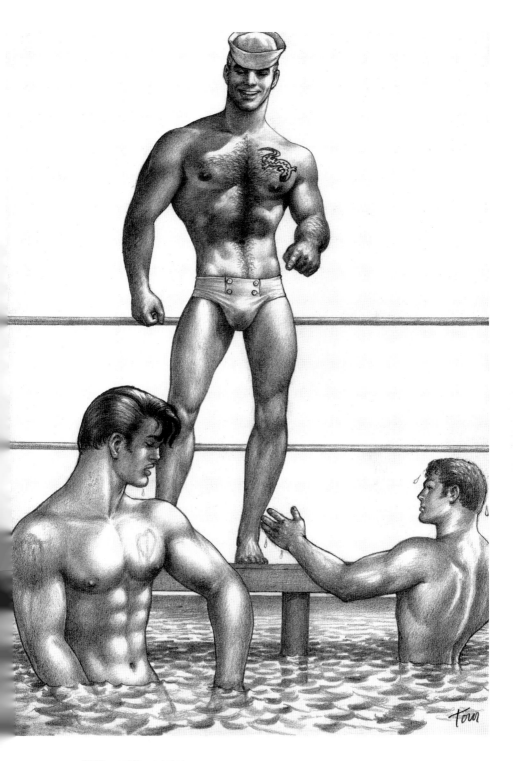

OPPOSITE AND ABOVE 1962, graphite on paper
PAGES 62-63 1963, graphite on paper

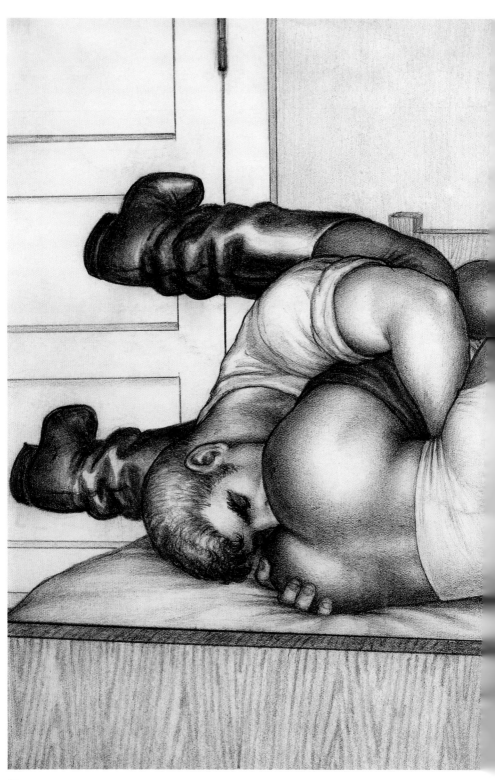

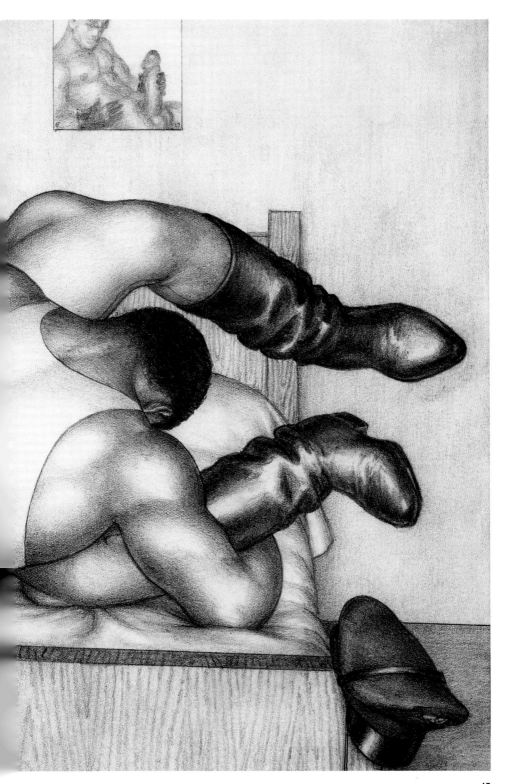

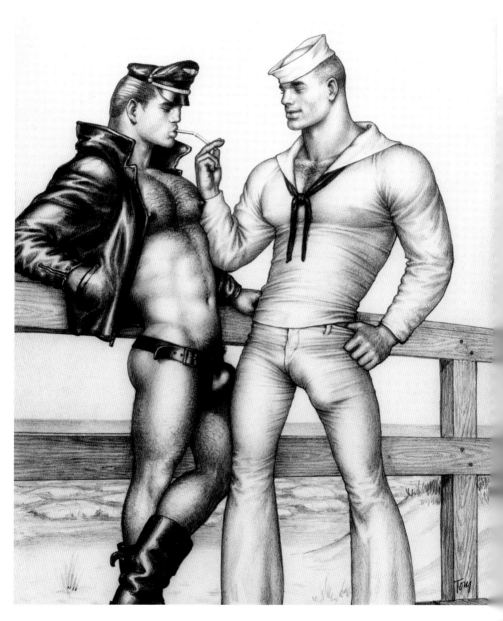

ABOVE AND OPPOSITE 1962, graphite on pap

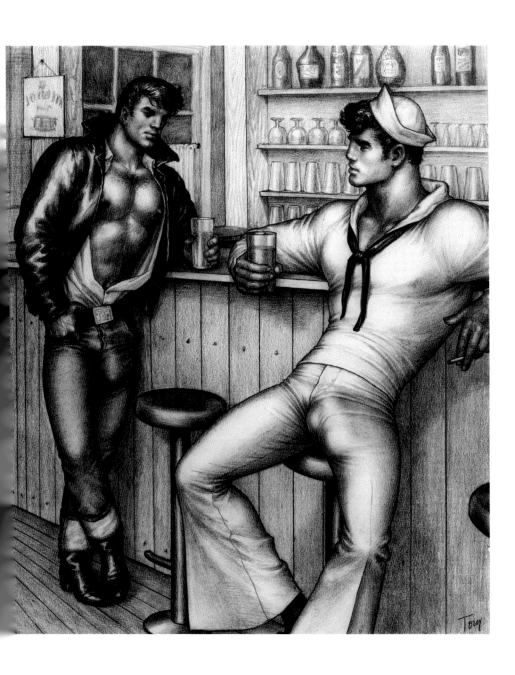

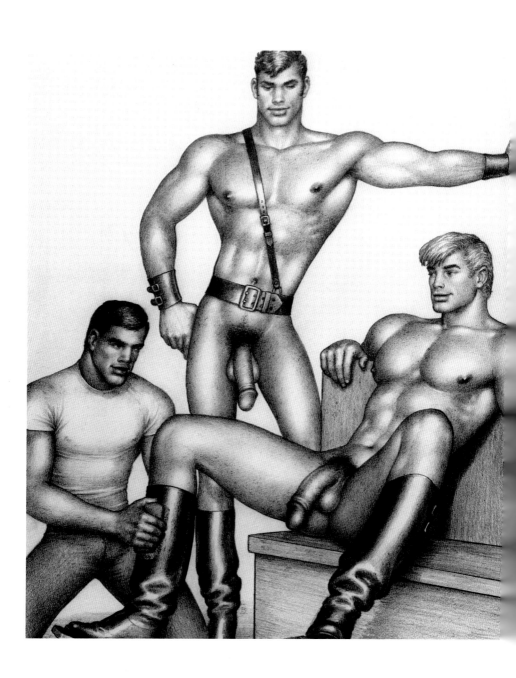

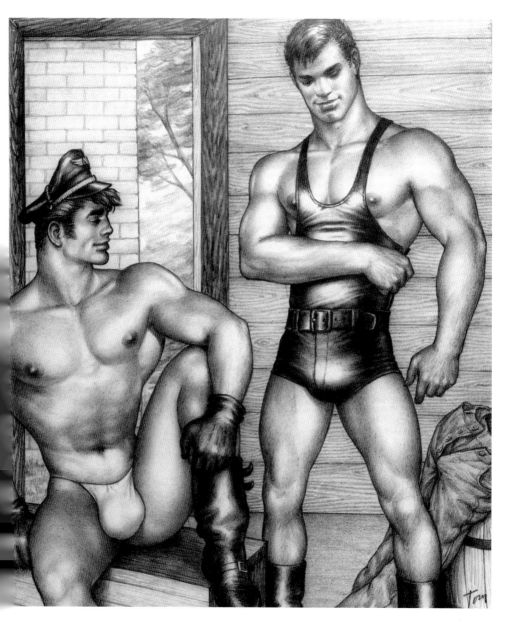

OPPOSITE AND ABOVE 1962, graphite on paper

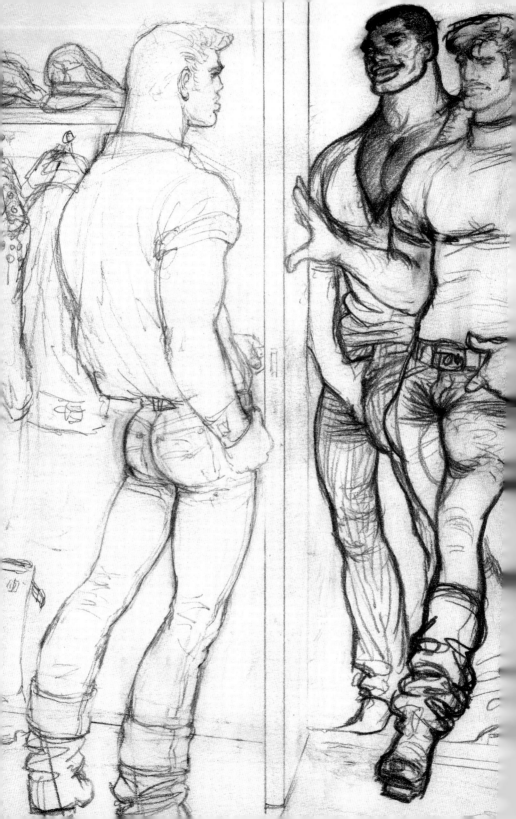

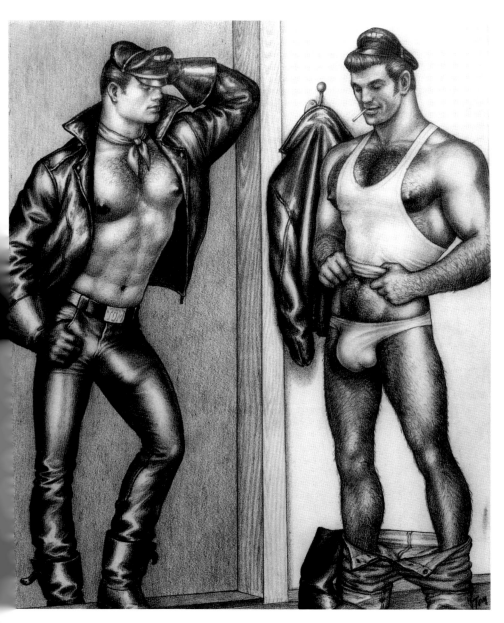

opposite circa 1965, graphite on paper
above 1962, graphite on paper

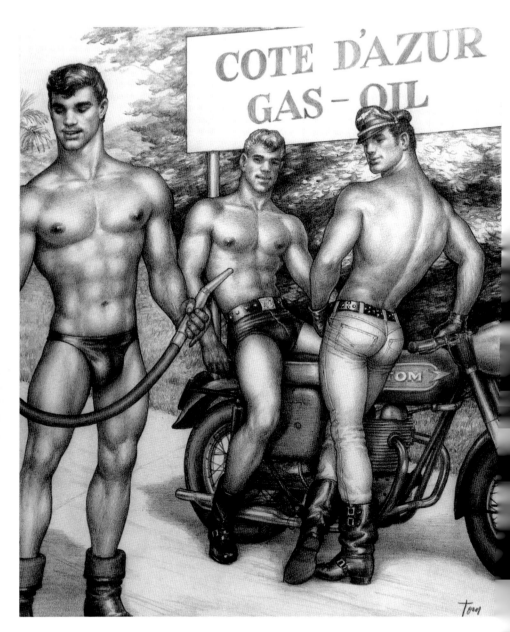

OPPOSITE AND ABOVE 1963, graphite on pap[e]

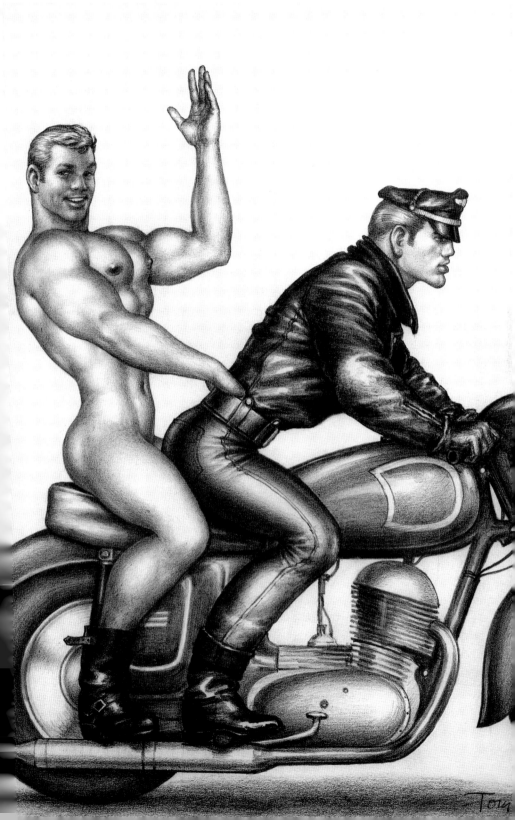

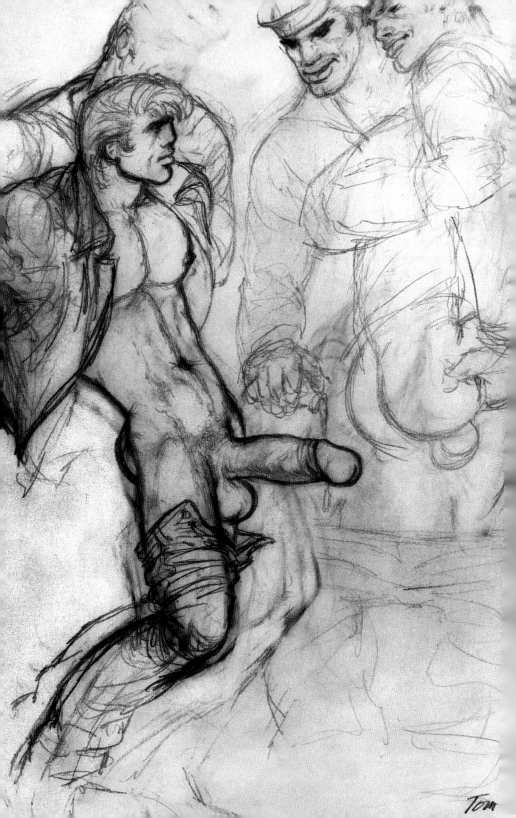

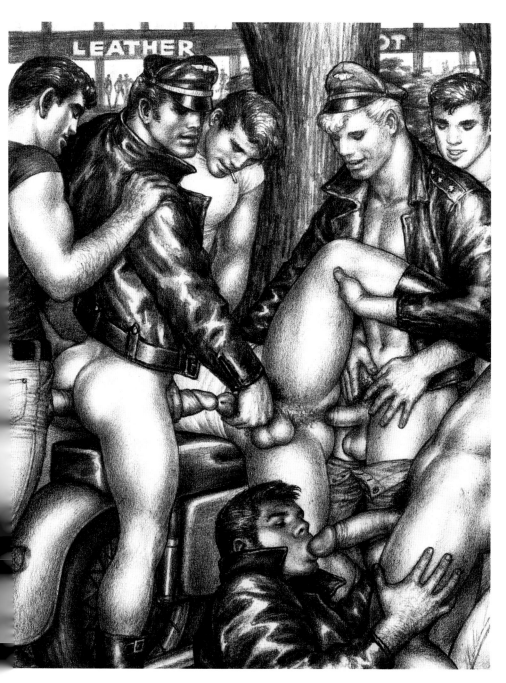

OPPOSITE circa 1962, graphite on paper
ABOVE AND PAGES 74-75 1963, graphite on paper

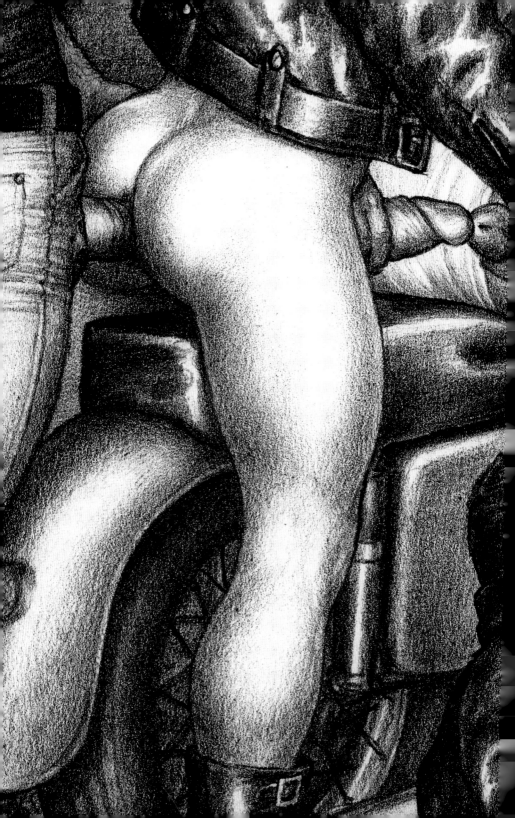

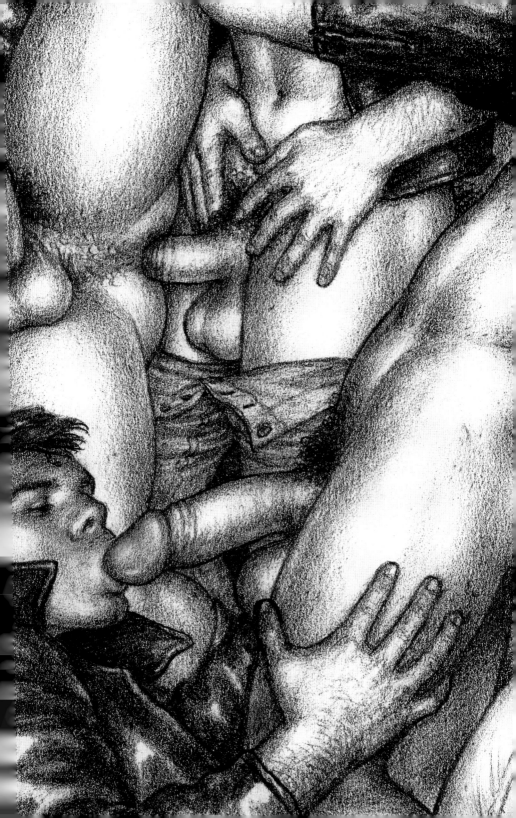

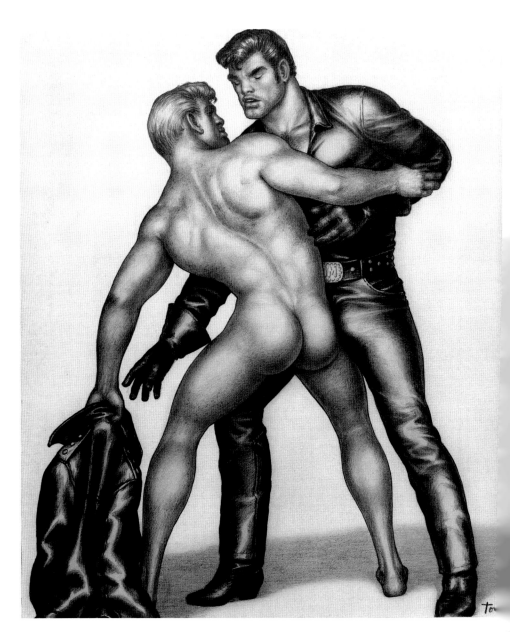

ABOVE AND OPPOSITE 1963, graphite on pape[r]

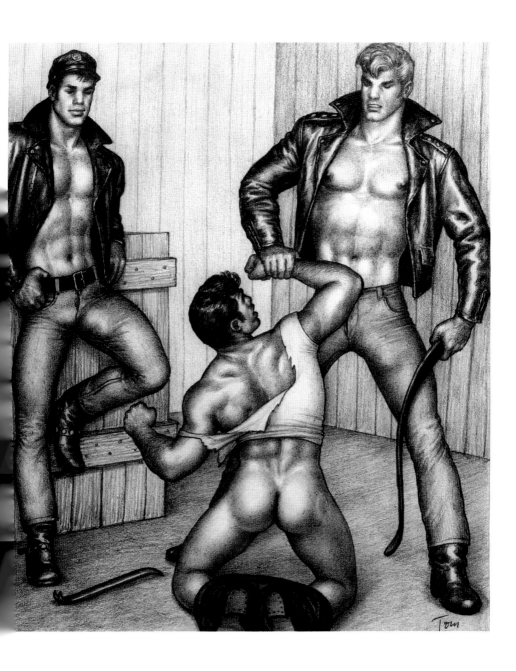

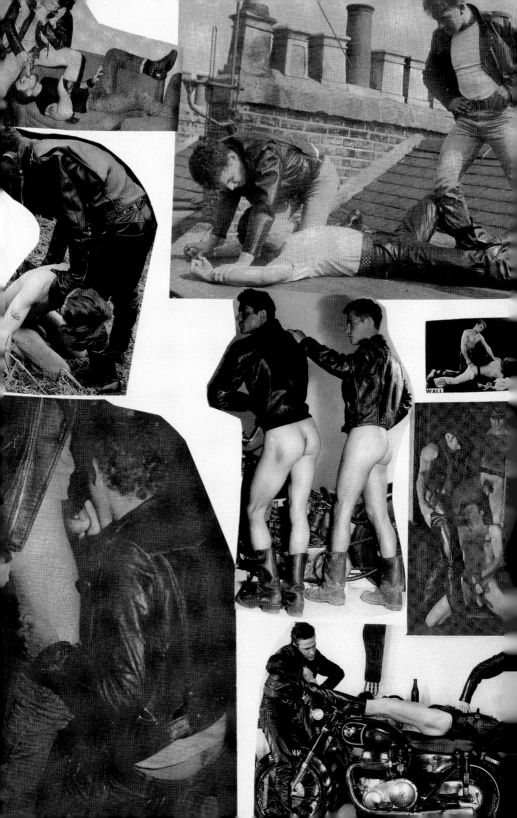

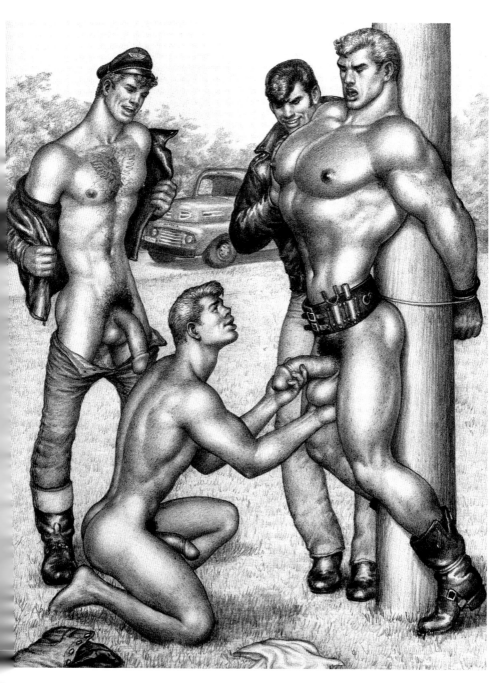

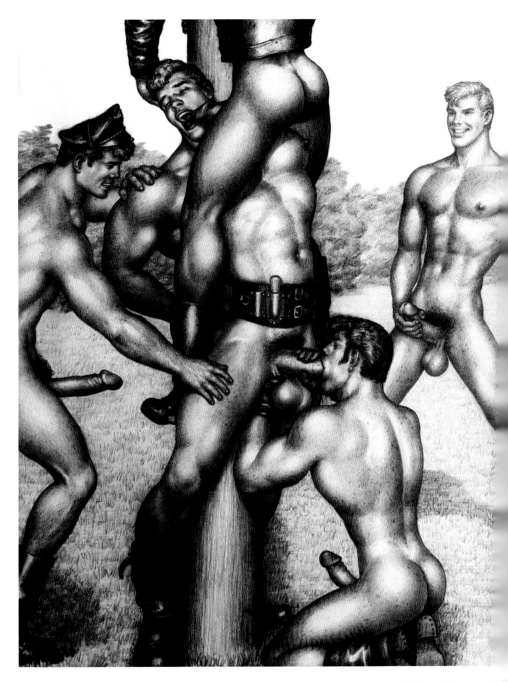

ABOVE AND OPPOSITE 1963, graphite on pap

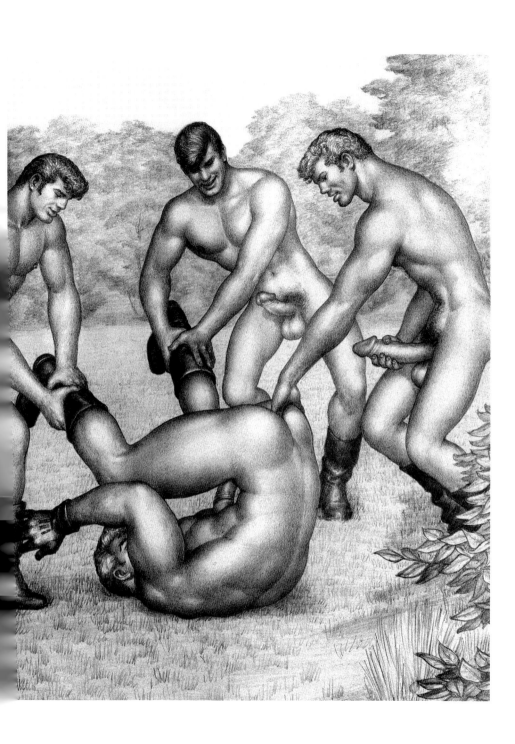

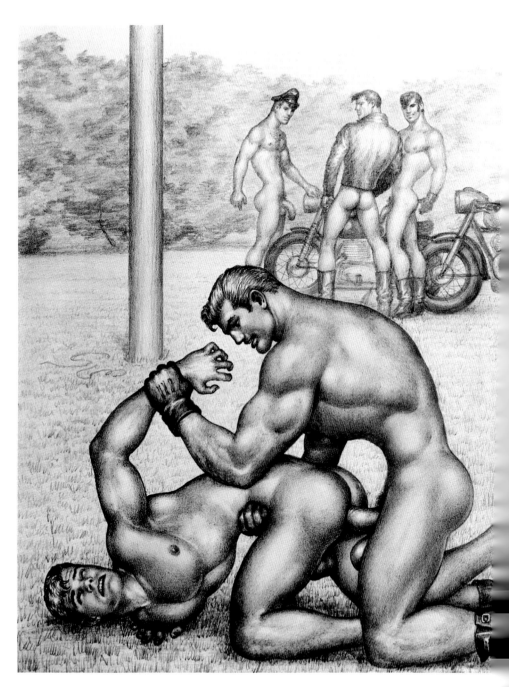

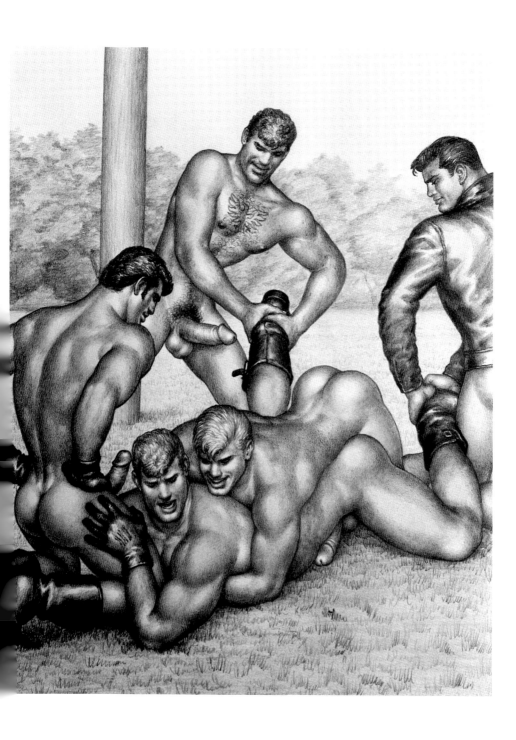

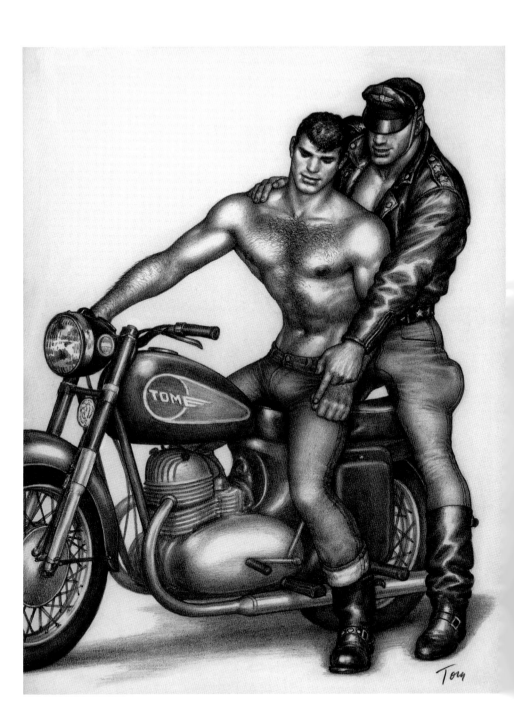

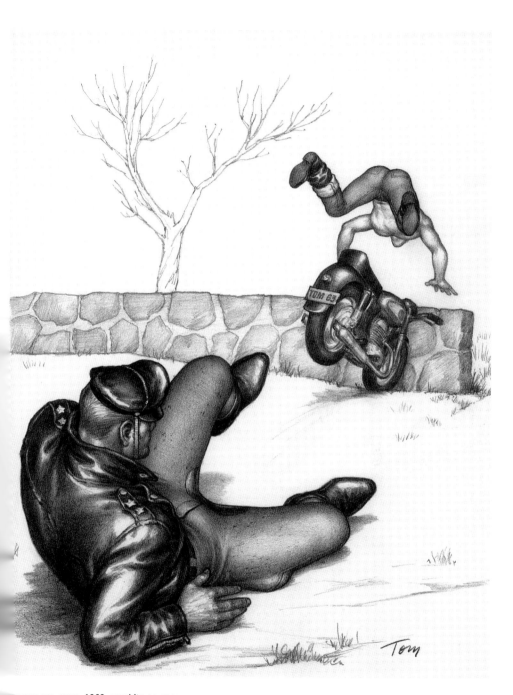

POSITE AND ABOVE 1963, graphite on paper

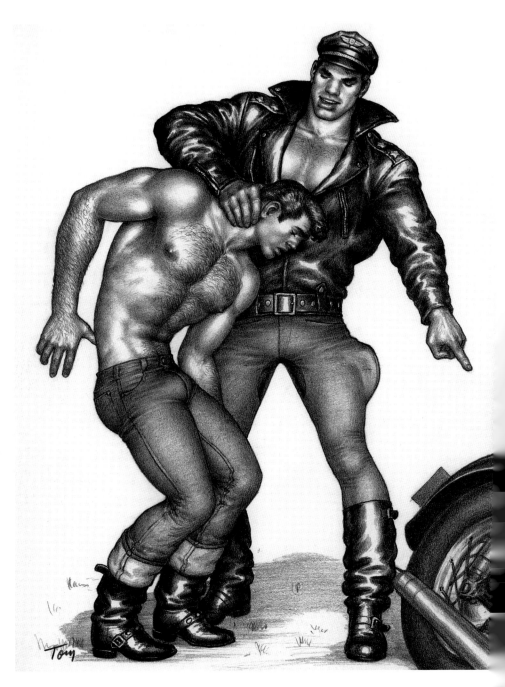

ABOVE AND OPPOSITE 1963, graphite on pap

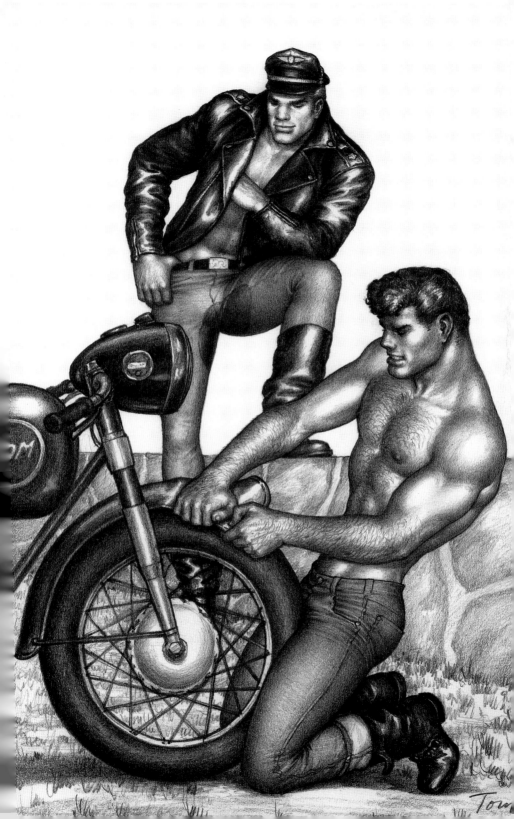

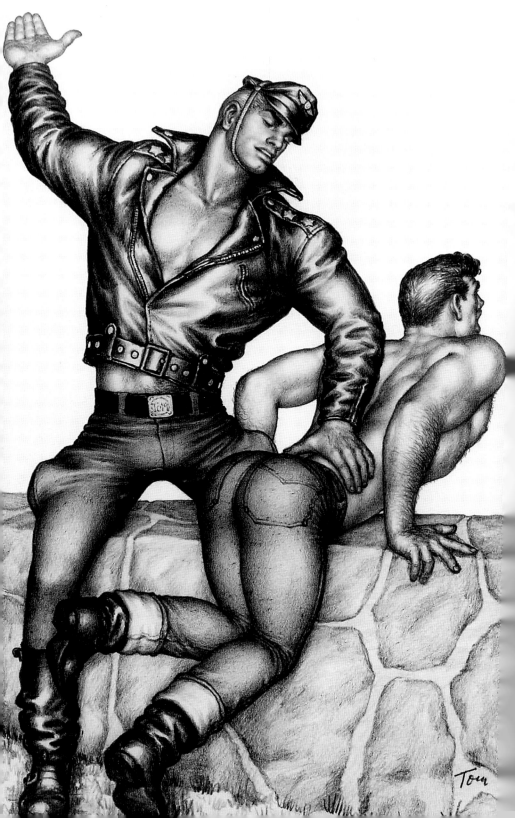

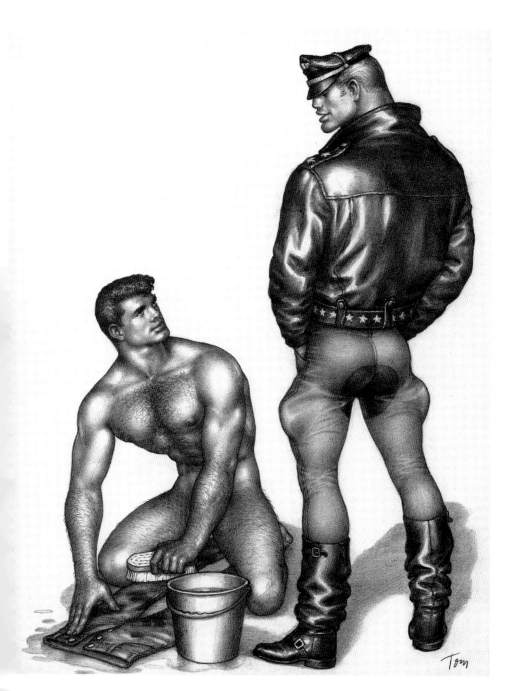

POSITE AND ABOVE 1963, graphite on paper

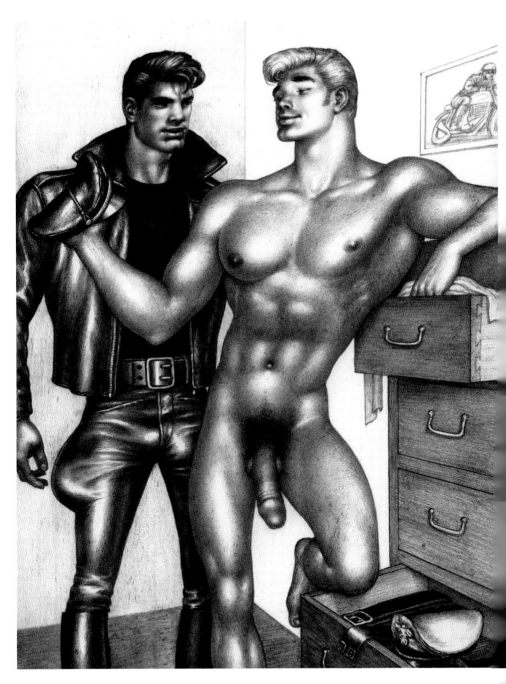

ABOVE 1964, graphite on pap
OPPOSITE 1963, graphite on pap

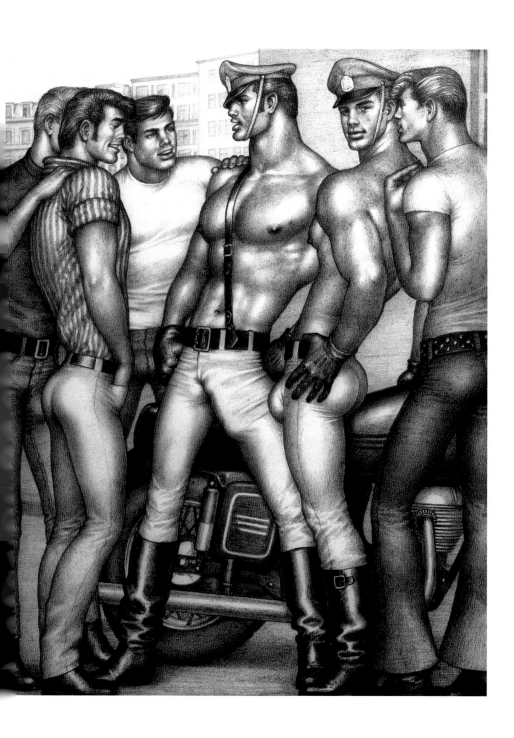

"The abstract, especially in those rough sketches, is very important to me... Sometimes those first few lines cut the paper into such satisfying shapes that I don't want to go on, but I always do, adding nostrils and nipples and bootstraps..."

—Tom of Finland

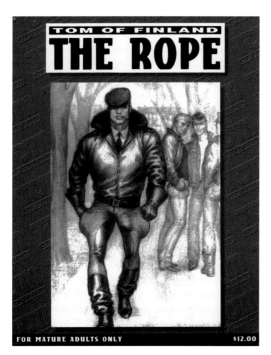

LEFT 1968, Cover for *The Rope* comic book
OPPOSITE 1968, graphite on paper

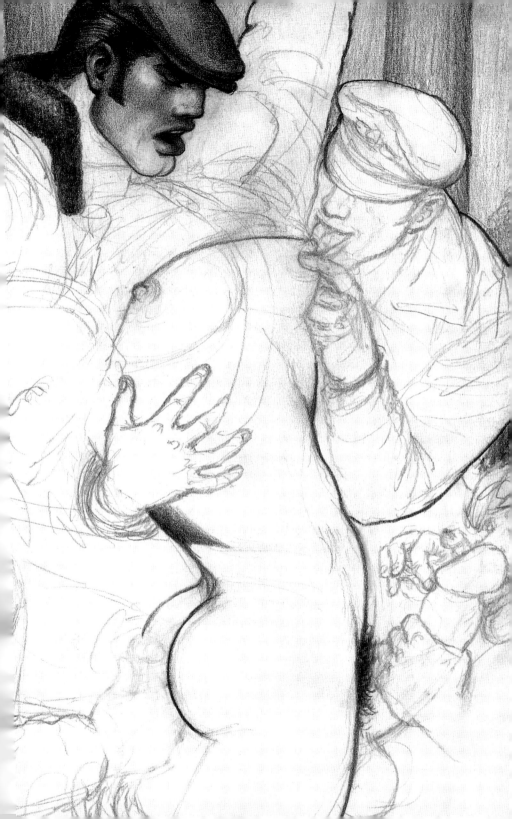

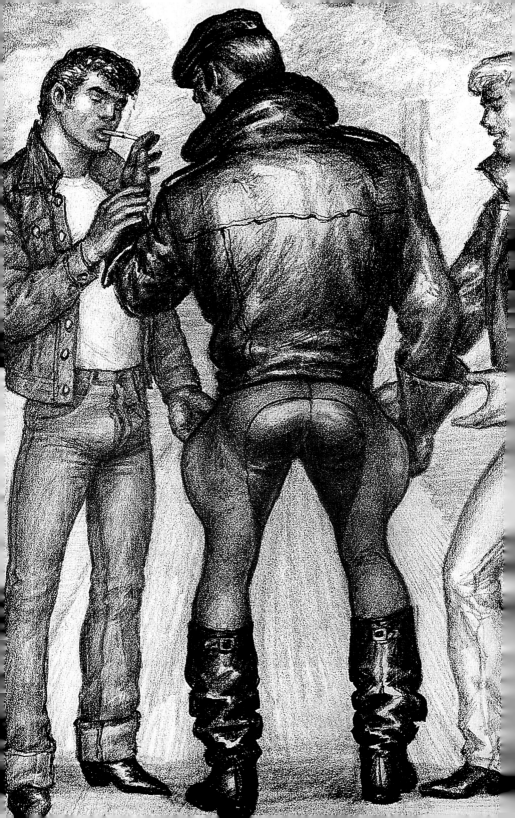

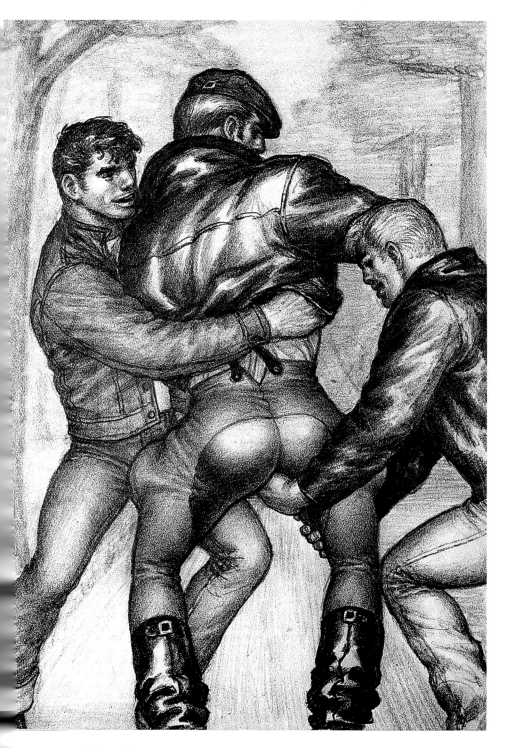

OSITE AND ABOVE 1968, graphite on paper

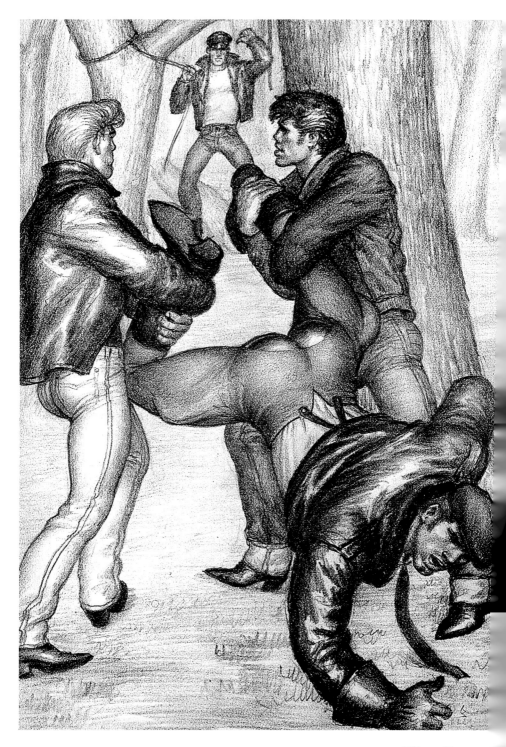

ABOVE AND OPPOSITE 1968, graphite on pa

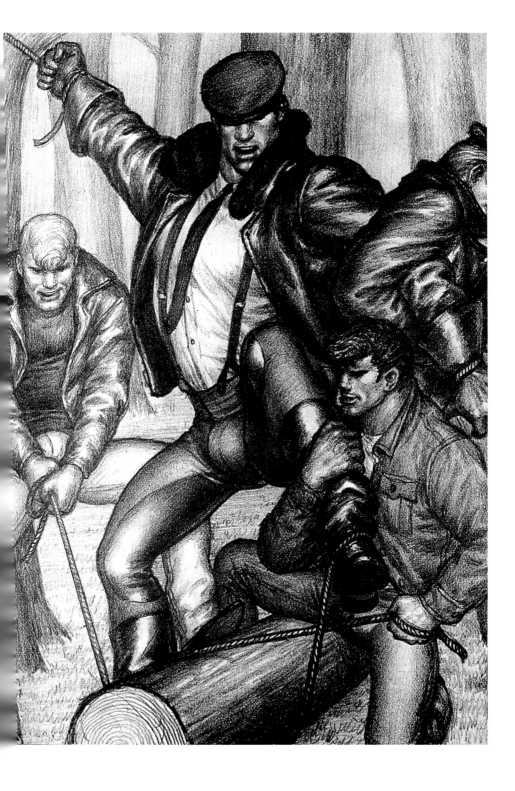

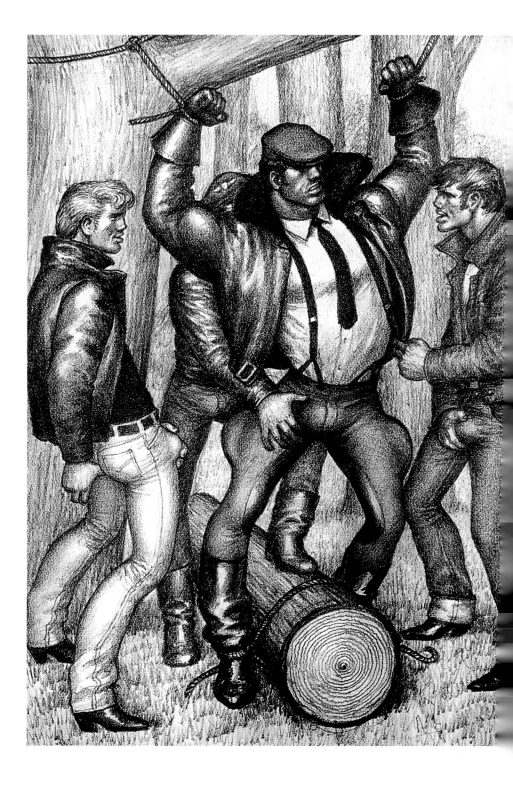

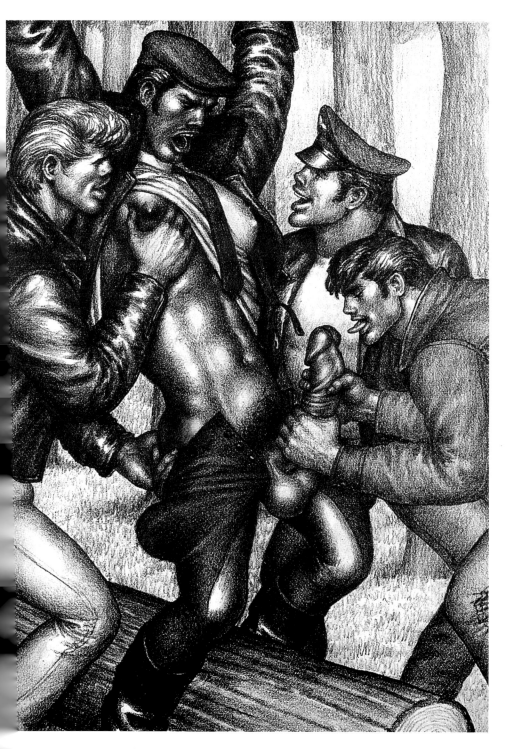

OSITE AND ABOVE 1968, graphite on paper

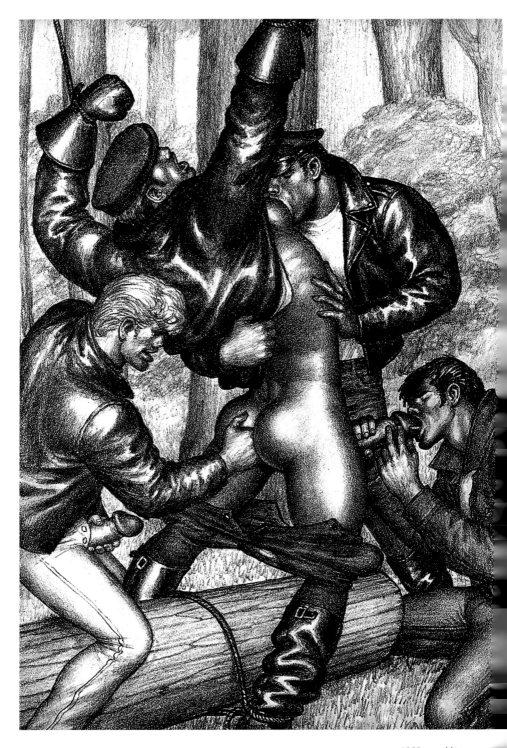

ABOVE AND OPPOSITE 1968, graphite on pa

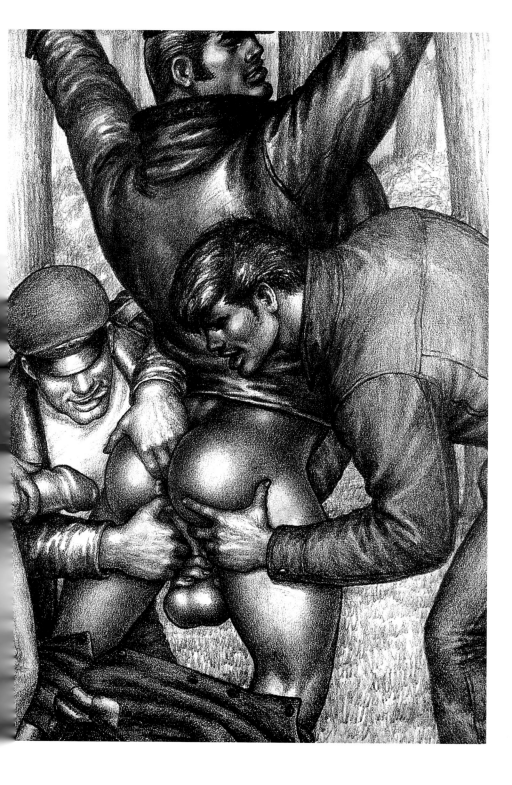

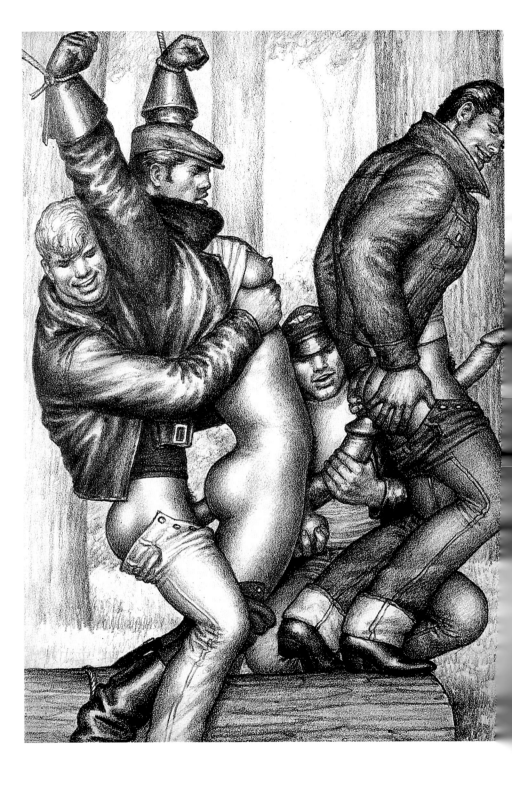

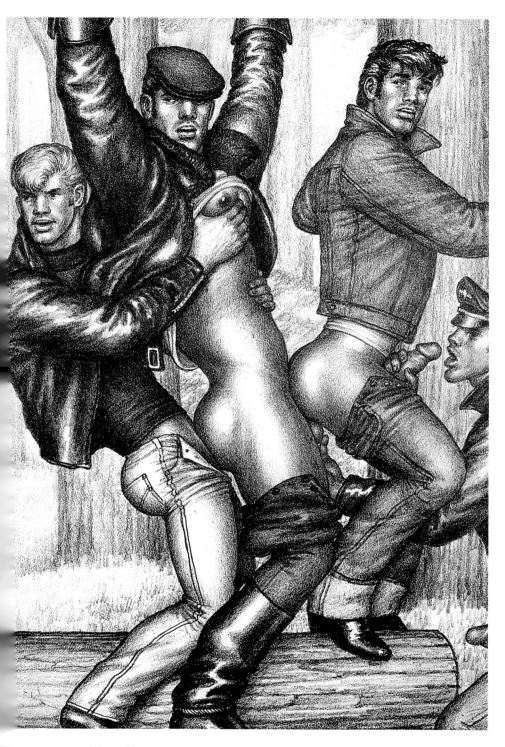

OSITE AND ABOVE 1968, graphite on paper

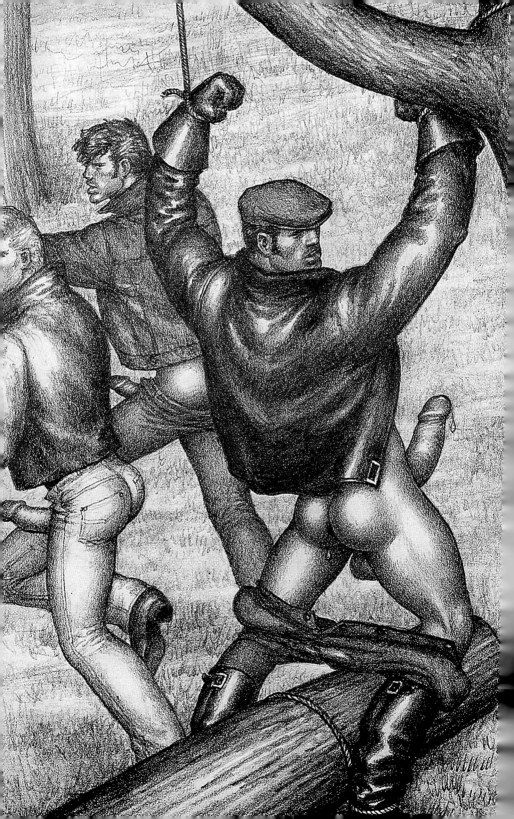

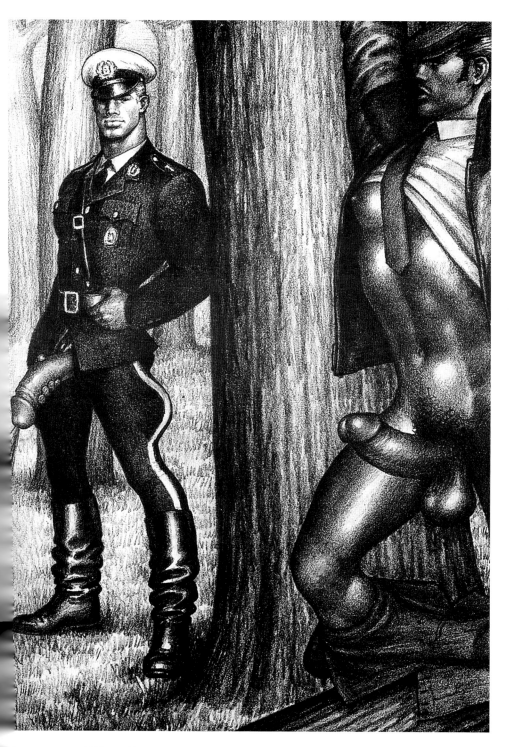

OPPOSITE AND ABOVE 1968, graphite on paper

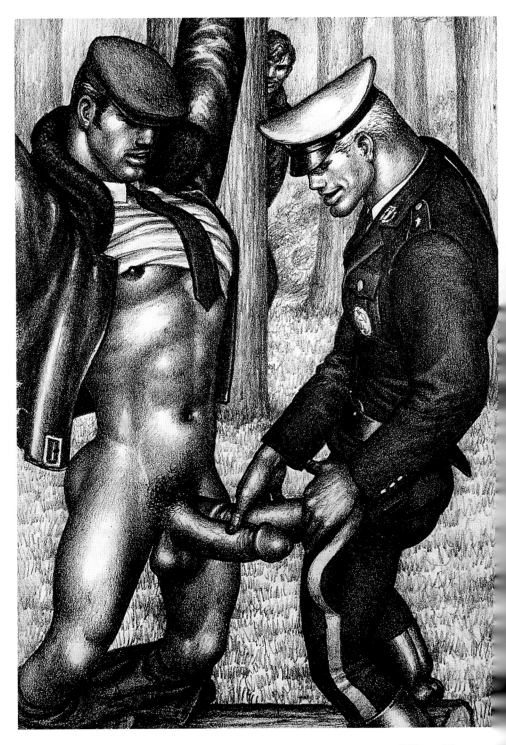

ABOVE AND OPPOSITE 1968, graphite on pap

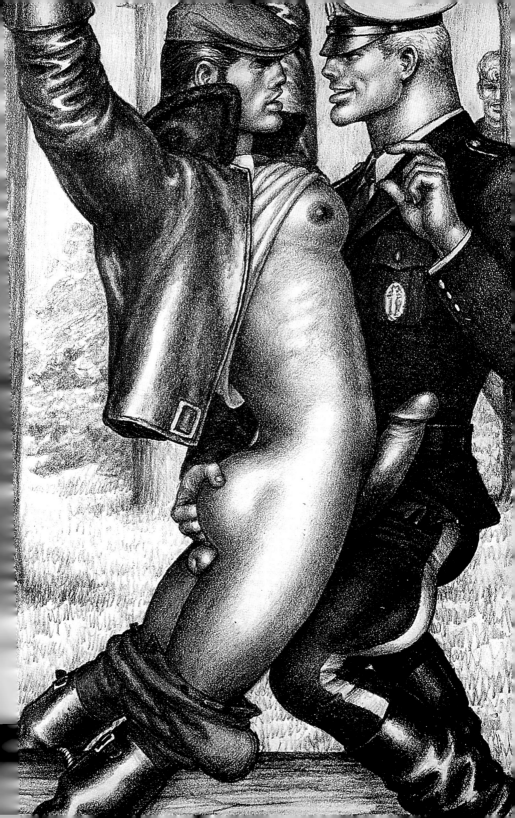

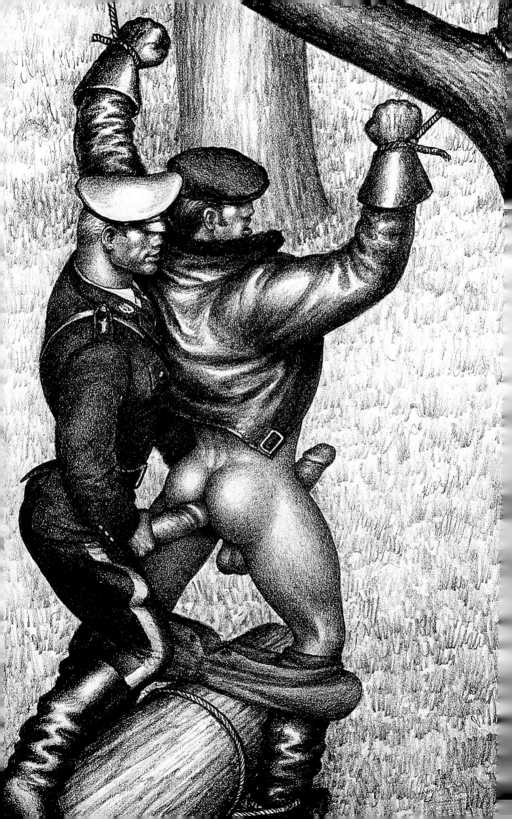

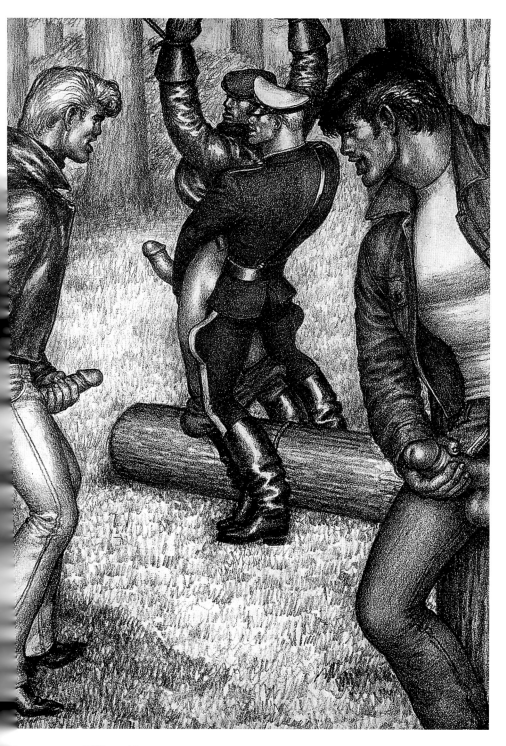

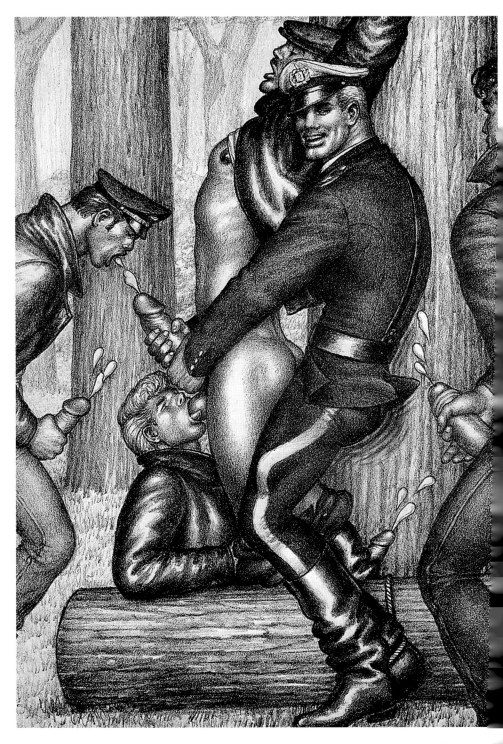

ABOVE AND OPPOSITE 1968, graphite on pa

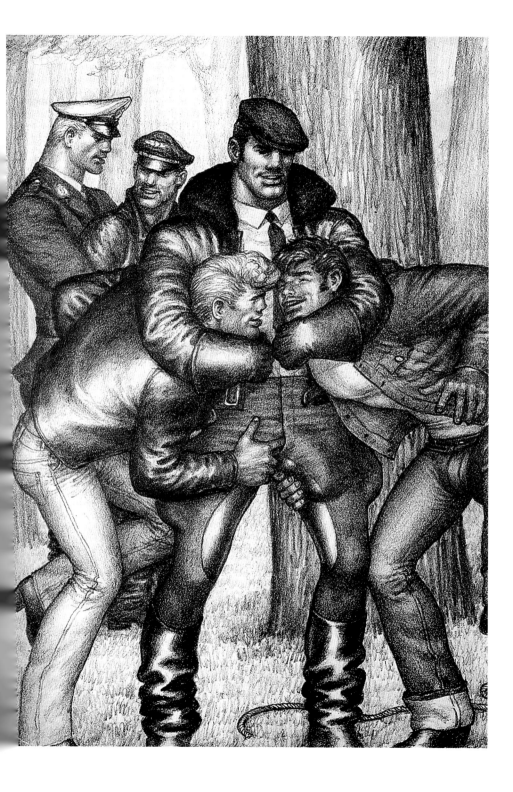

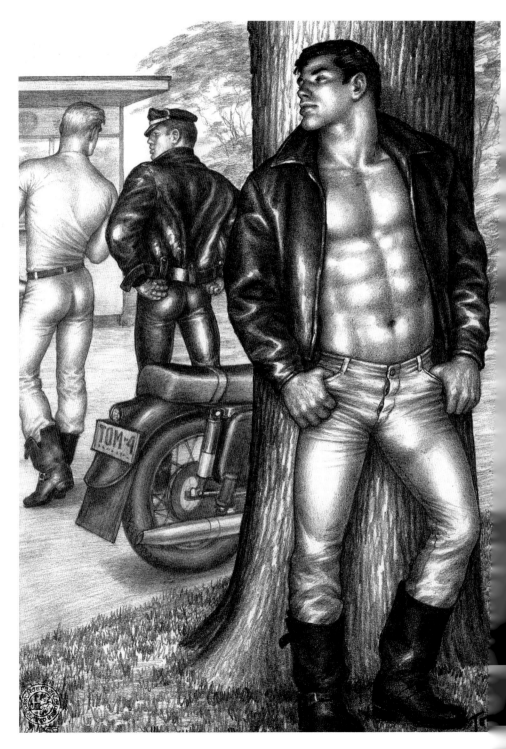

ABOVE, OPPOSITE, AND PAGES **114-115** 1964, graphite on pa

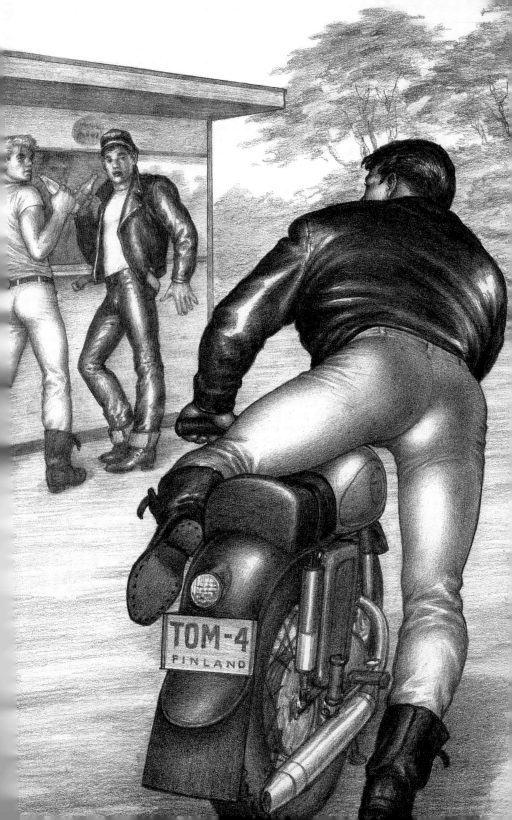

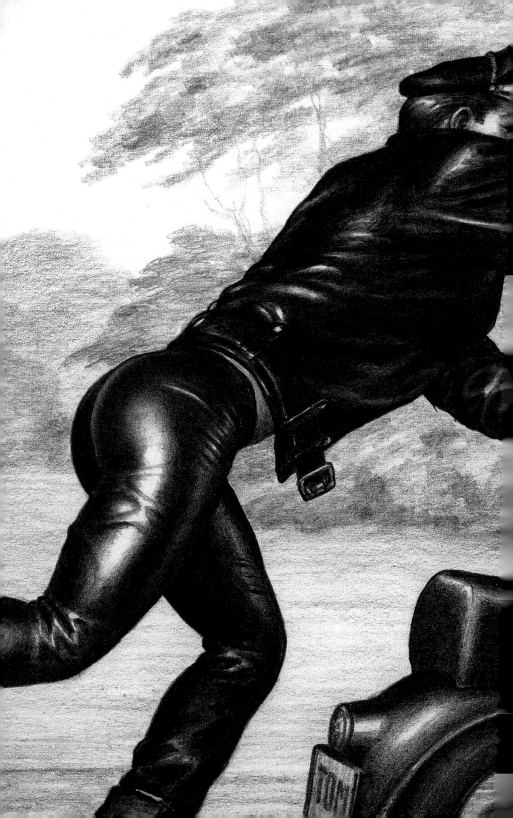

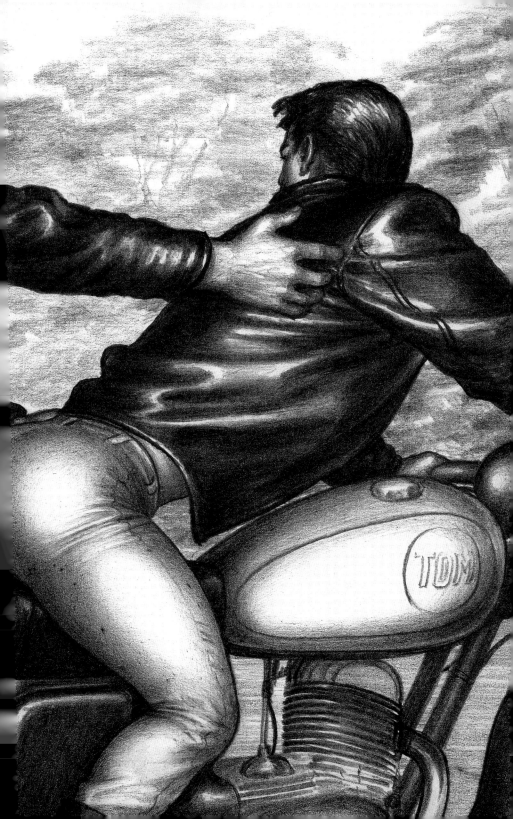

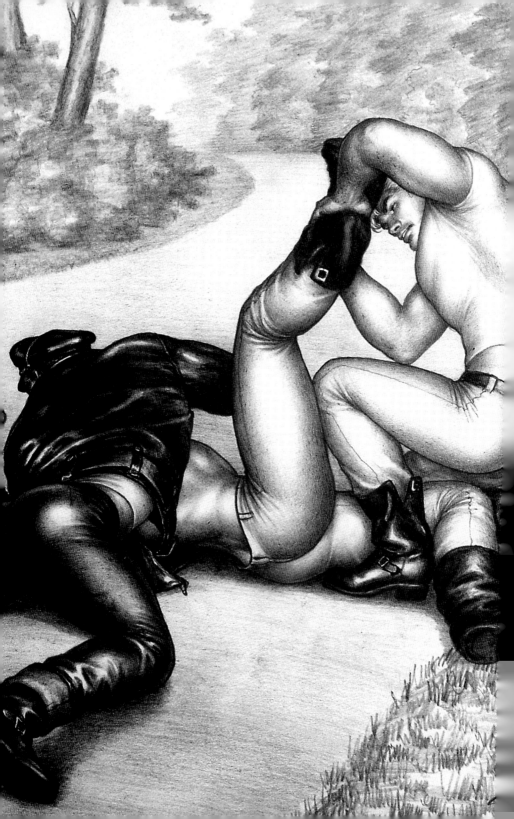

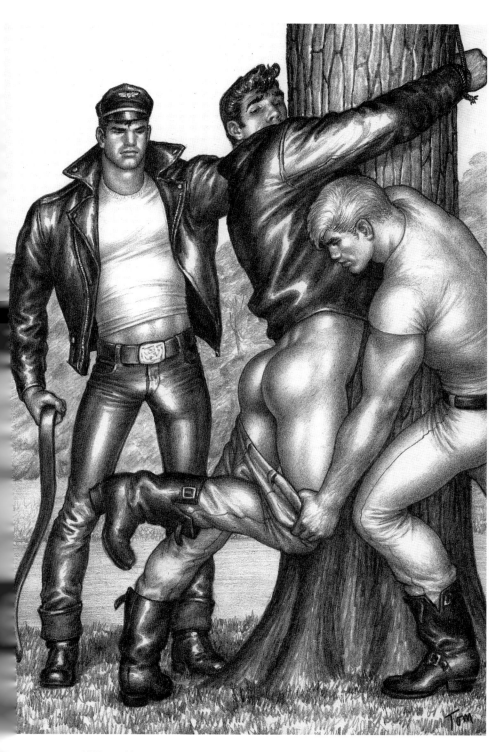

OSITE AND ABOVE 1964, graphite on paper

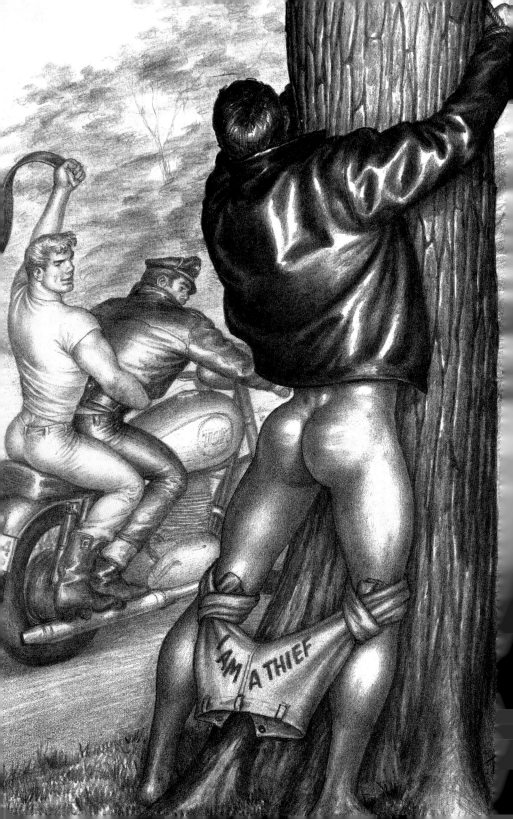

"My whole life long I have done nothing but interpret my dreams of ultimate masculinity, and draw them."

—Tom of Finland, from an interview with Patrick Sarfati in *Rebel*

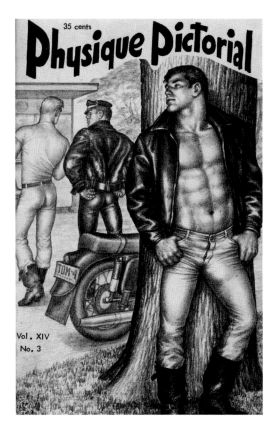

OPPOSITE 1964, graphite on paper
RIGHT *Physique Pictorial,* Vol. 14, No. 3

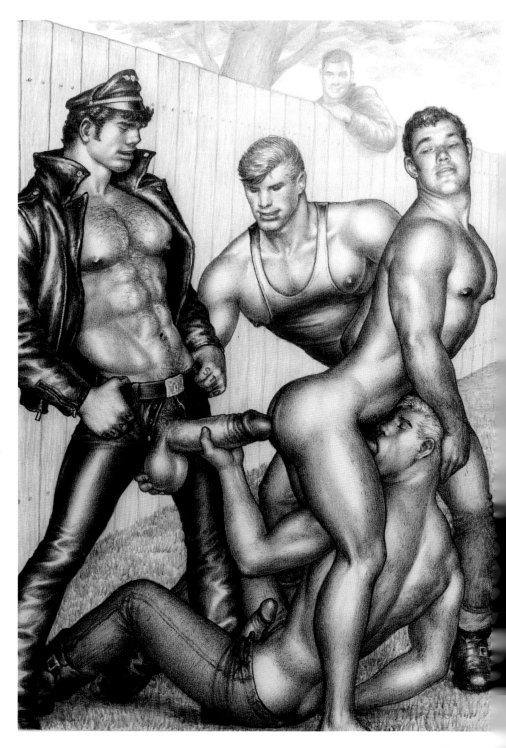

ABOVE AND OPPOSITE 1964, graphite on pap

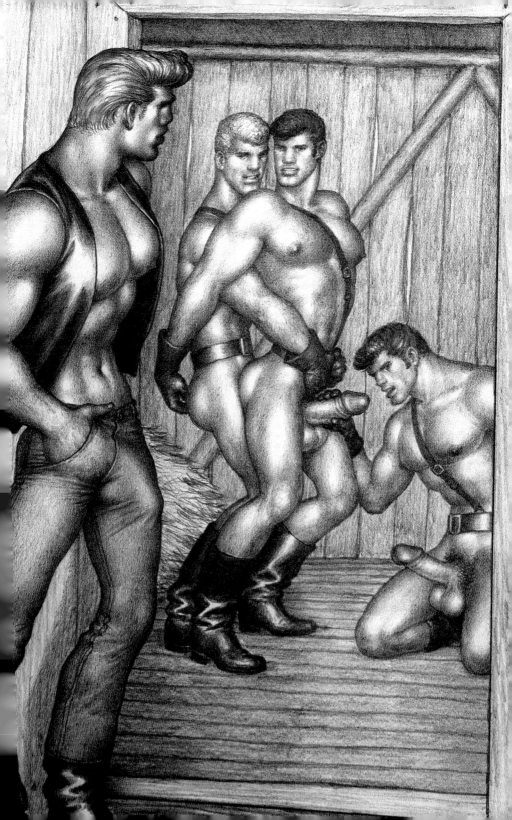

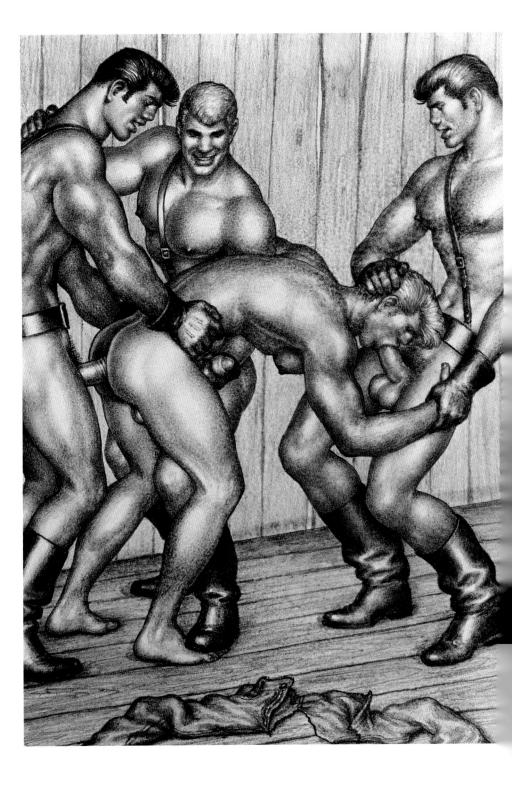

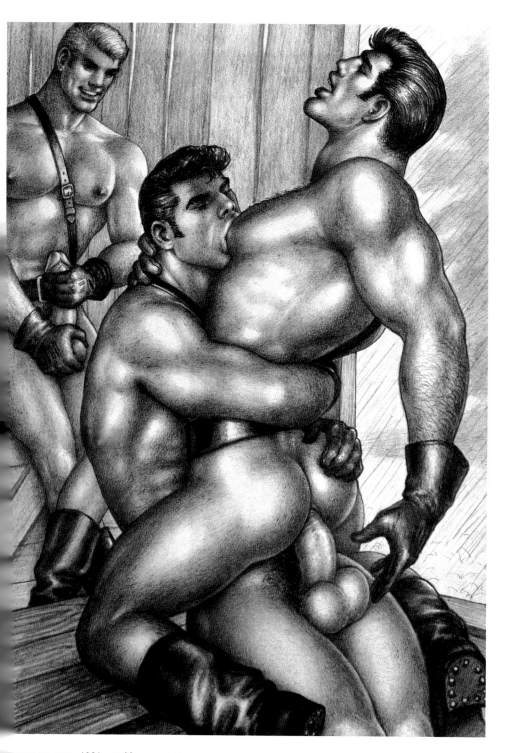

OSITE AND ABOVE 1964, graphite on paper

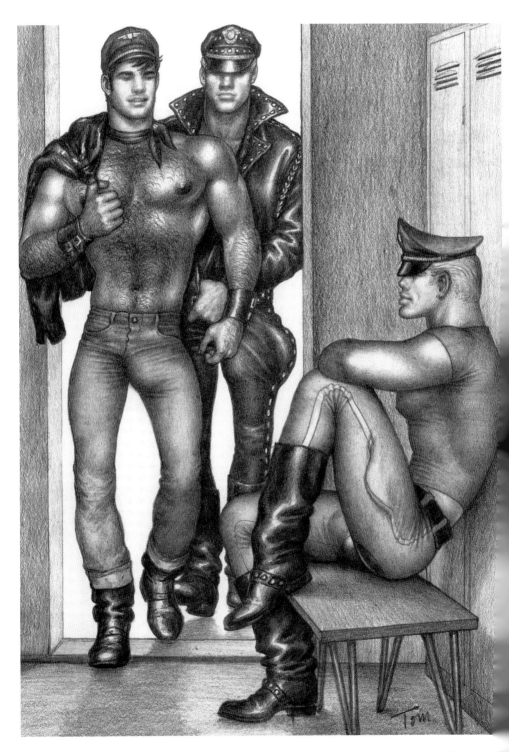

ABOVE AND OPPOSITE 1965, graphite on pap

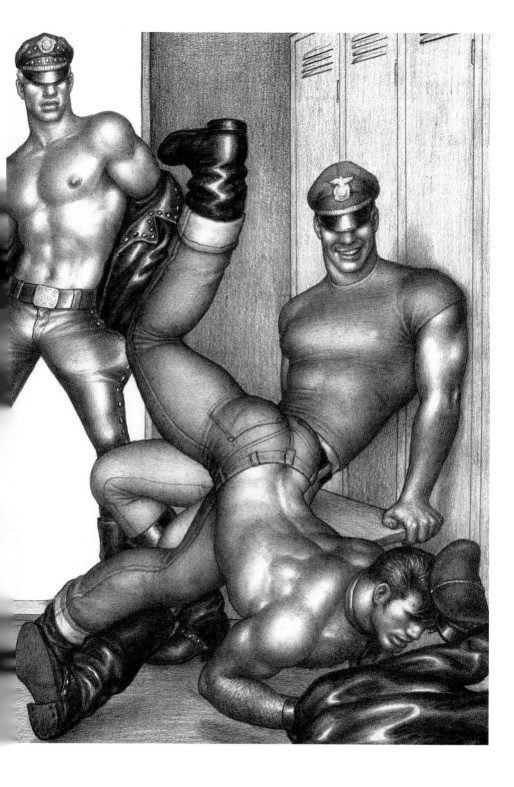

125

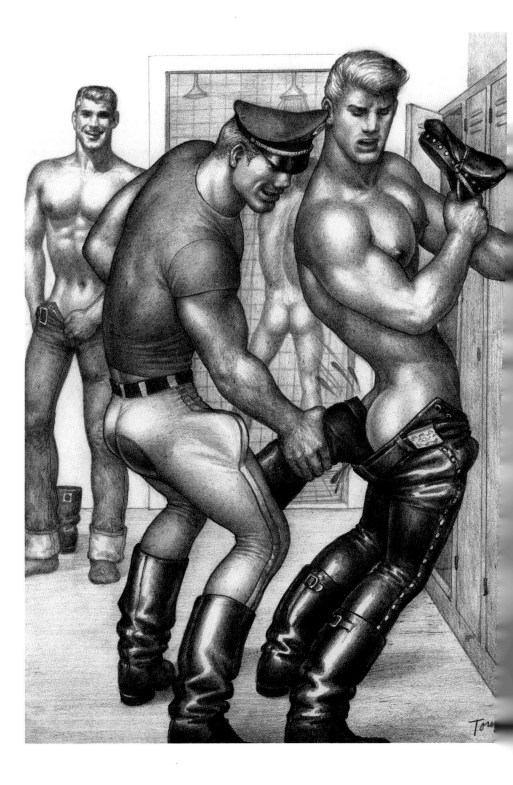

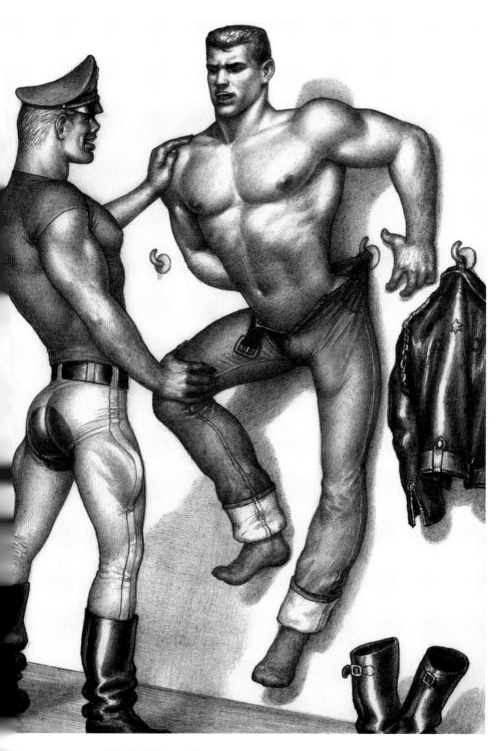

OSITE, ABOVE, AND PAGES **128-129** 1965, graphite on paper

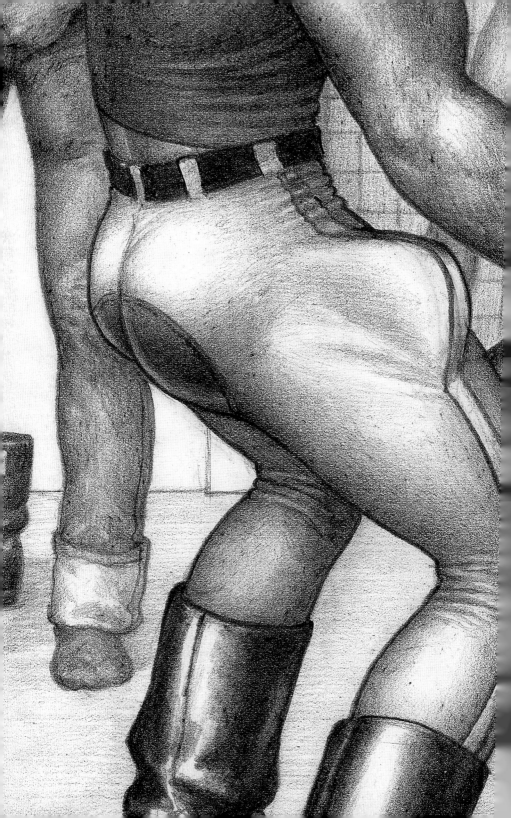

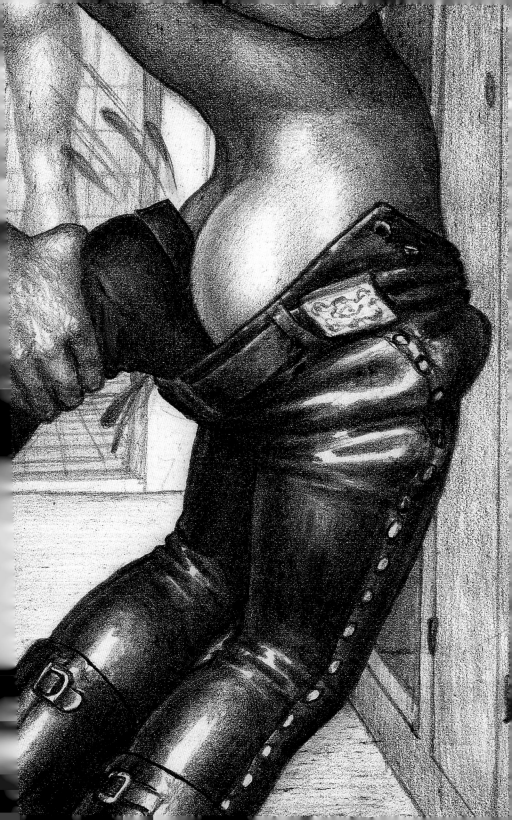

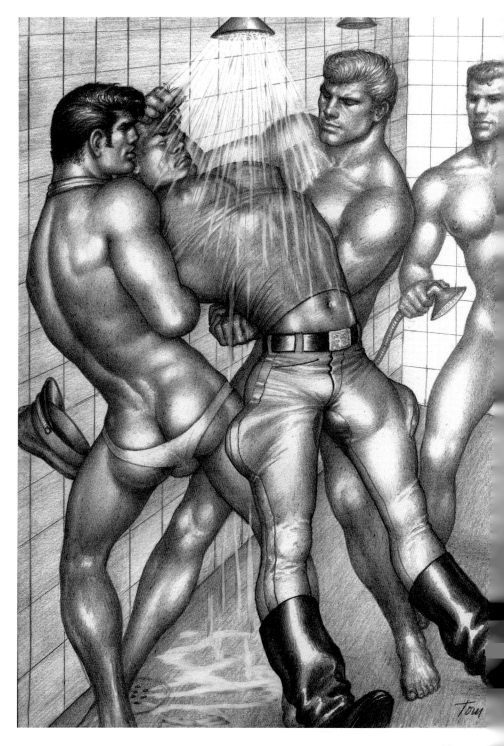

ABOVE 1965, graphite on pa◦
OPPOSITE circa 1964, graphite on pa

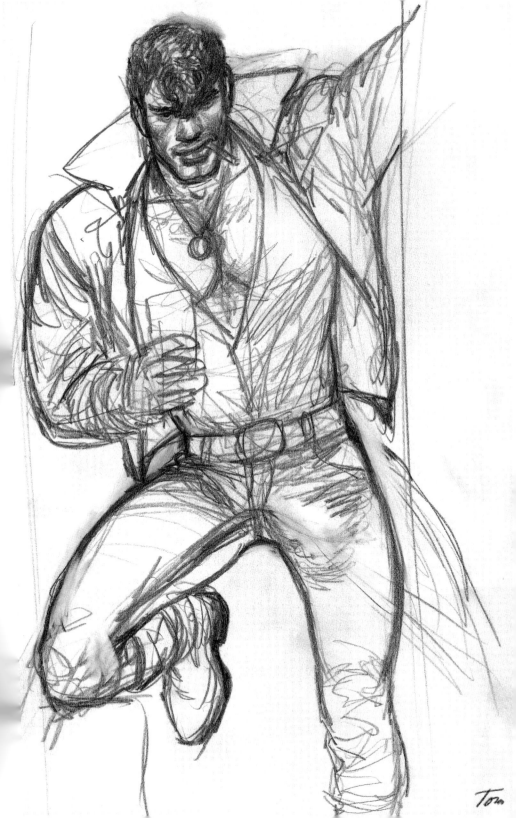

"In those days, a gay man was made to feel nothing but shame about his feelings and his sexuality. I wanted my drawings to counteract that, to show gay men being happy and positive about who they were."

—Tom of Finland

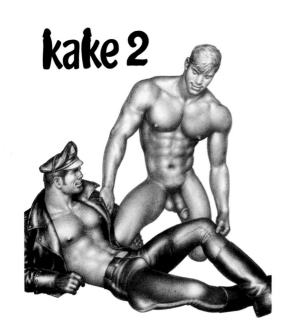

kake 2

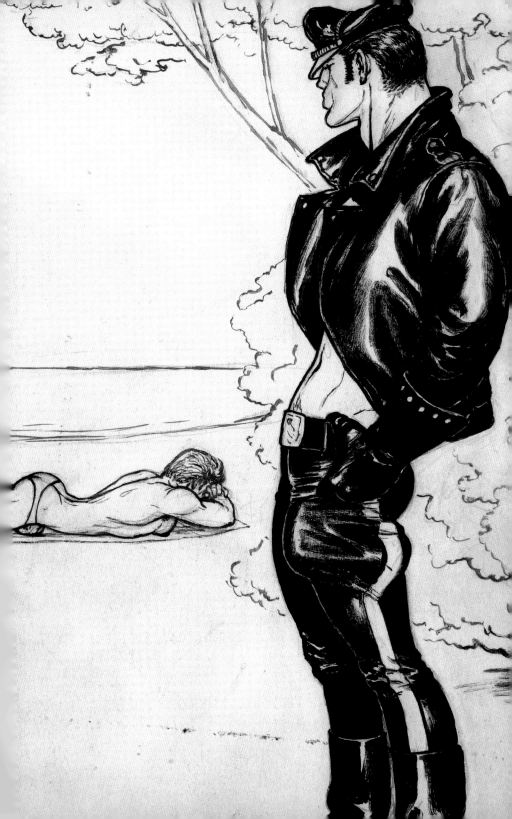

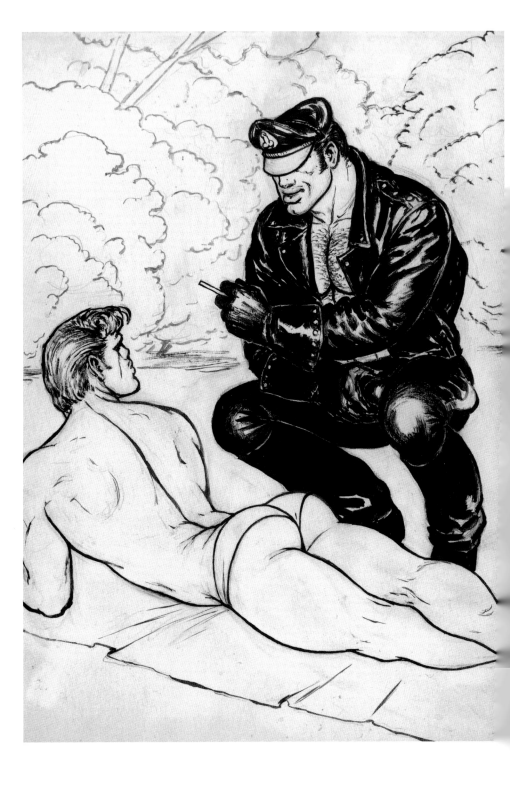

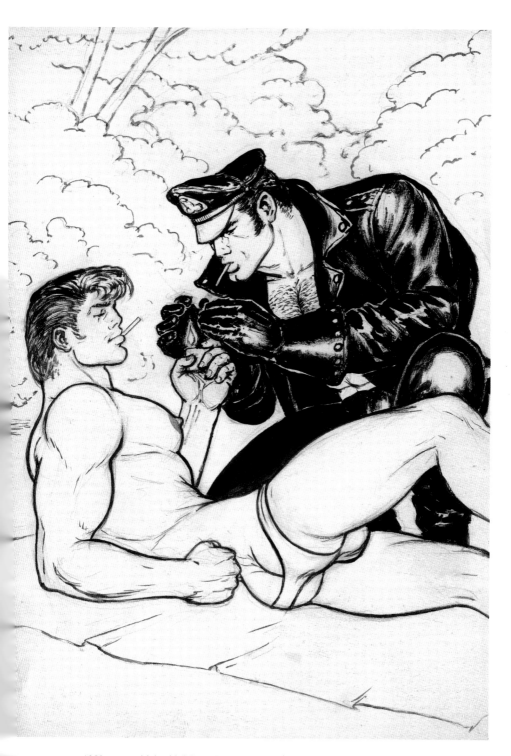

OPPOSITE AND ABOVE 1968, pen and ink with ink wash on paper

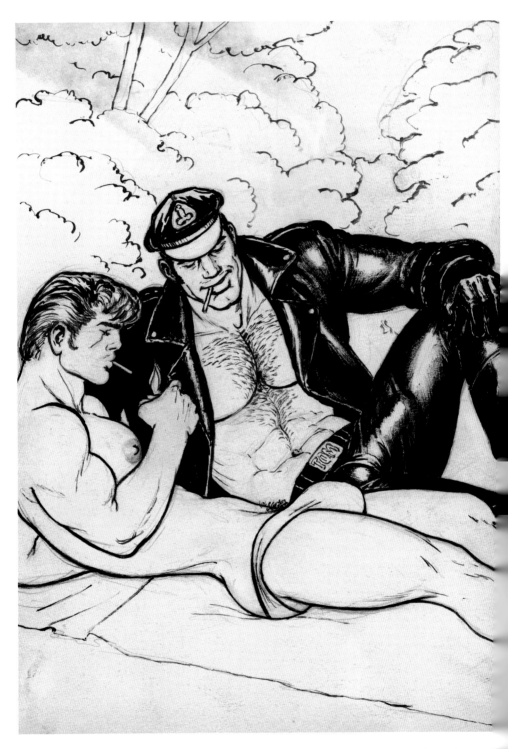

ABOVE AND OPPOSITE 1968, pen and ink with ink wash on pap

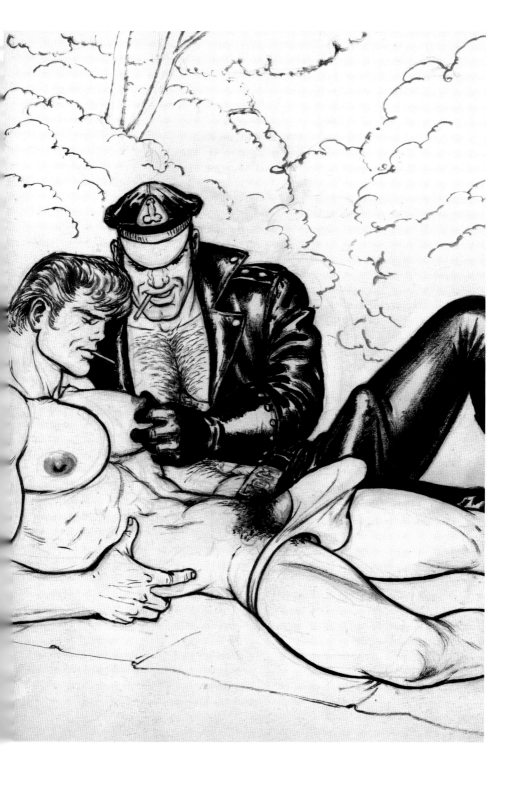

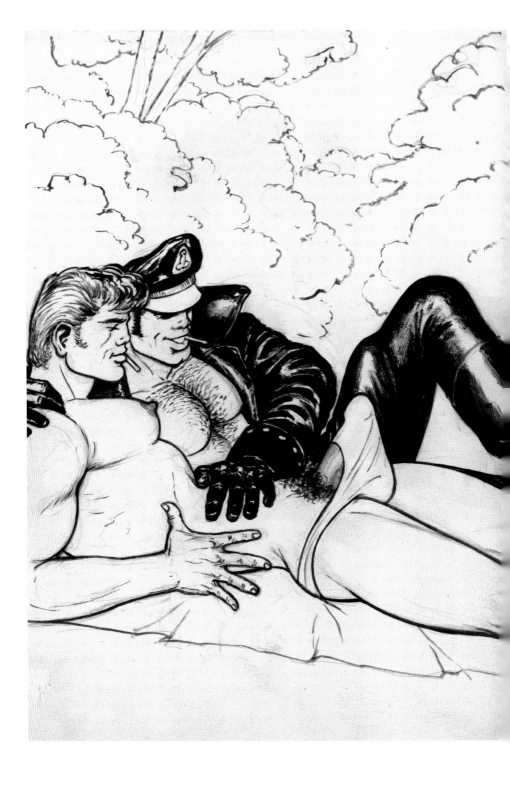

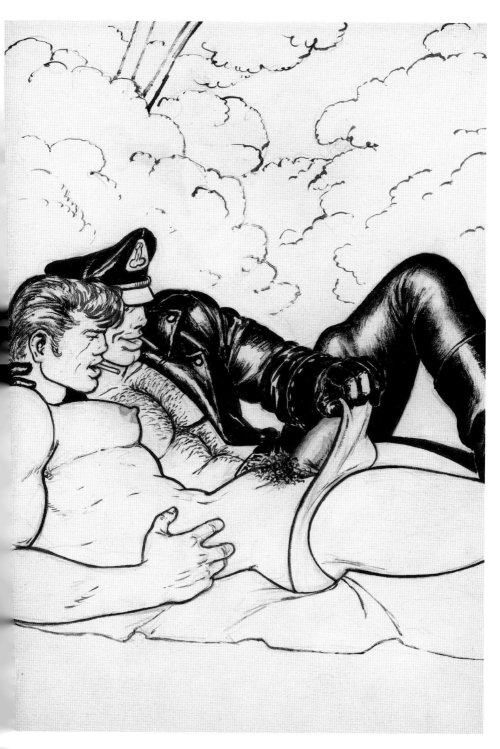

OSITE AND ABOVE 1968, pen and ink with ink wash on paper

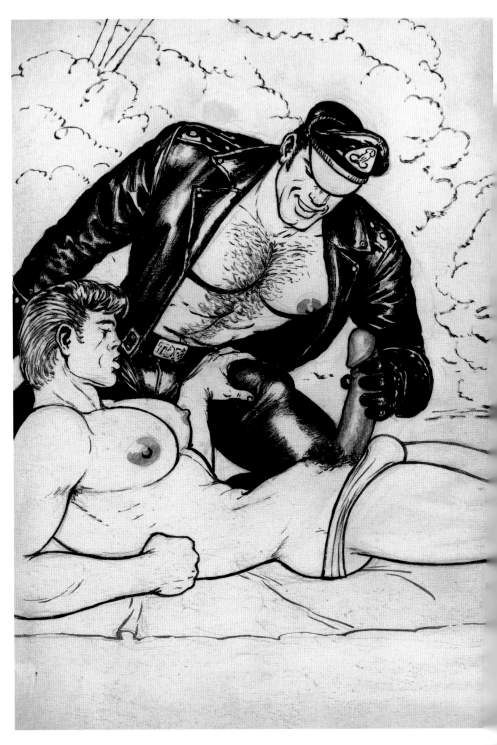

ABOVE AND OPPOSITE 1968, pen and ink with ink wash on pa

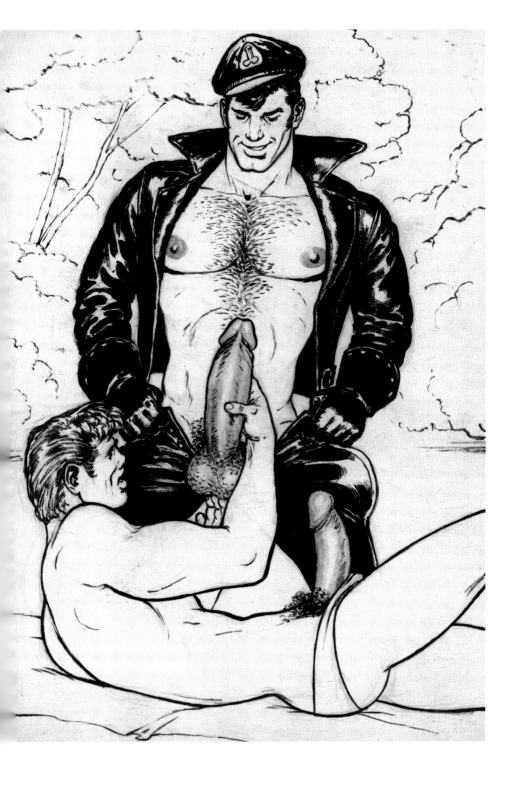

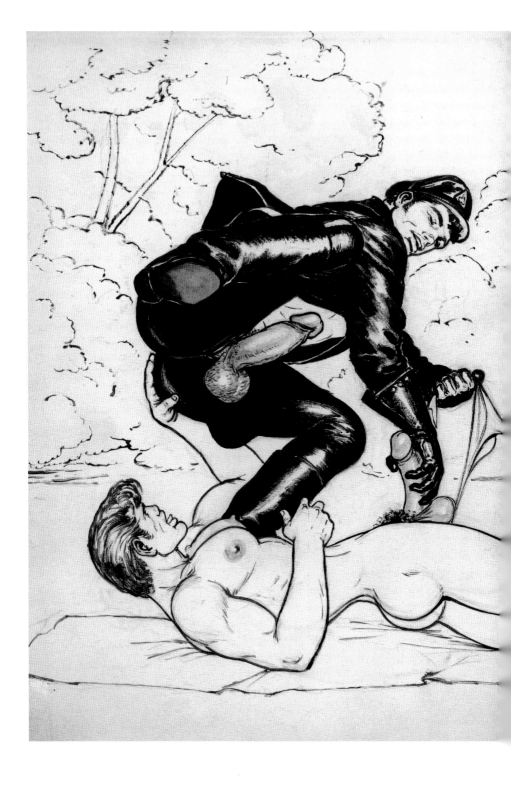

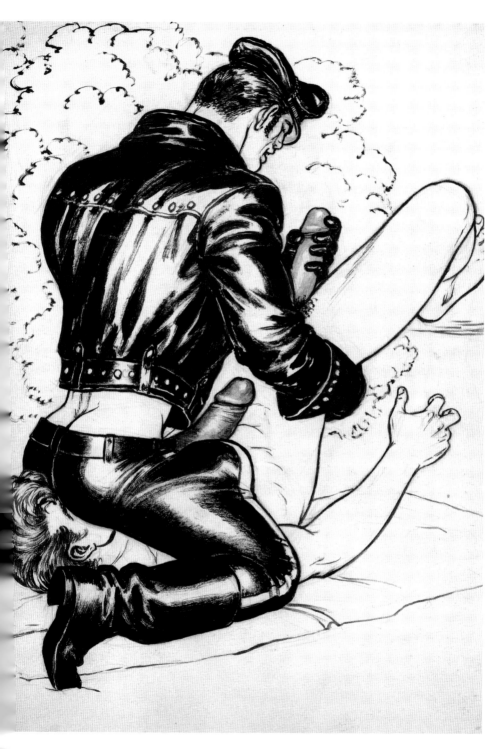

OSITE AND ABOVE 1968, pen and ink with ink wash on paper

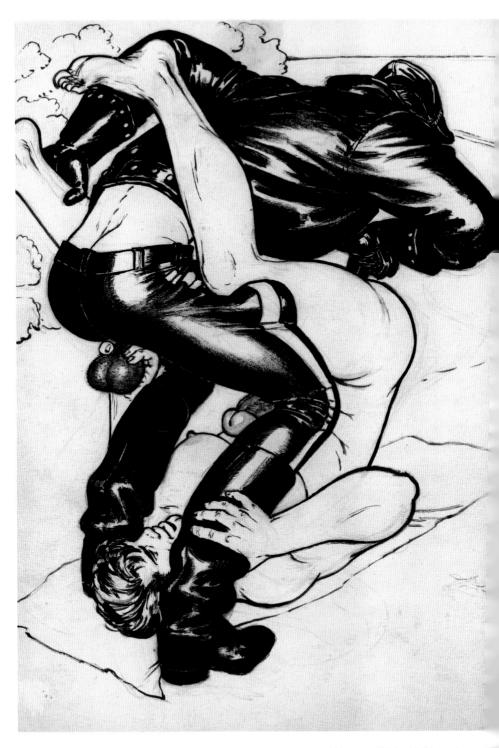

ABOVE AND OPPOSITE 1968, pen and ink with ink wash on p

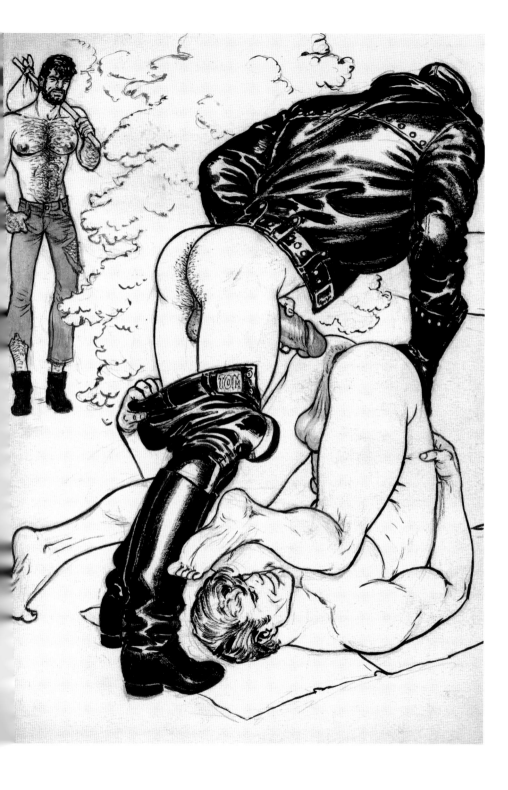

145

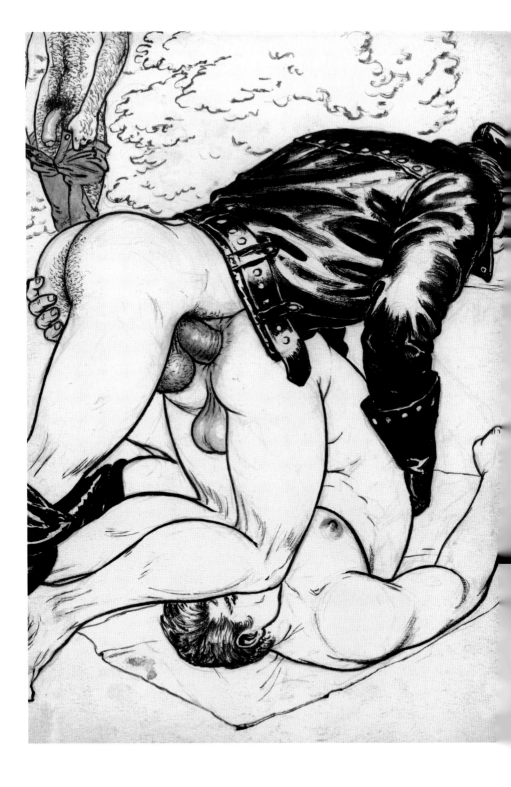

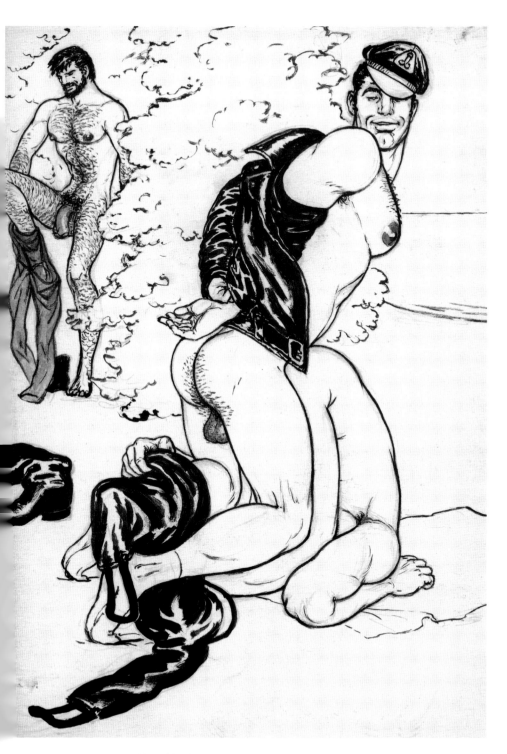

OPPOSITE AND ABOVE 1968, pen and ink with ink wash on paper

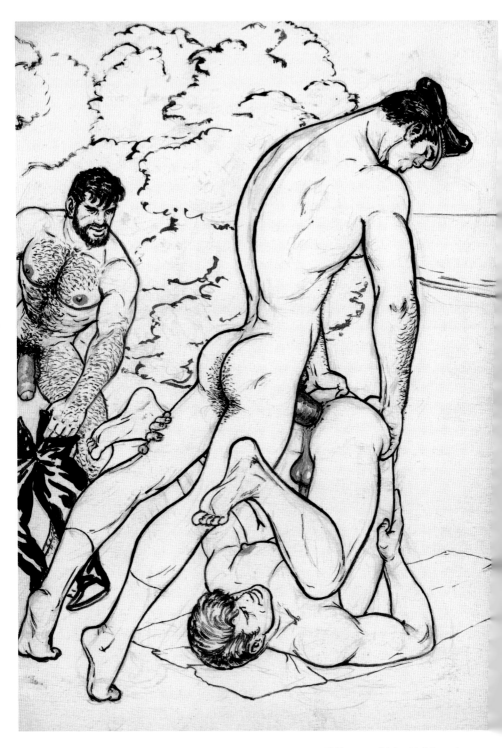

ABOVE AND OPPOSITE 1968, pen and ink with ink wash on pa

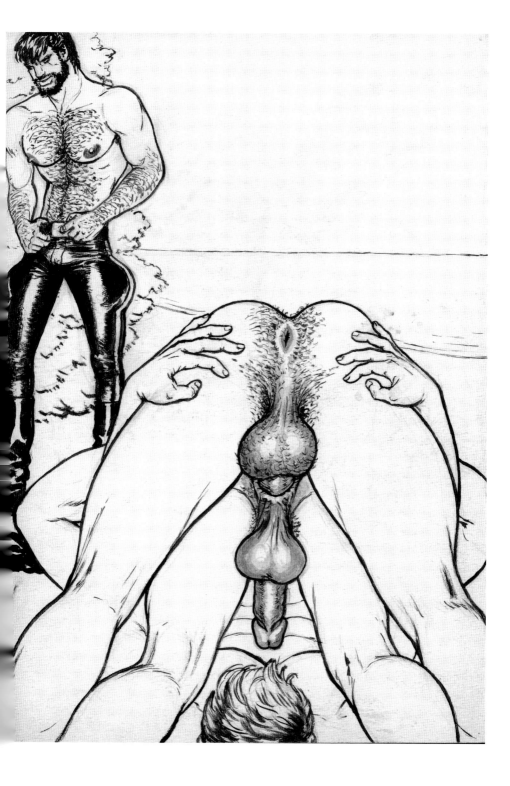

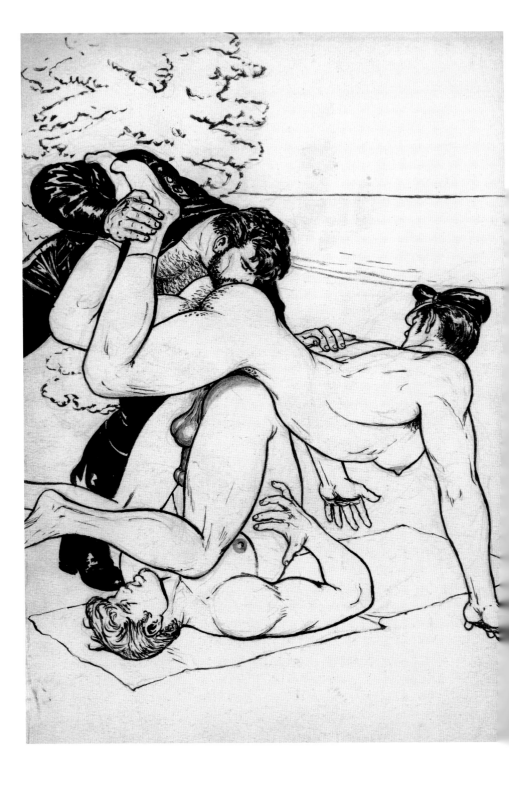

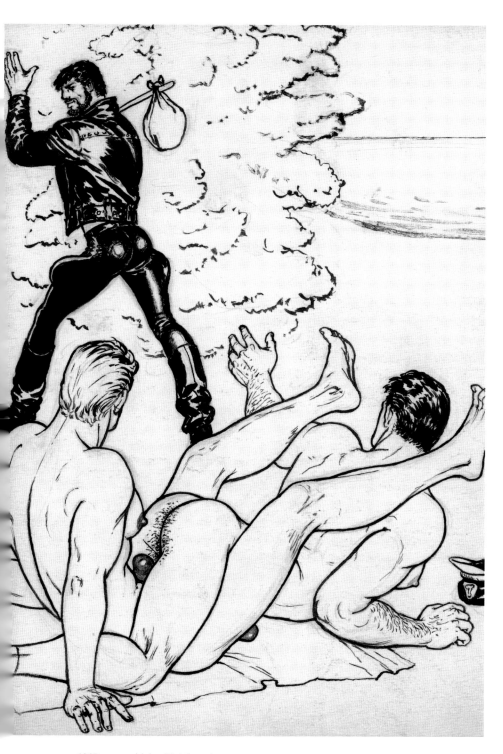

OSITE AND ABOVE 1968, pen and ink with ink wash on paper

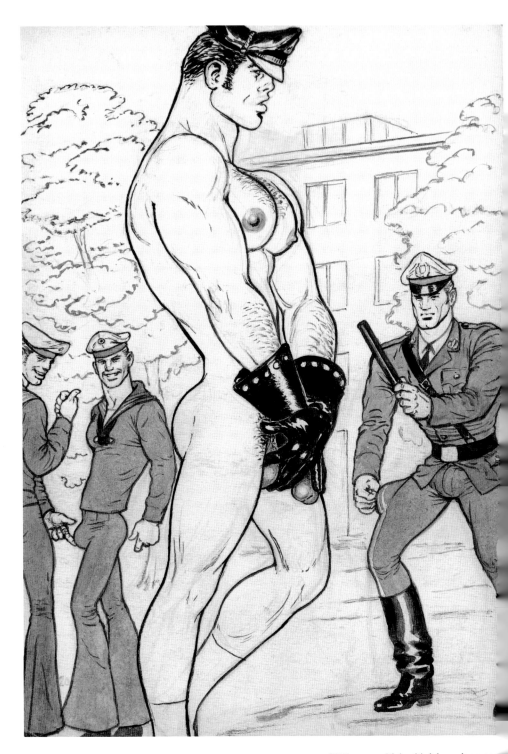

ABOVE 1968, pen and ink with ink wash on pa
OPPOSITE Reference photo collage by T

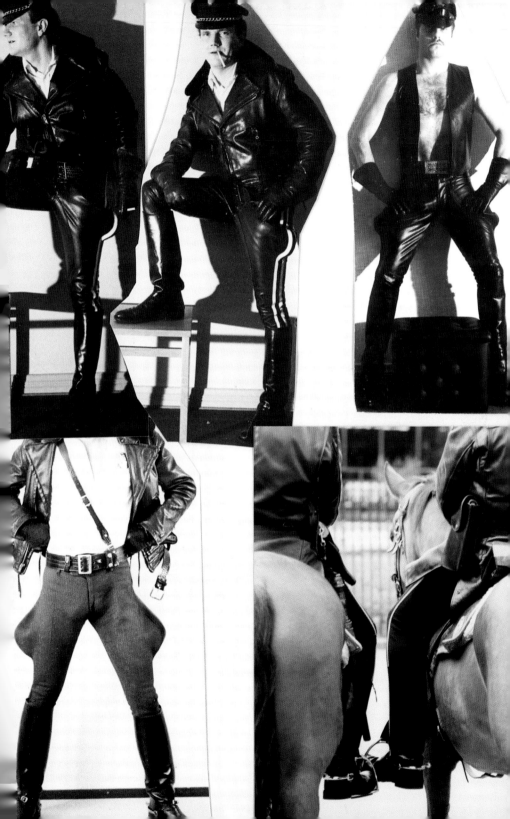

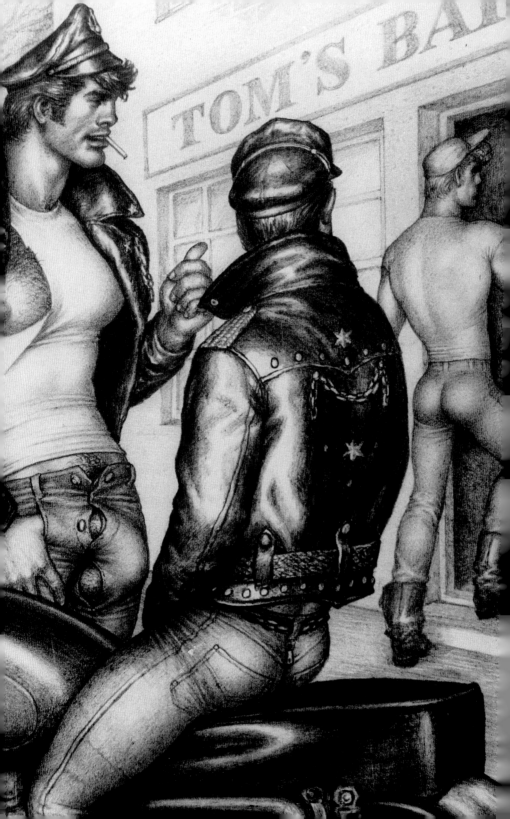

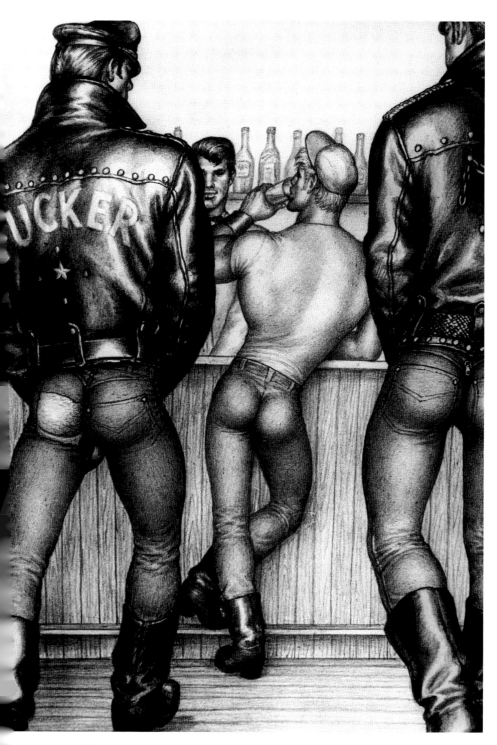

OSITE AND ABOVE 1965, graphite on paper

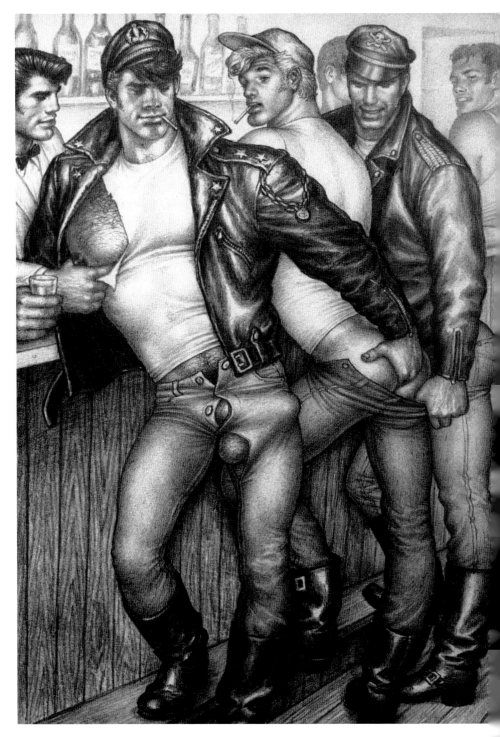

ABOVE, OPPOSITE, AND PAGES 158-159 1965, graphite on pa

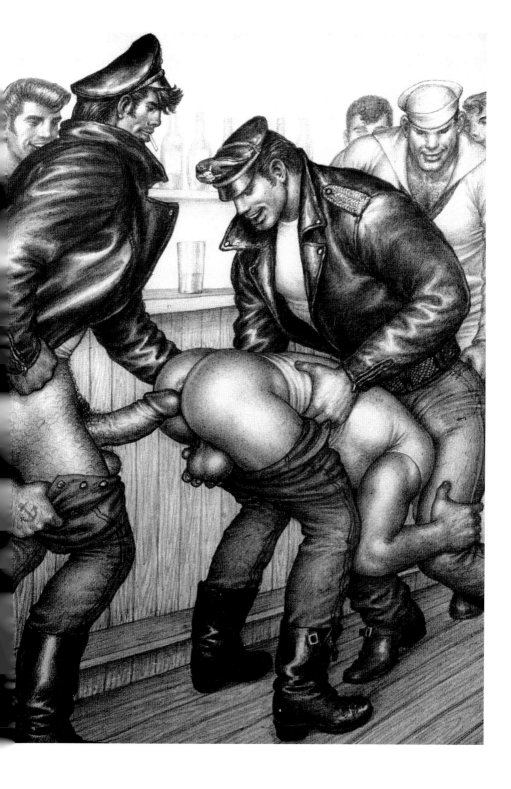

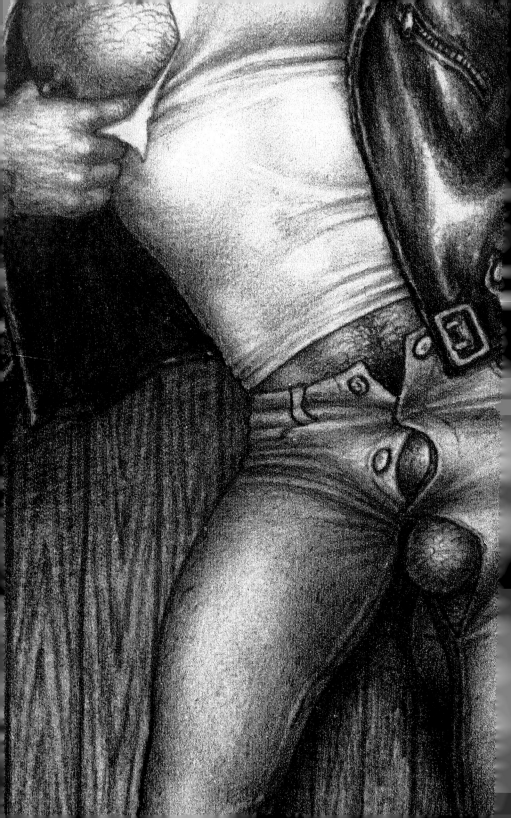

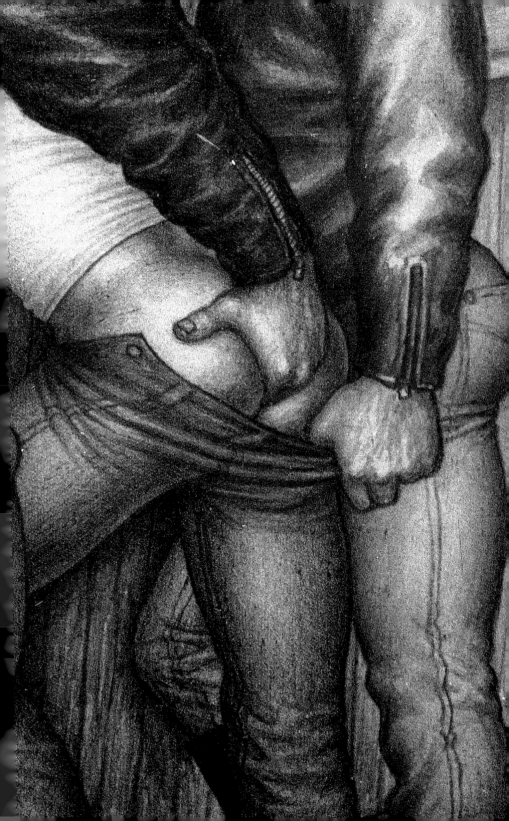

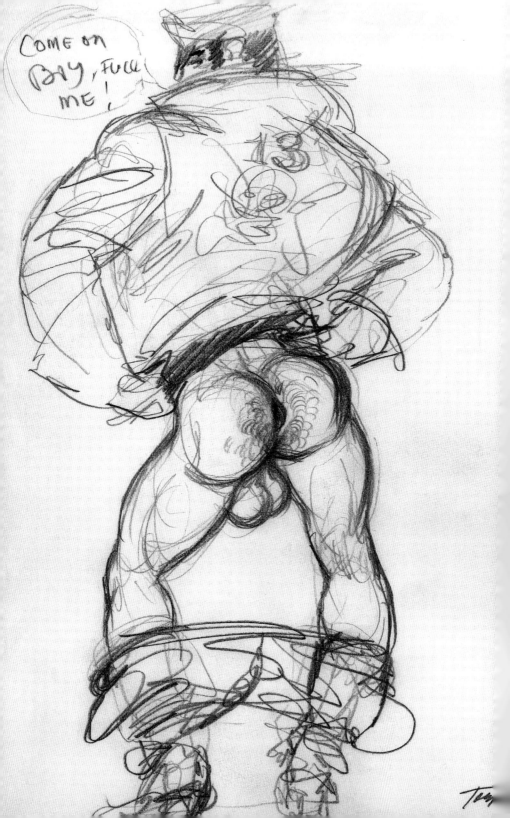

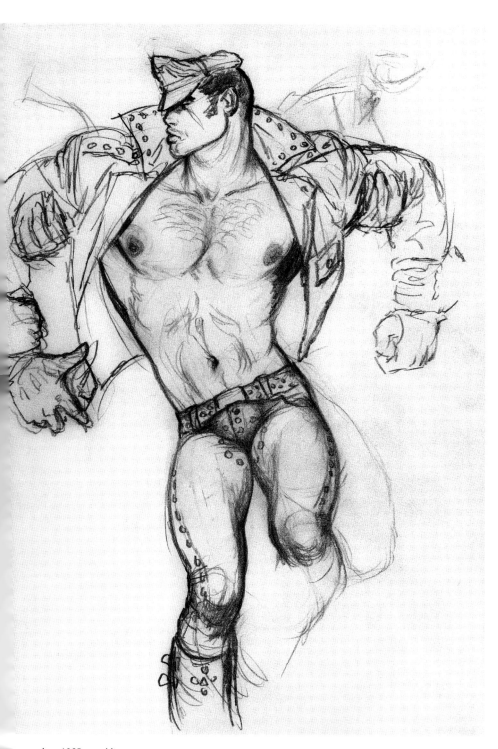

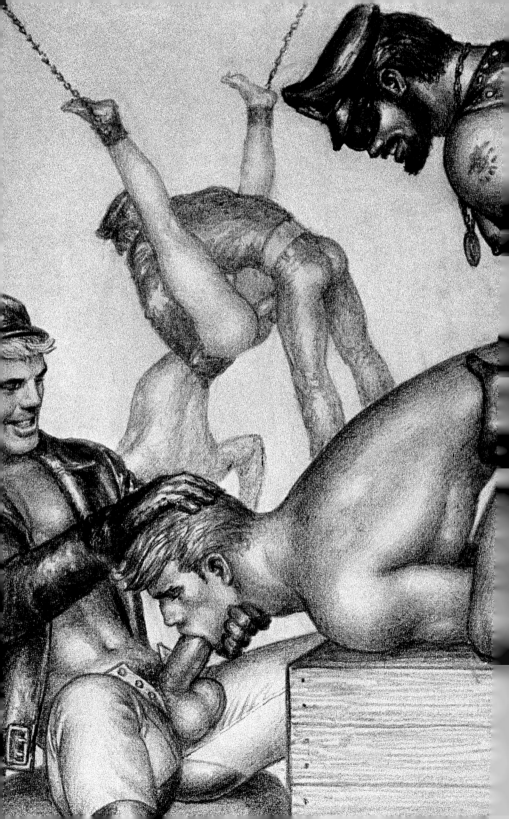

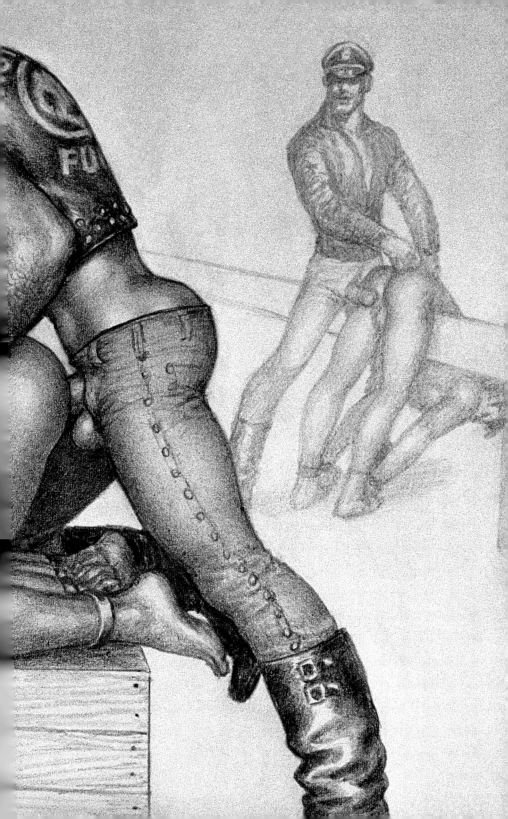

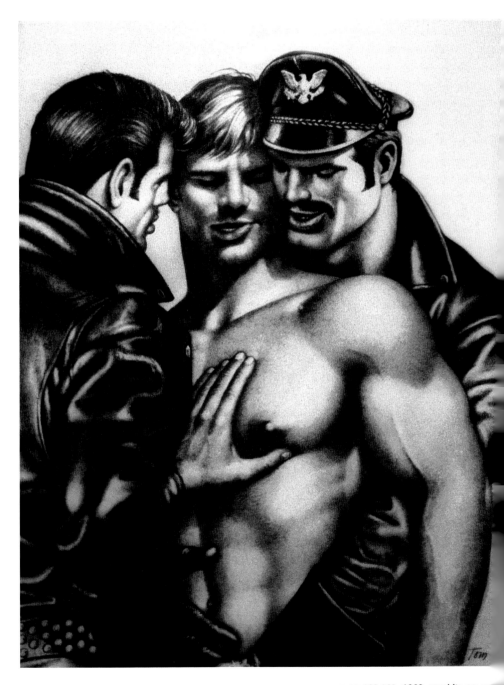

PAGES **162-163** 1968, graphite on pa▓
ABOVE 1979, graphite on pa▓

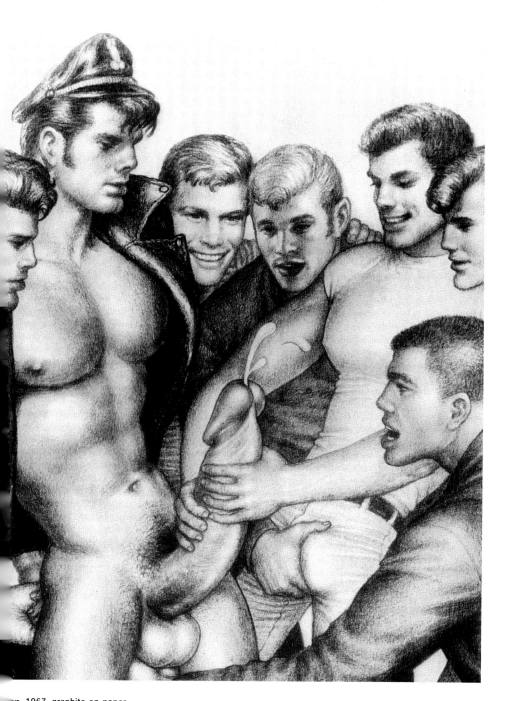

VE 1967, graphite on paper
166 1969, graphite on paper
167 1968, graphite on paper

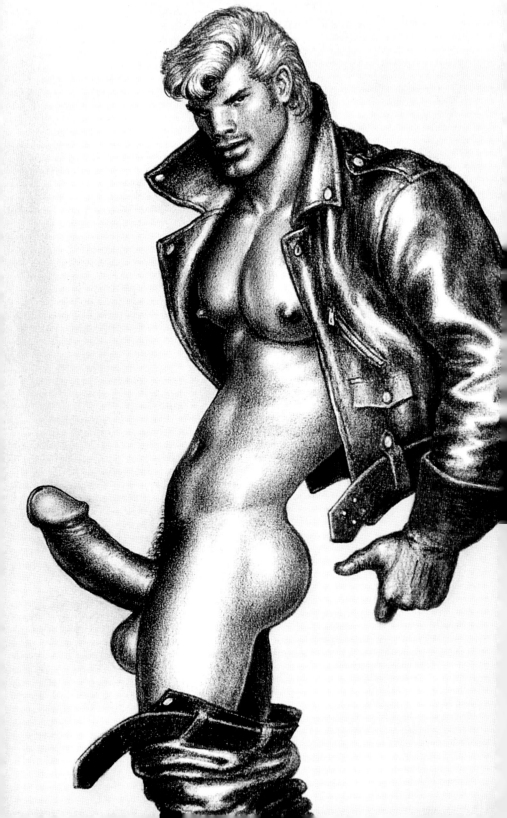

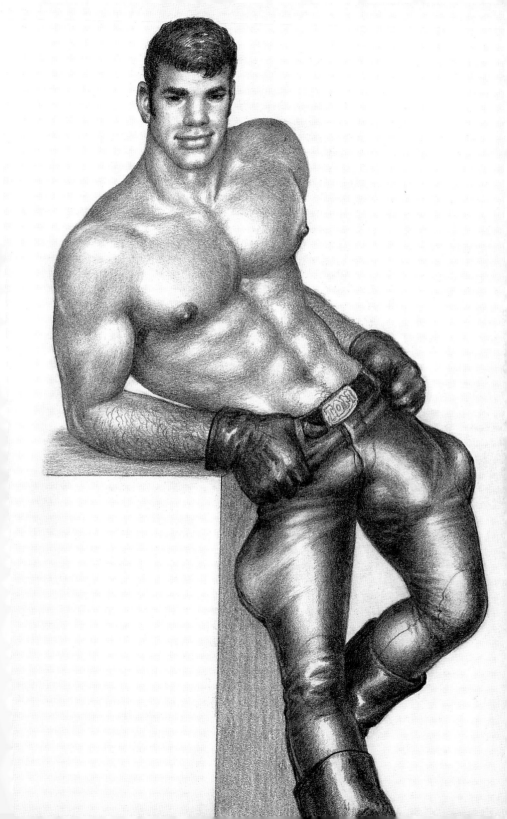

"Yes, I consider my work pornography. Pornography means to stimulate people's sexual feelings, and I'm always very aware of that. My motive is lower than art."

—Tom of Finland

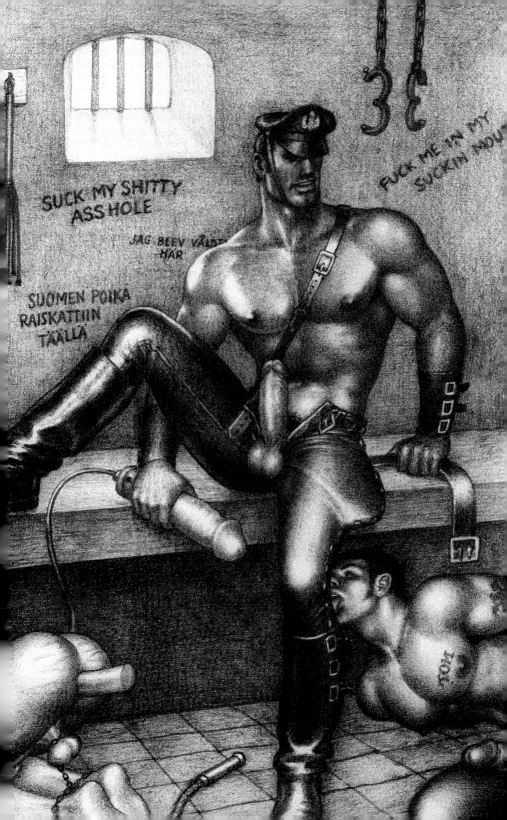

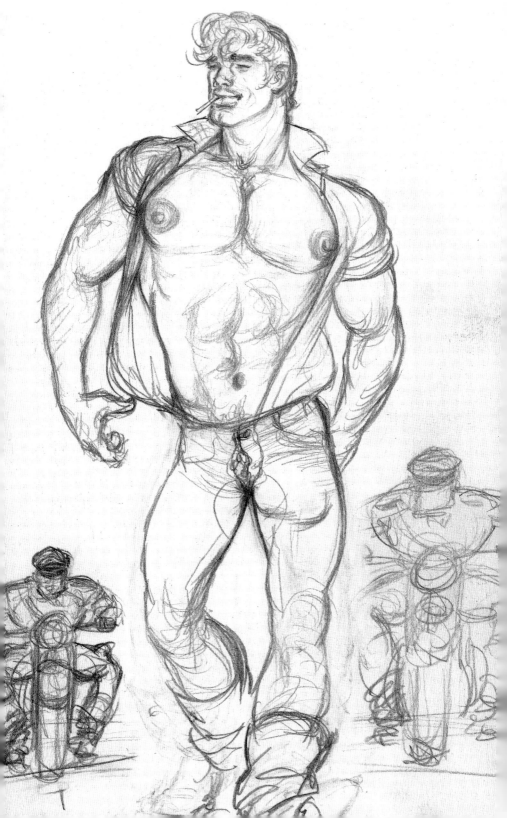

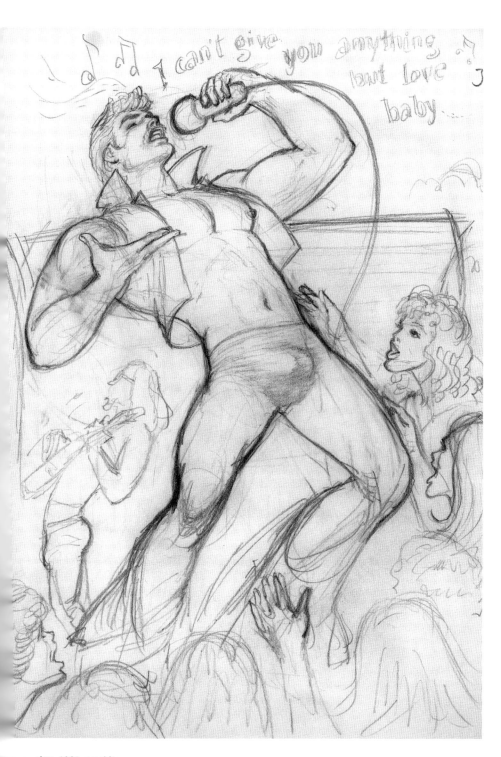

OSITE circa 1964, graphite on paper
VE 1973, graphite on paper

"I believe there is a lot to the world that can't be seen or touched, and if you turn away from that you are avoiding an important part of life, maybe the very heart of it."
—Tom of Finland

TOM OF FINLAND
RINGO & THE RENEGADES

LEFT *Ringo and the Renegades* comic book cover,
OPPOSITE 1973, pen and ink with ink wash on pa

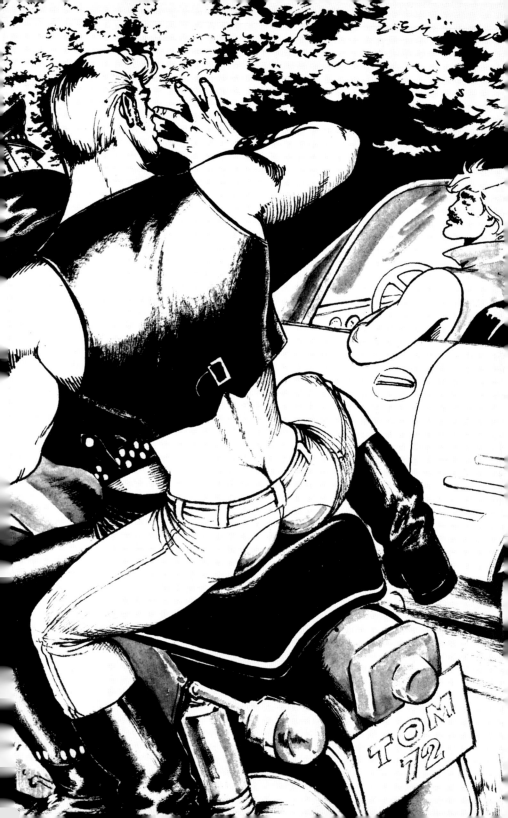

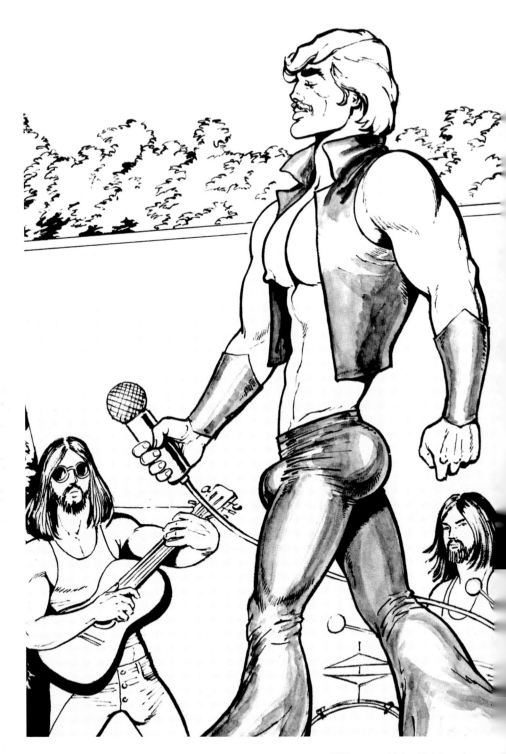

ABOVE AND OPPOSITE 1973, pen and ink with ink wash on p

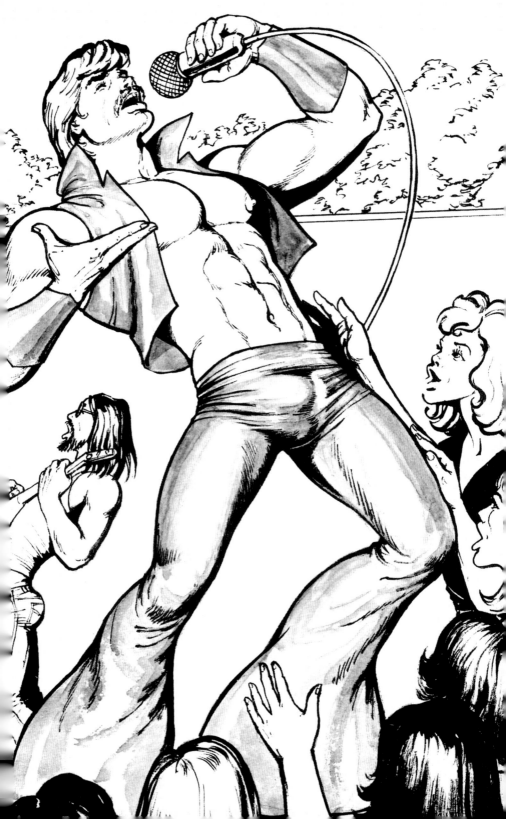

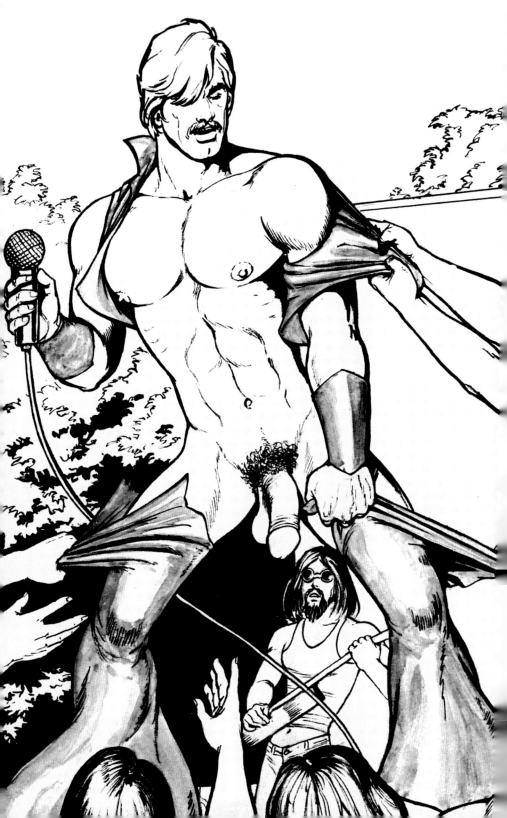

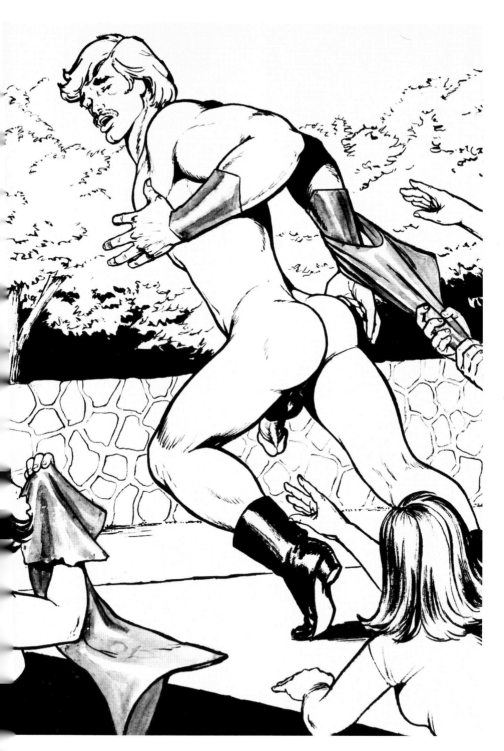

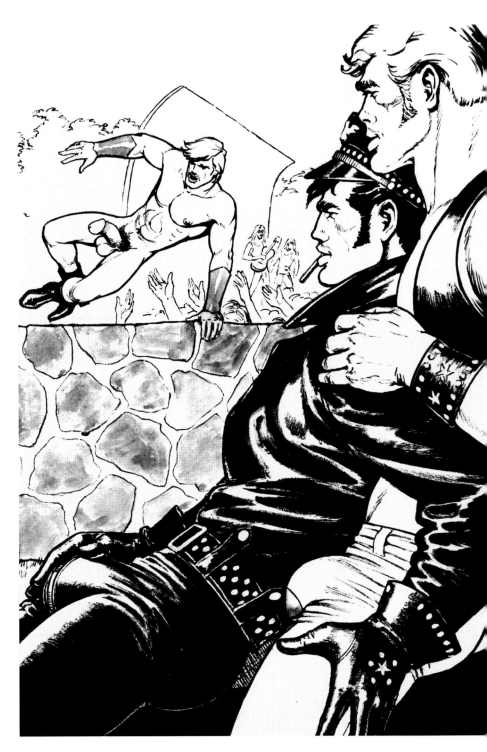

ABOVE AND OPPOSITE 1973, pen and ink with ink wash on p

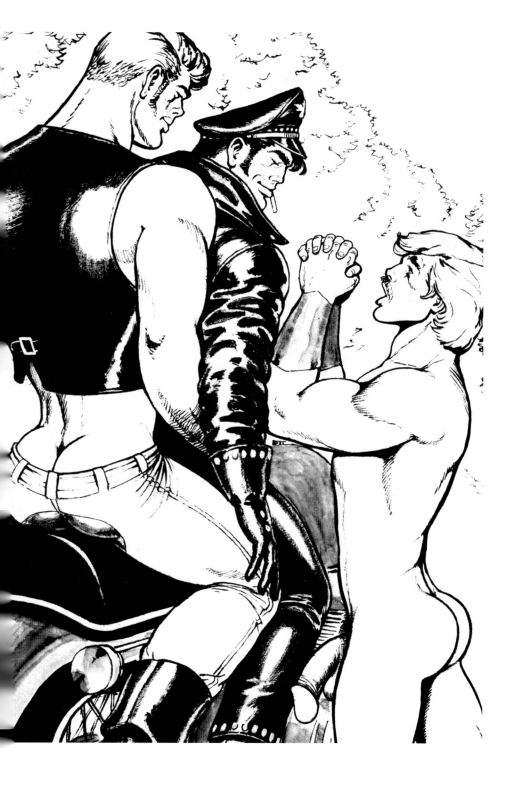

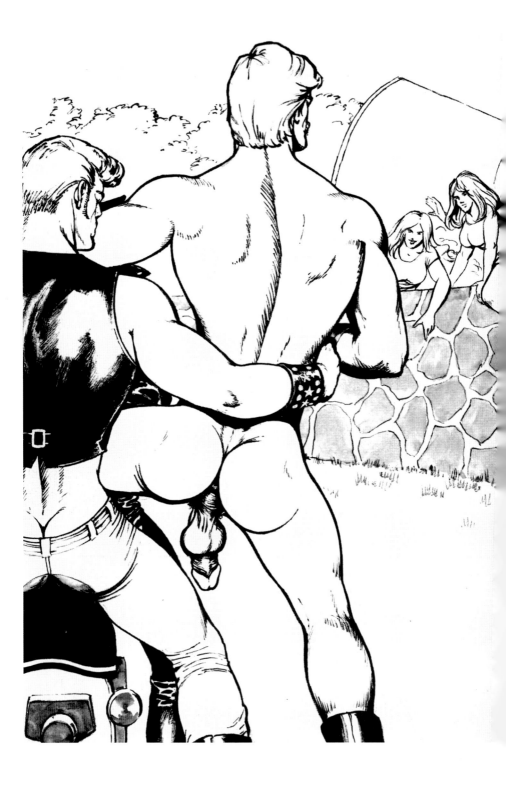

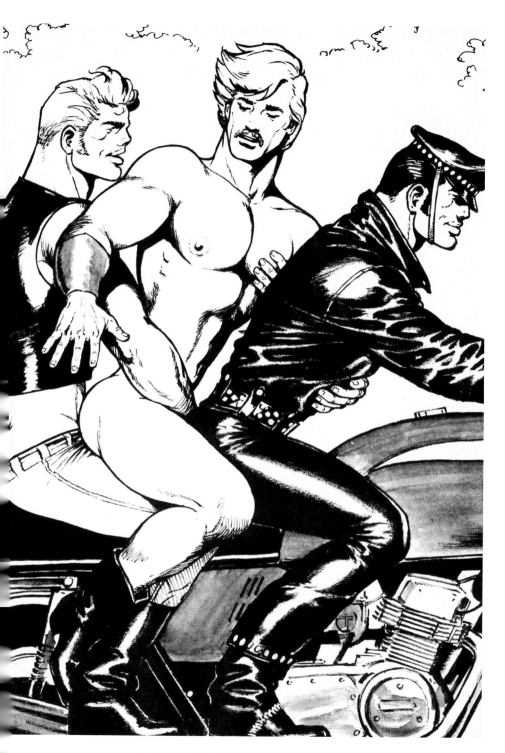

OSITE AND ABOVE 1973, pen and ink with ink wash on paper

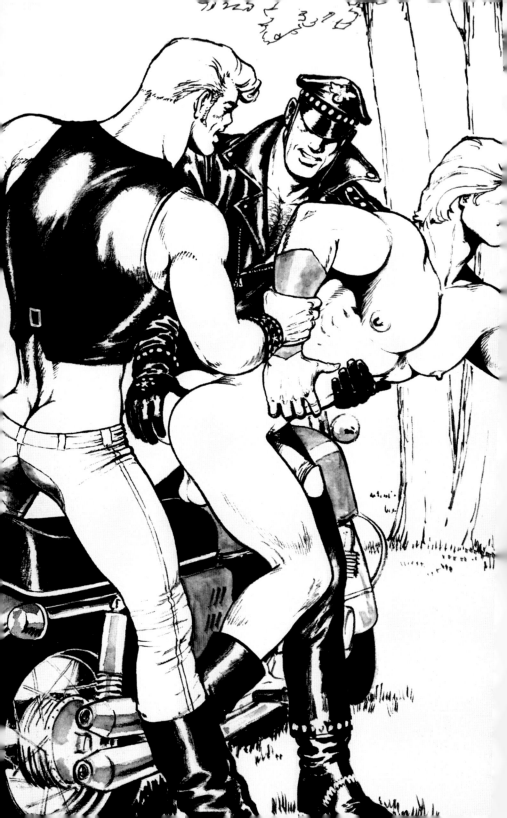

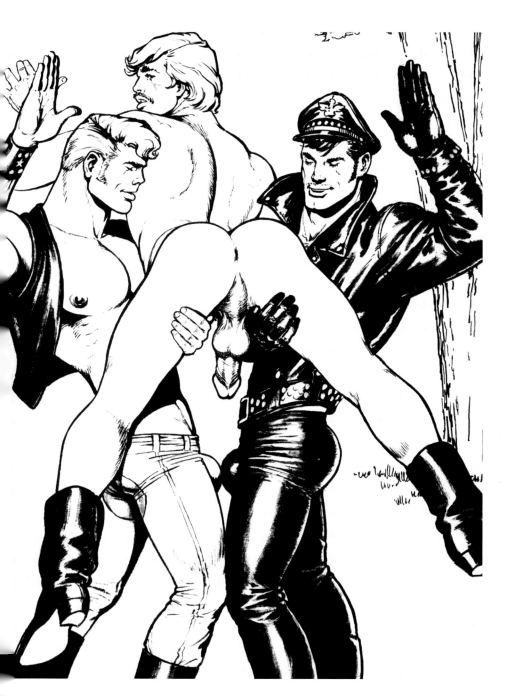

OSITE AND ABOVE 1973, pen and ink with ink wash on paper

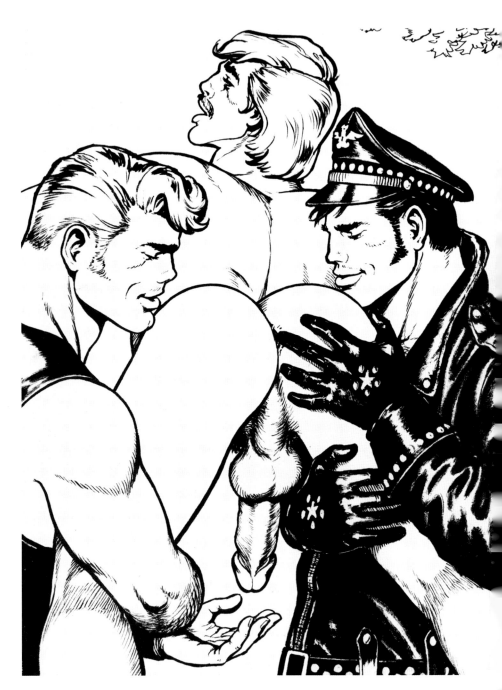

ABOVE AND OPPOSITE 1973, pen and ink with ink wash on pa

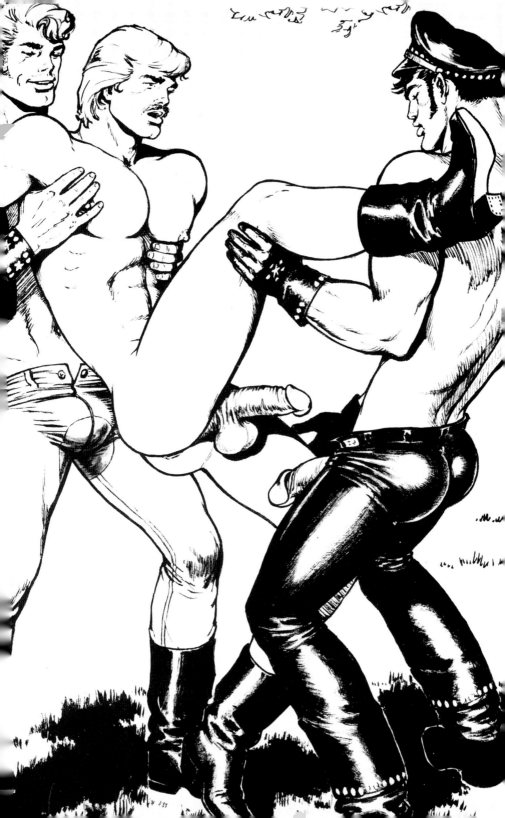

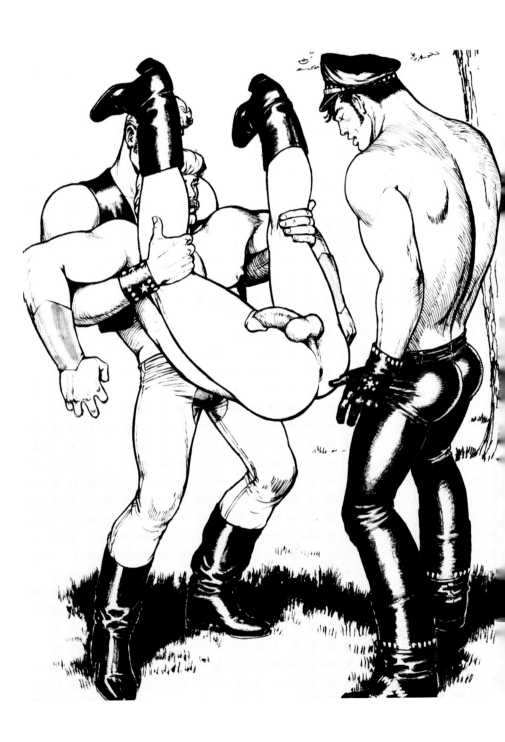

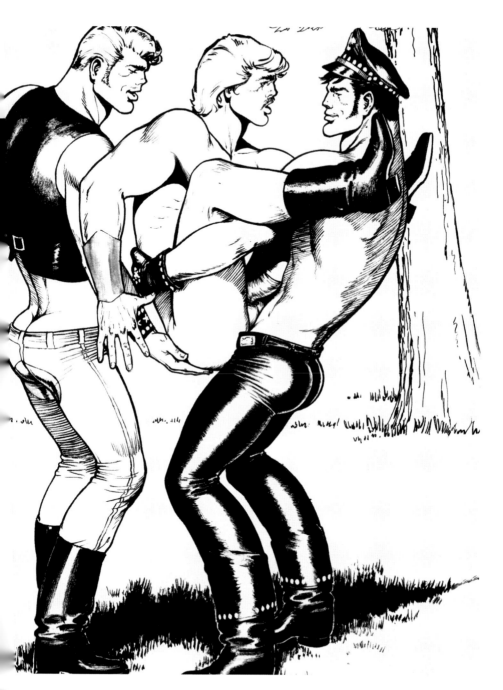

SITE AND ABOVE 1973, pen and ink with ink wash on paper

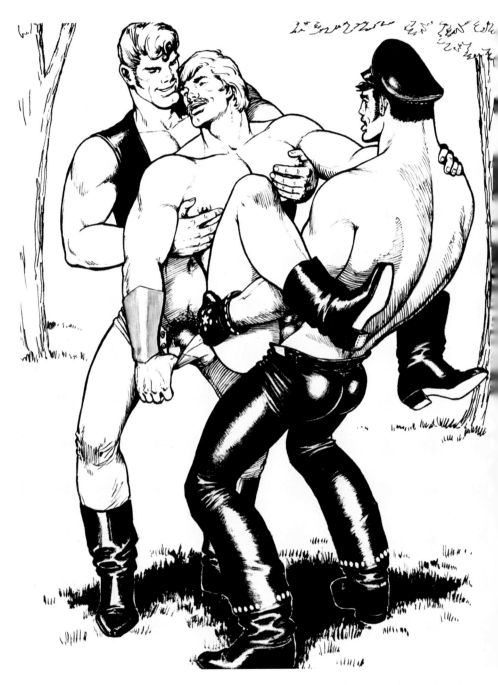

ABOVE AND OPPOSITE 1973, pen and ink with ink wash on p

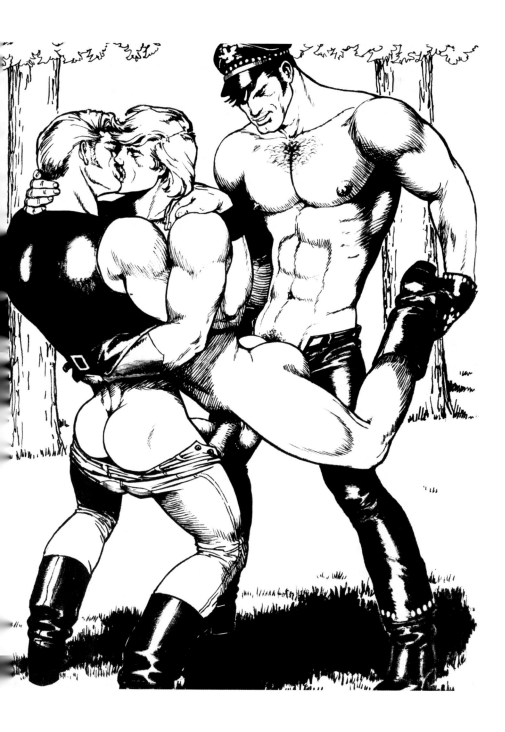

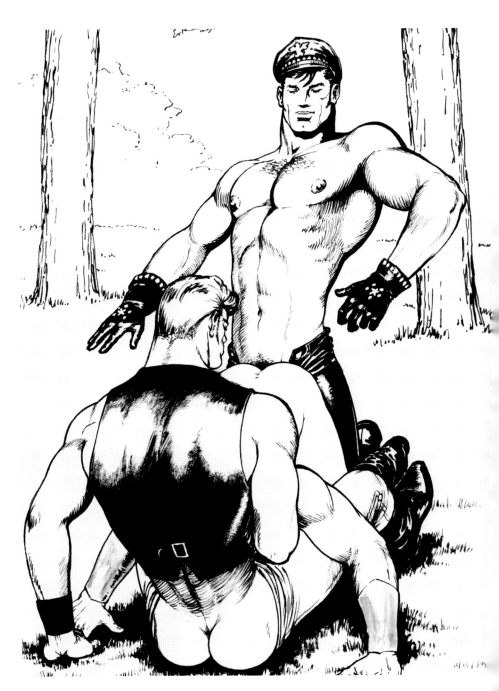

ABOVE AND OPPOSITE 1973, pen and ink with ink wash on p

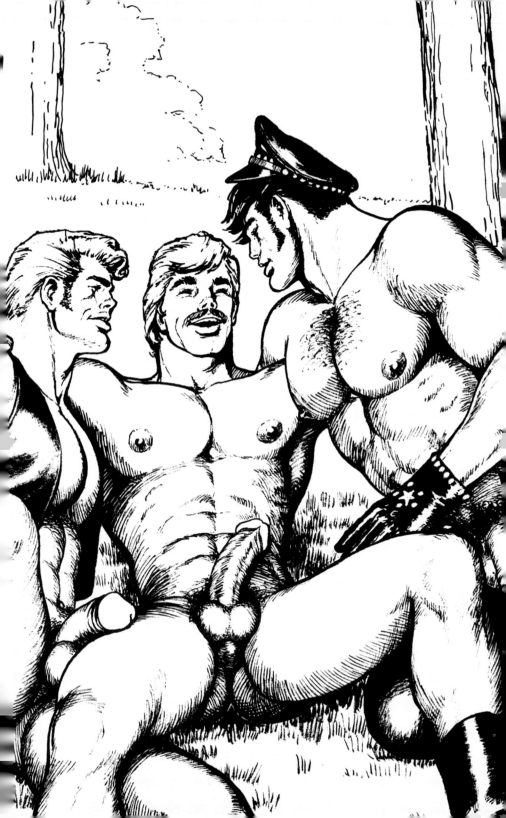

"My drawings are primarily meant for guys who may have experienced misunderstanding and oppression and feel that they have somehow failed in their lives. I want to encourage them. I want to tell them not to give up..."

—Tom of Finland

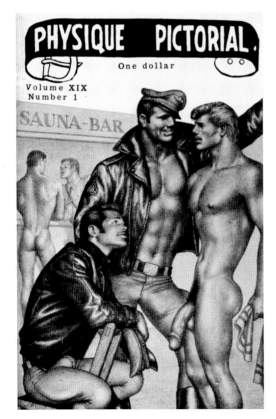

LEFT *Physique Pictorial*, Vol. 19, No. 1
OPPOSITE 1969, graphite on paper

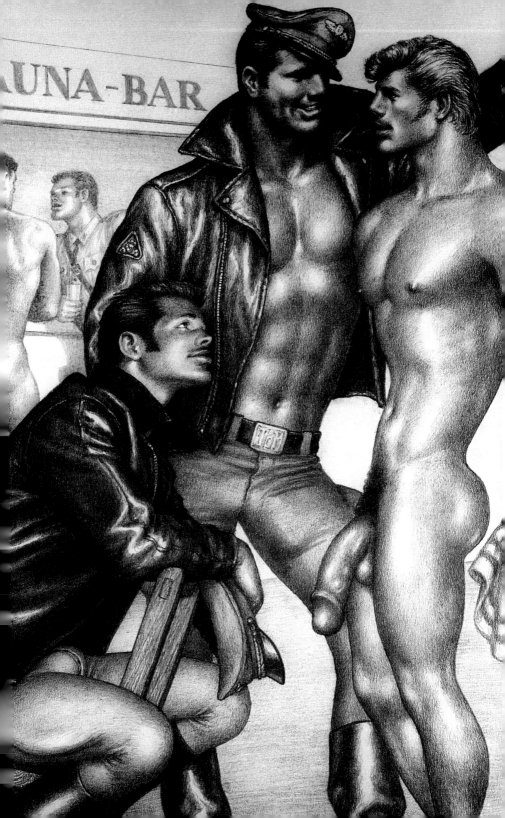

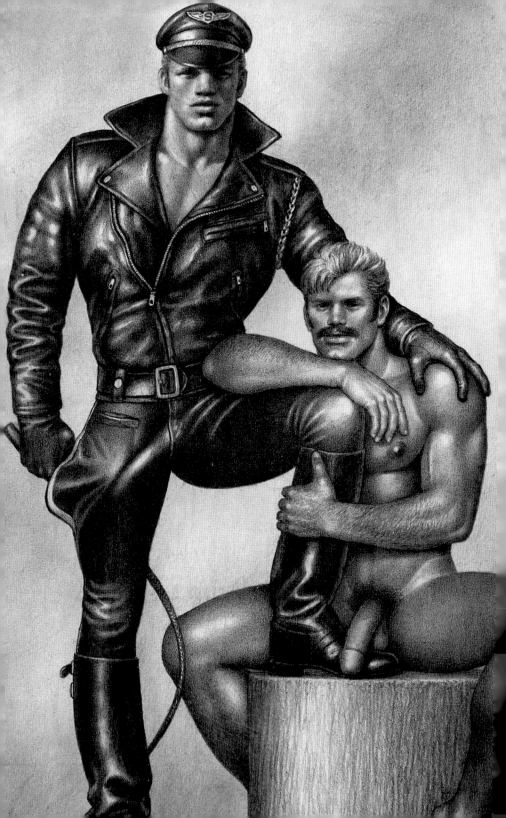

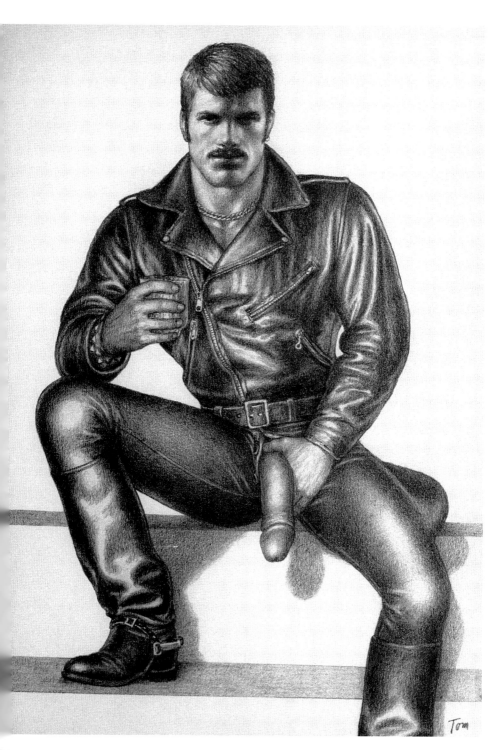

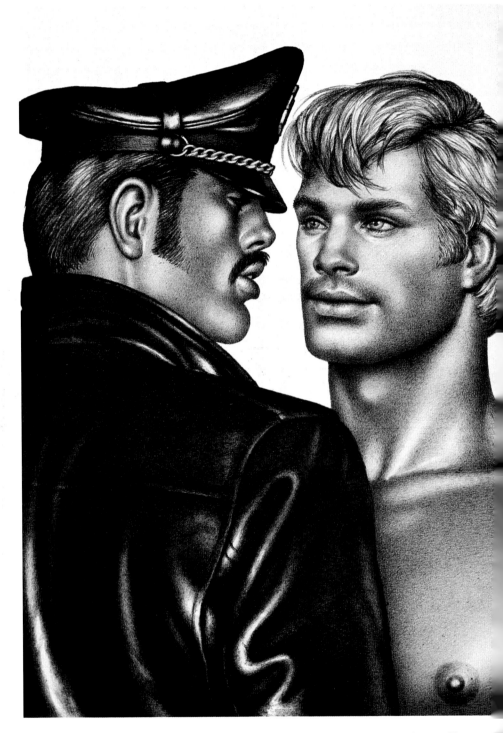

ABOVE AND OPPOSITE 1976, graphite on pa

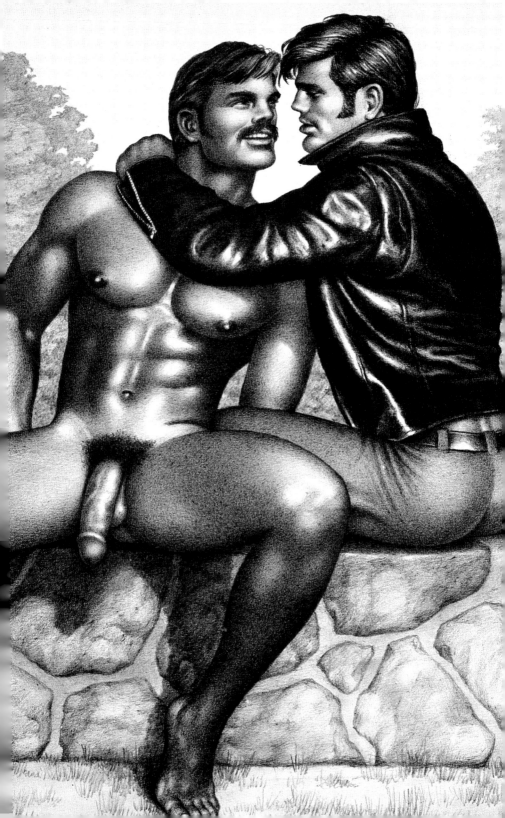

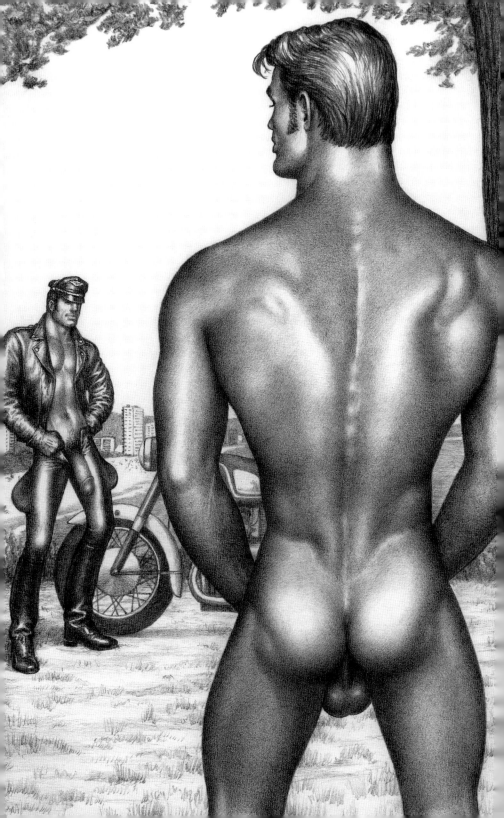

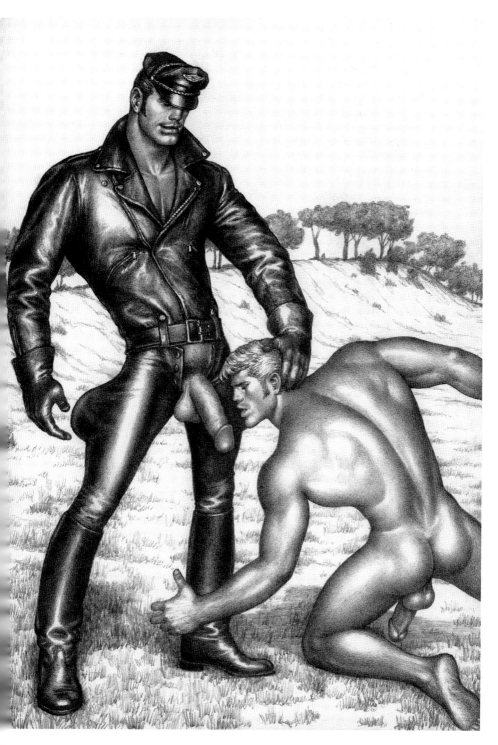

OSITE AND ABOVE 1972, graphite on paper

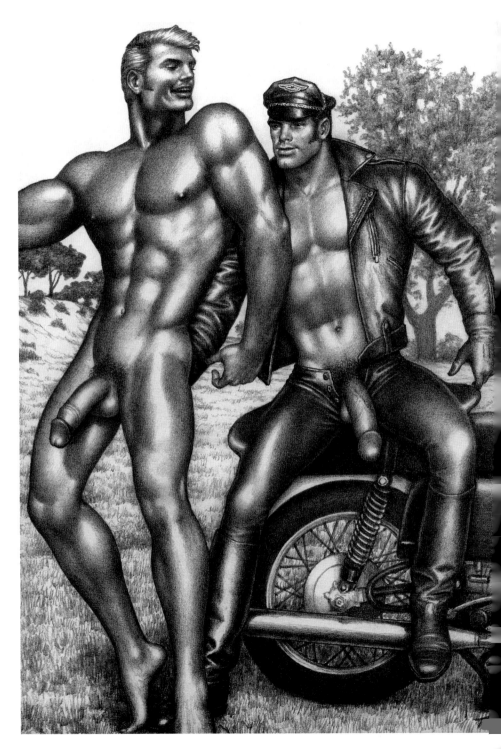

ABOVE AND OPPOSITE 1972, graphite on pa

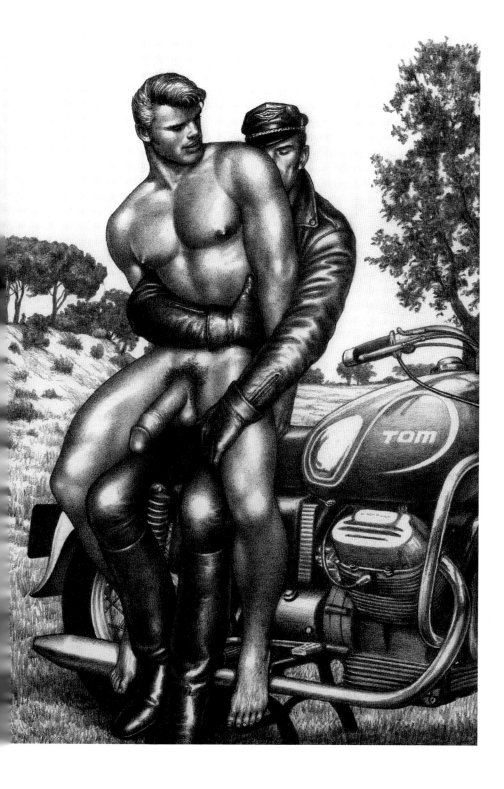

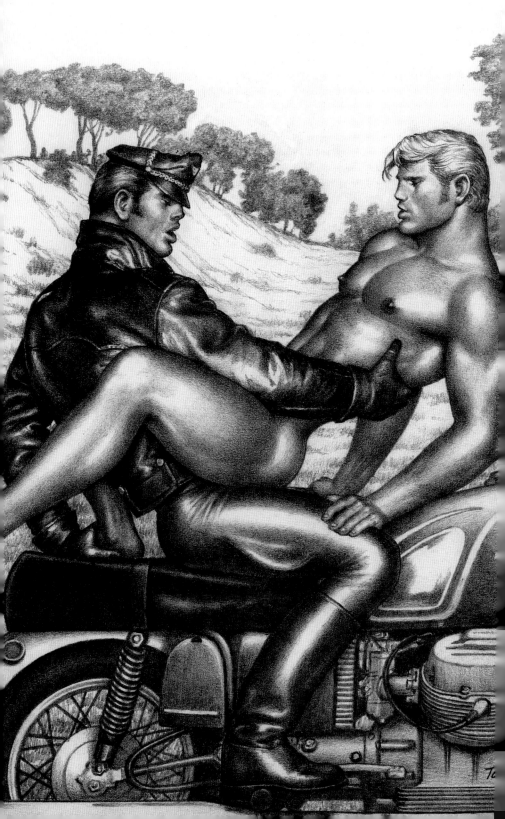

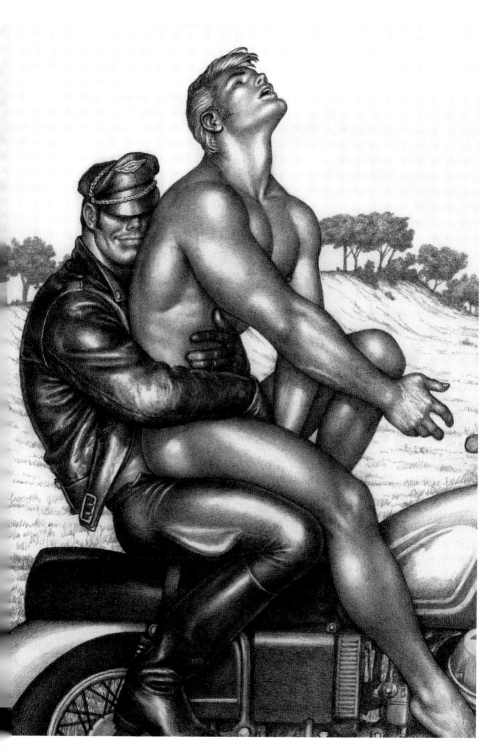

SITE AND ABOVE 1972, graphite on paper
204-205 1971, graphite on paper

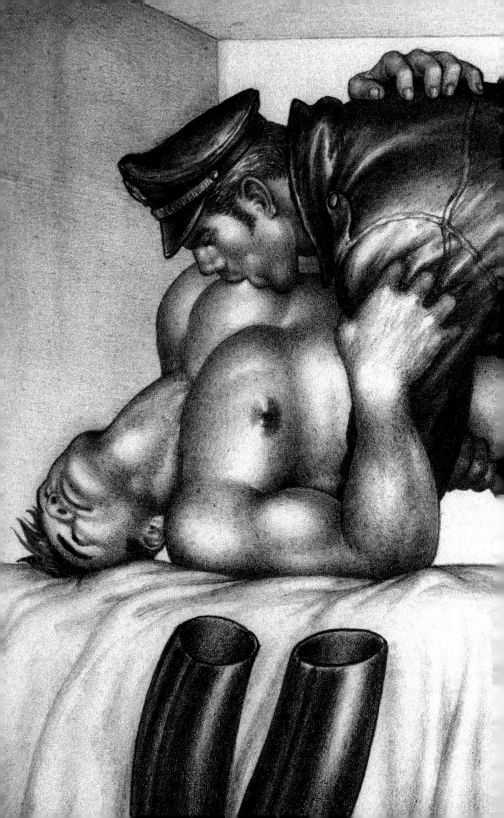

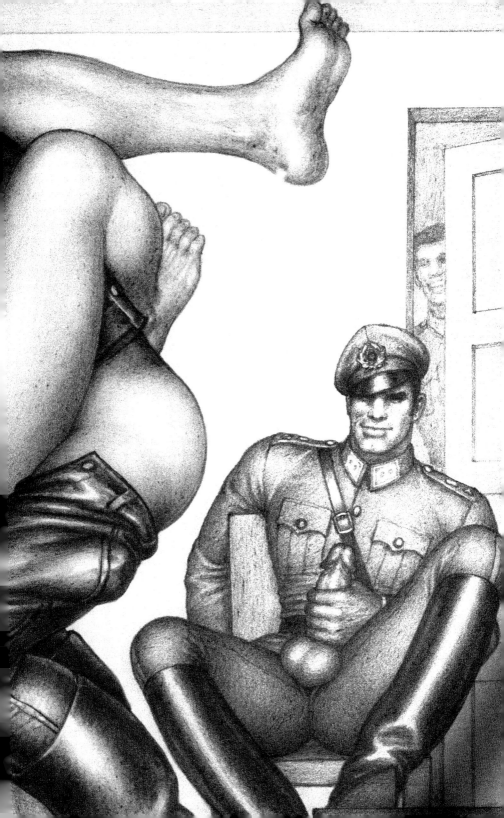

"Cock size doesn't matter to me. I didn't start doing those gigantic cocks until the censors let the magazines publish full frontal nudity. I had to come up with something you couldn't get in a photograph. I'm an ass man myself."

—Tom of Finland

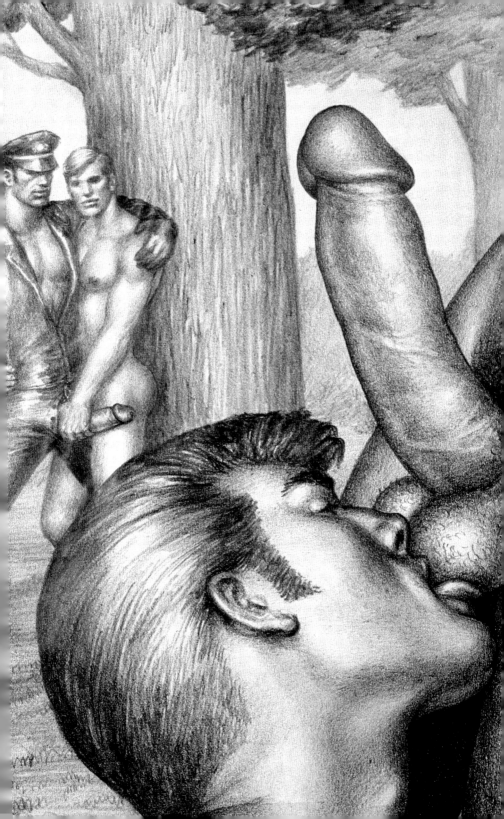

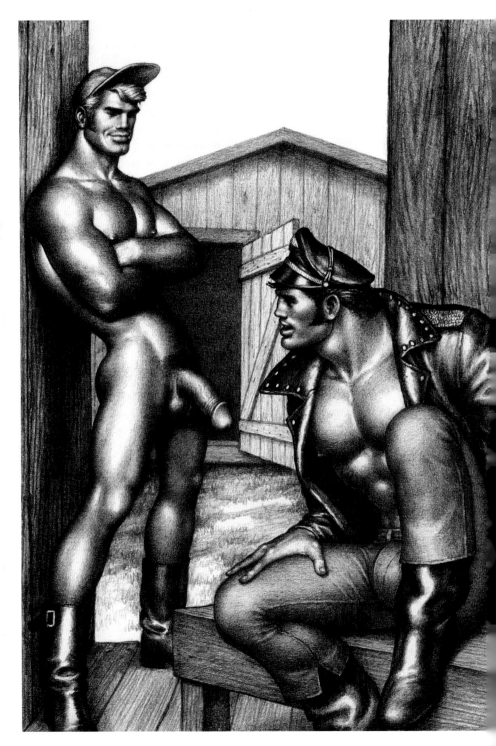

ABOVE AND OPPOSITE 1973, graphite on p

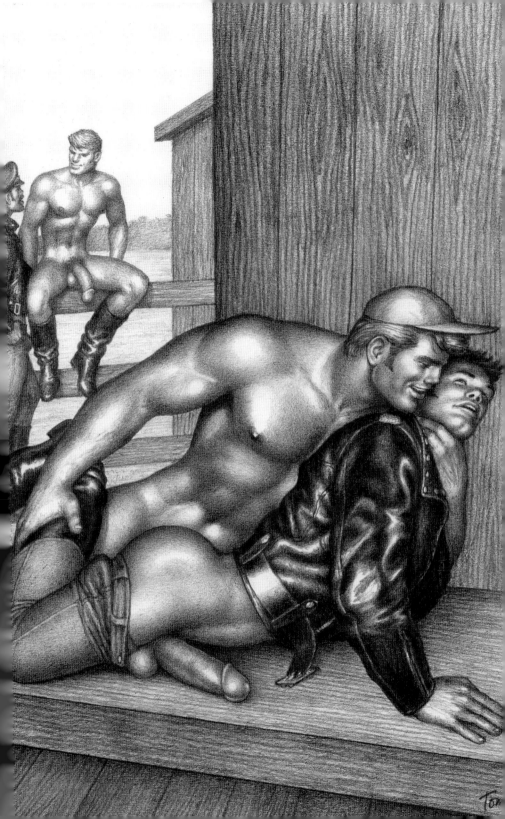

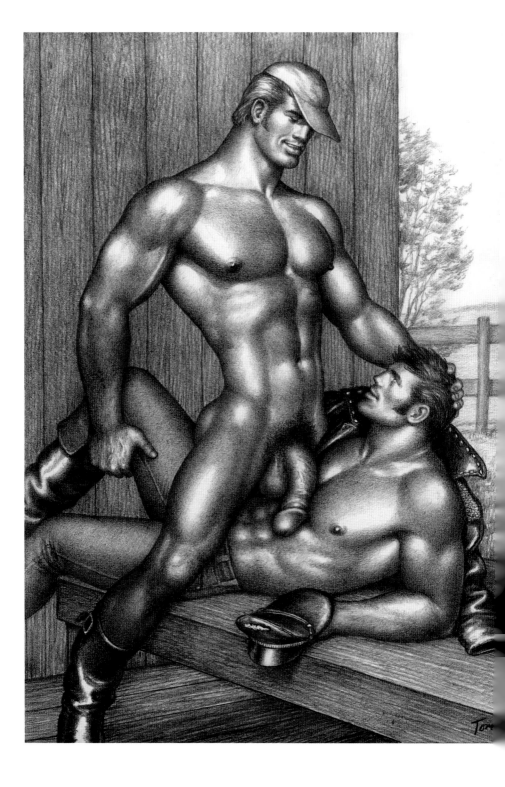

210

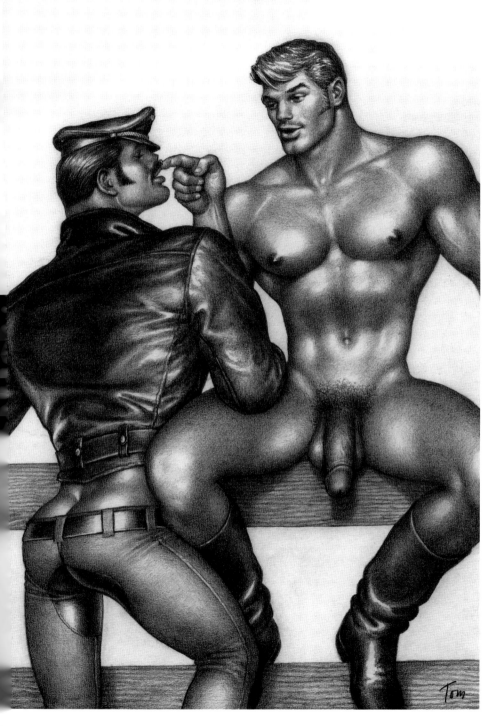

OSITE AND ABOVE 1973, graphite on paper

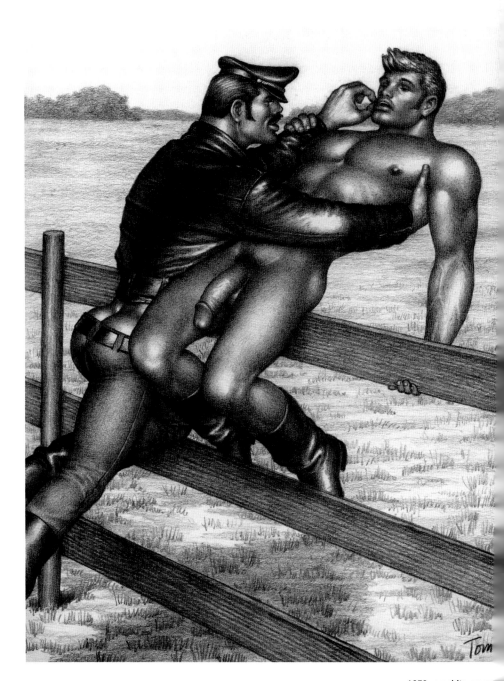

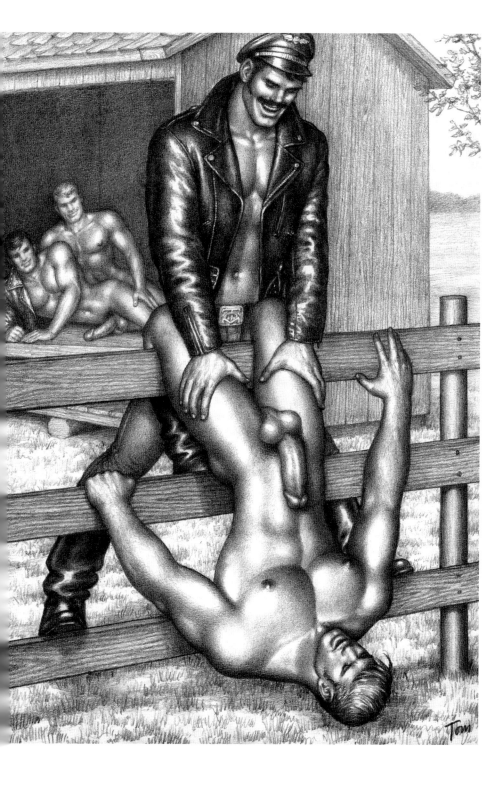

RIGHT 1986, graphite on paper

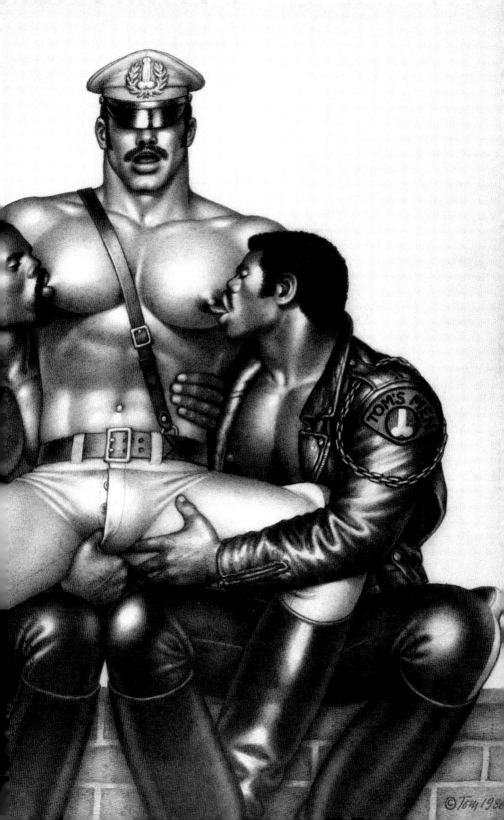

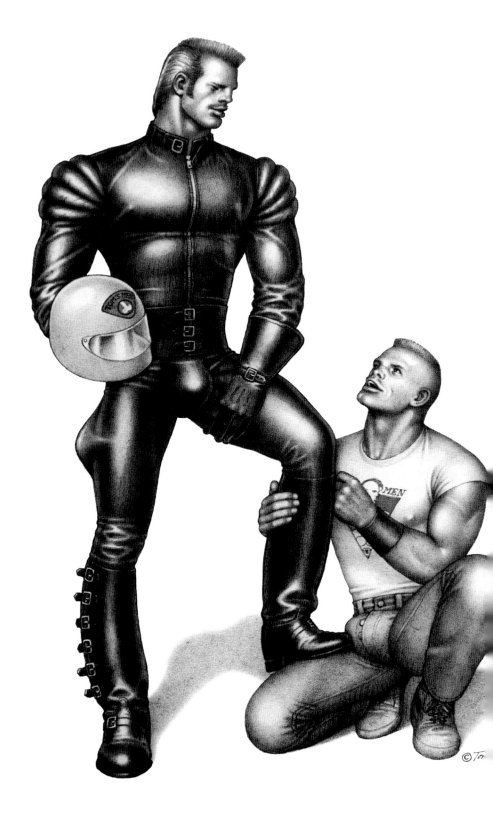

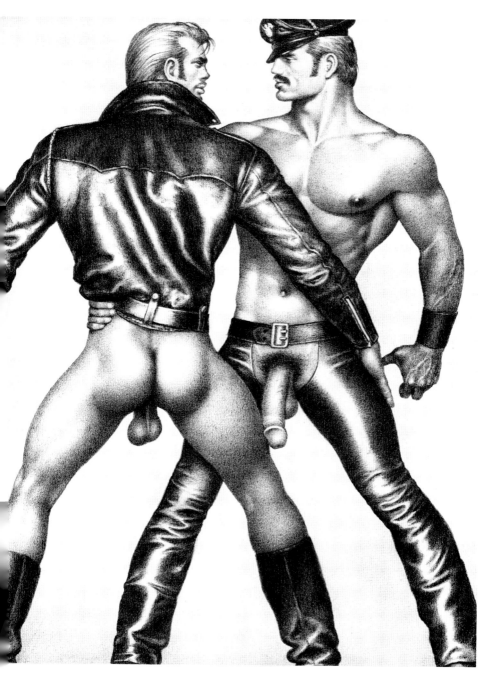

SITE 1987, graphite on paper
E 1977, graphite on paper

"I know my little 'dirty drawings' are never going to hang in the main salons of the Louvre, but if our world learns to accept all the different ways of loving, then maybe I could have a place in one of the smaller side rooms."

—Tom of Finland

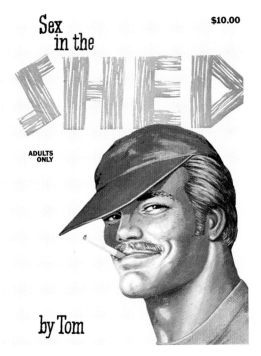

LEFT *Sex in the Shed* comic book cover, 1975
OPPOSITE 1975, pen, ink, and gouache on paper

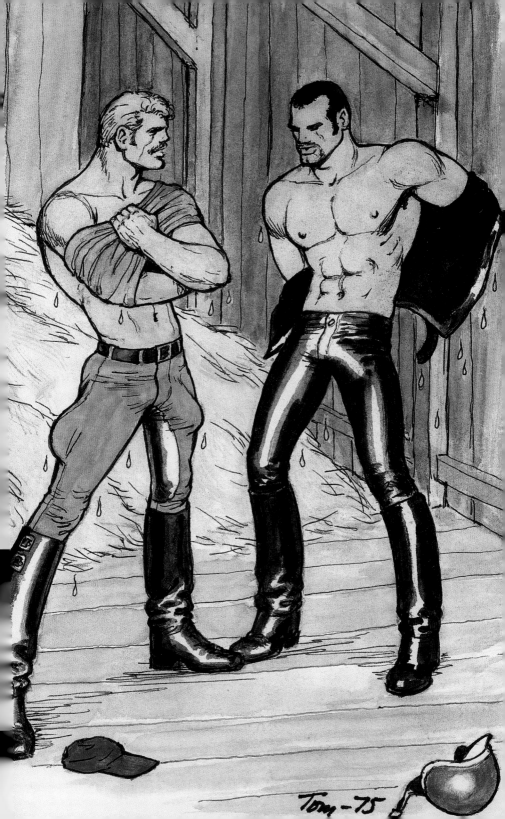

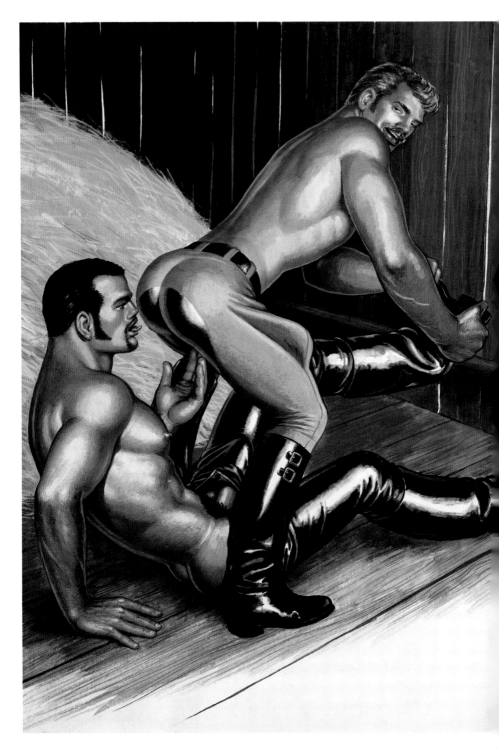

ABOVE AND OPPOSITE 1975, gouache on p·
PAGES 222-223 1975, graphite on p·

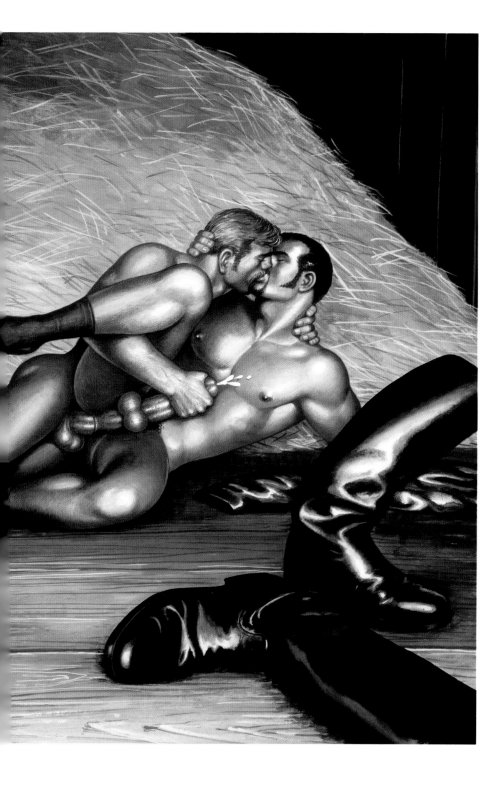

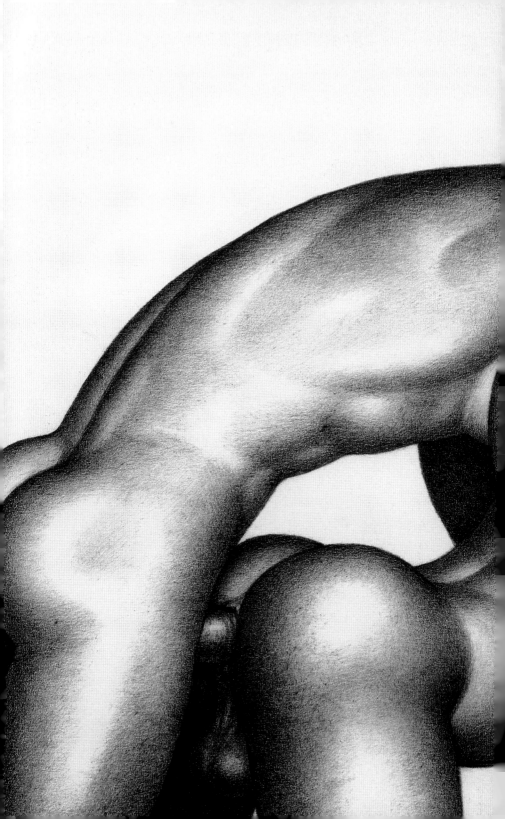

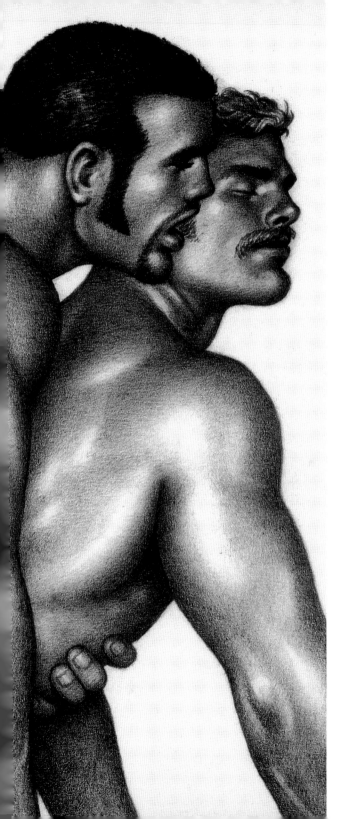

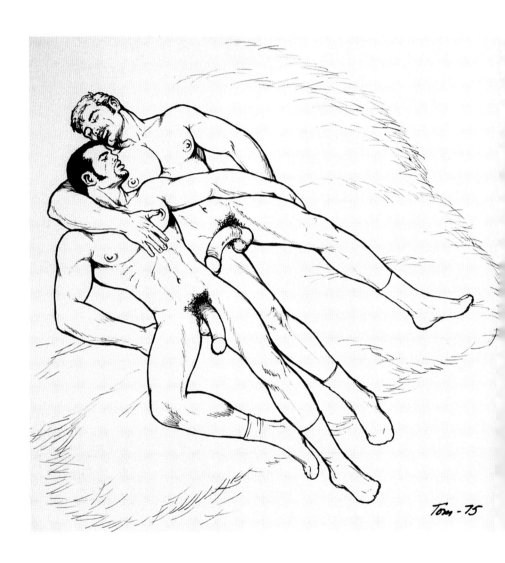

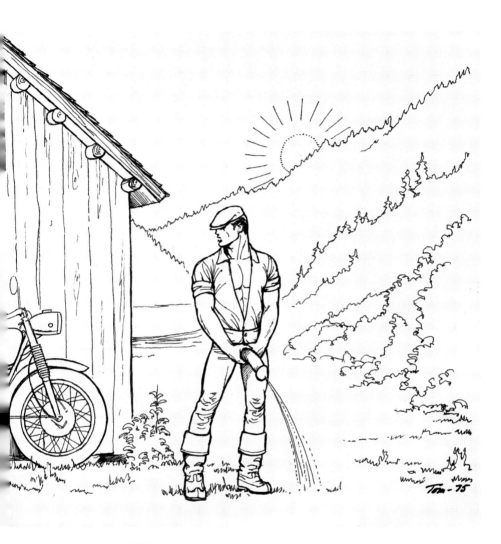

OSITE AND ABOVE 1975, pen and ink on paper
ES 226-227 1975, gouache on paper

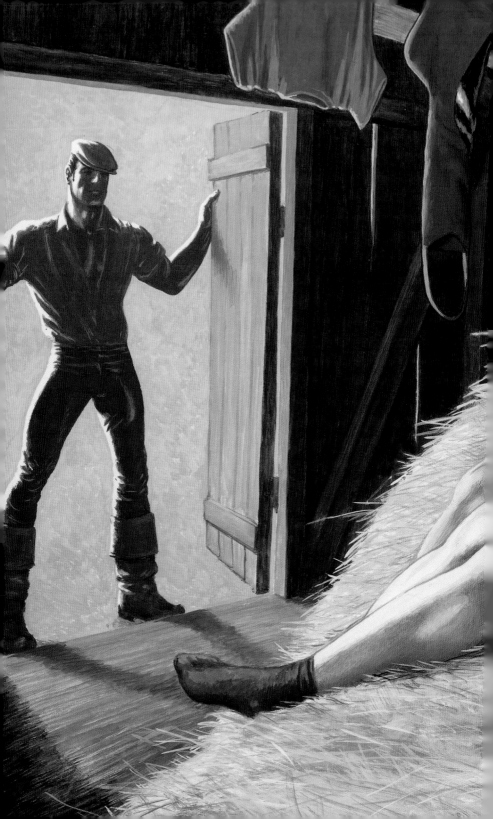

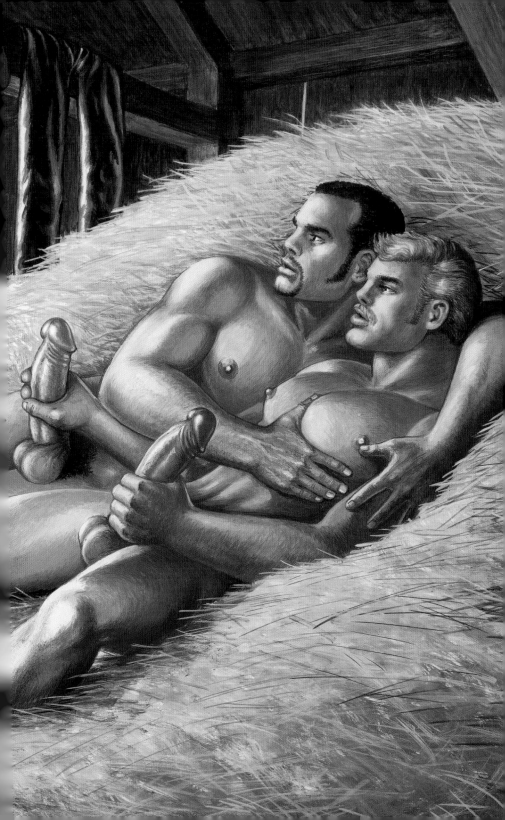

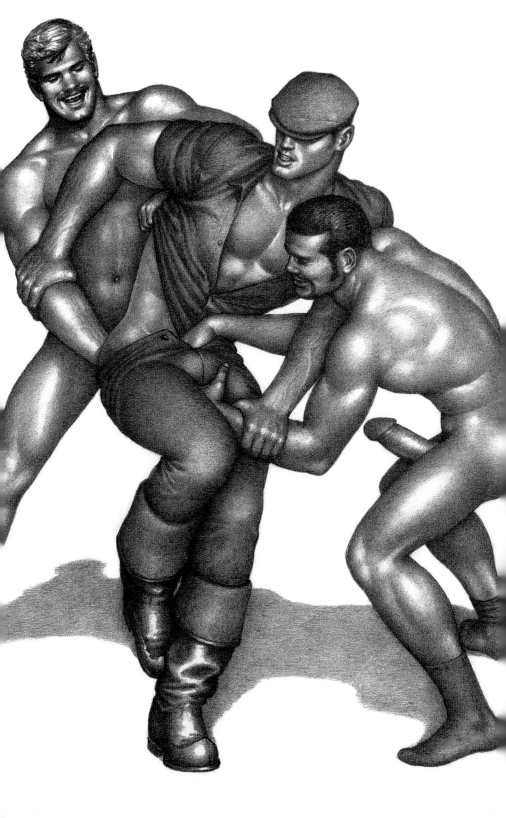

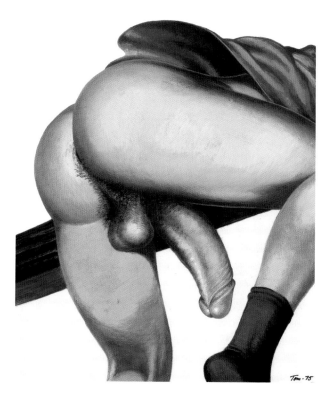

OPPOSITE 1975, graphite on paper
ABOVE 1975, gouache on paper

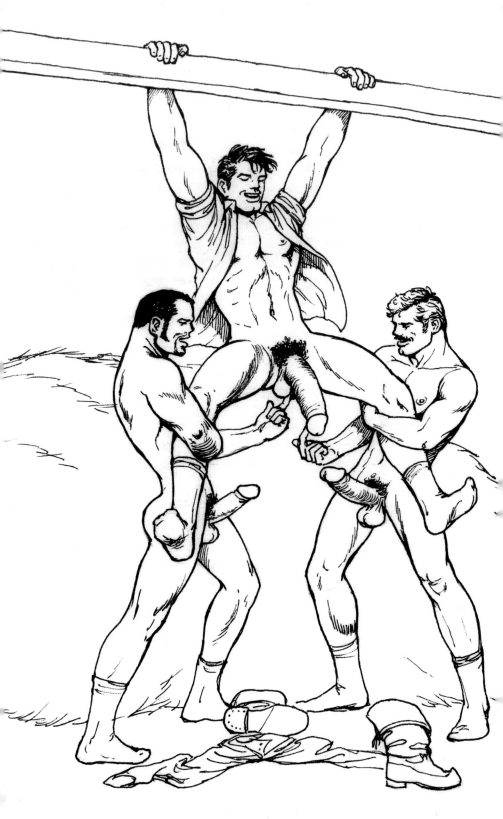

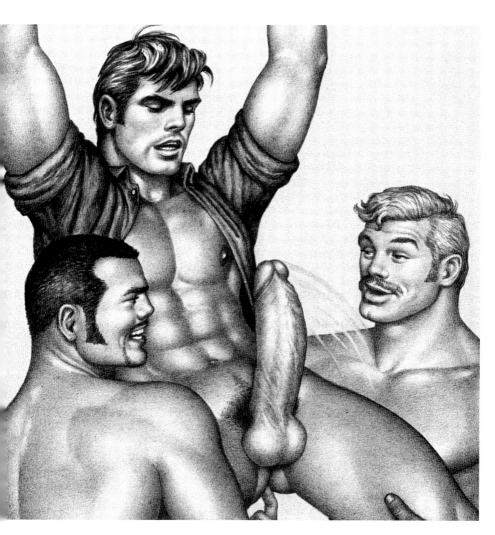

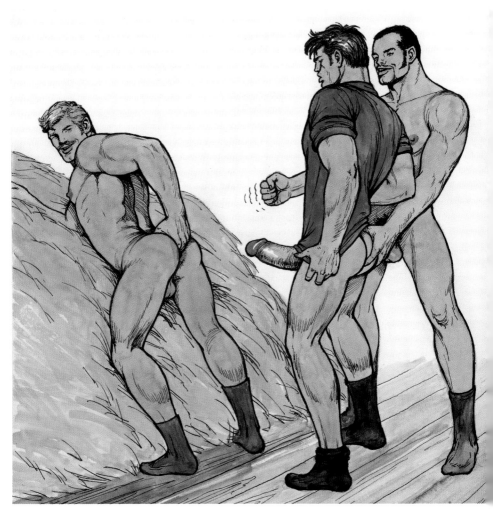

ABOVE AND OPPOSITE 1975, pen, ink, and gouache on pap
PAGES 234-235 1975, gouache on pap

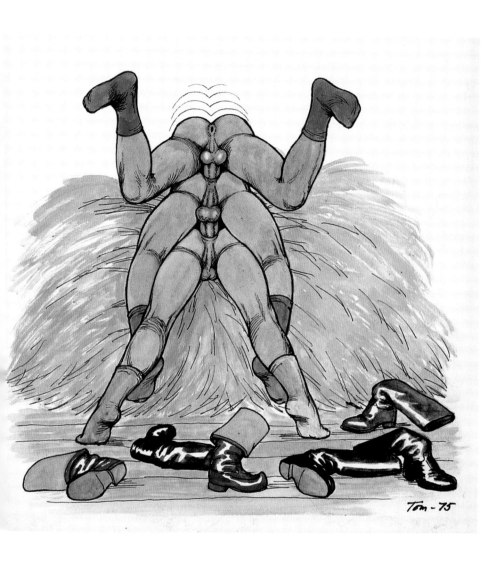

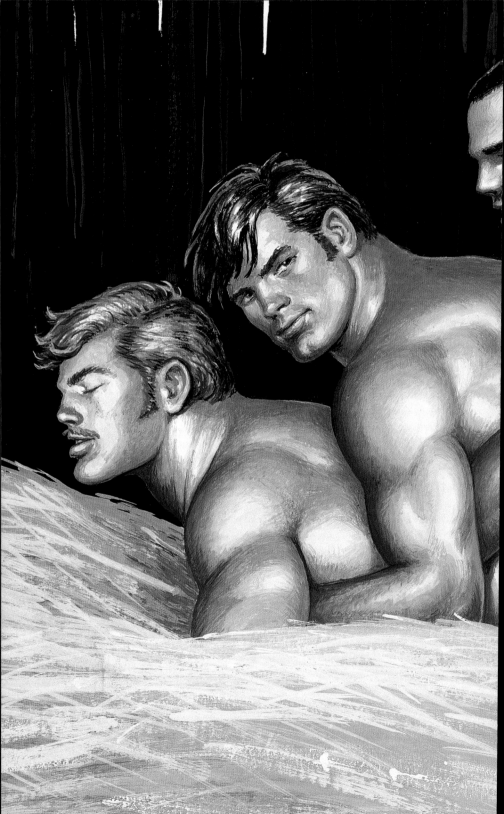

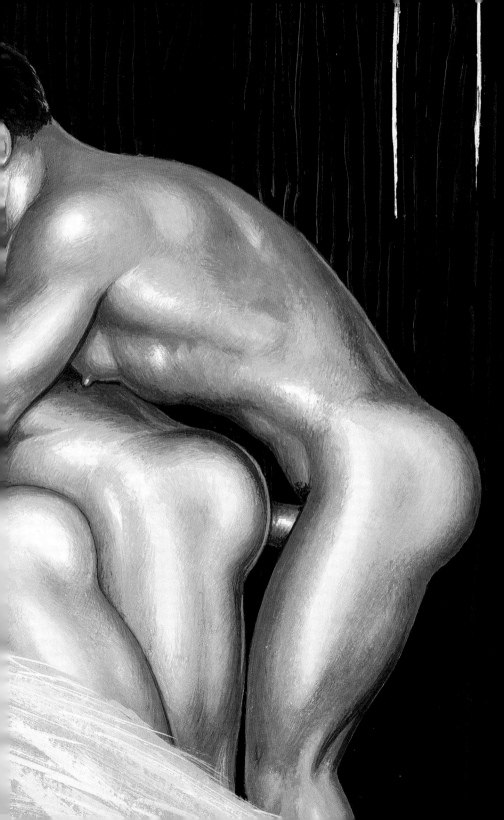

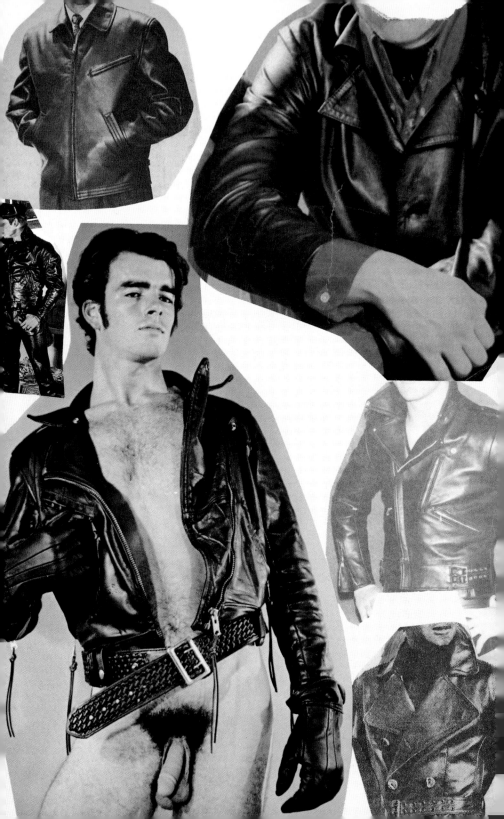

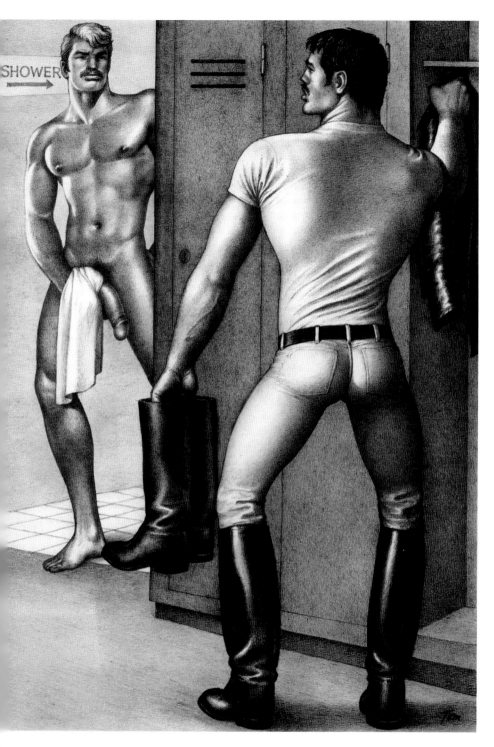

ᴏSITE Reference photo collage by Tom
ᴱ 1977, graphite on paper

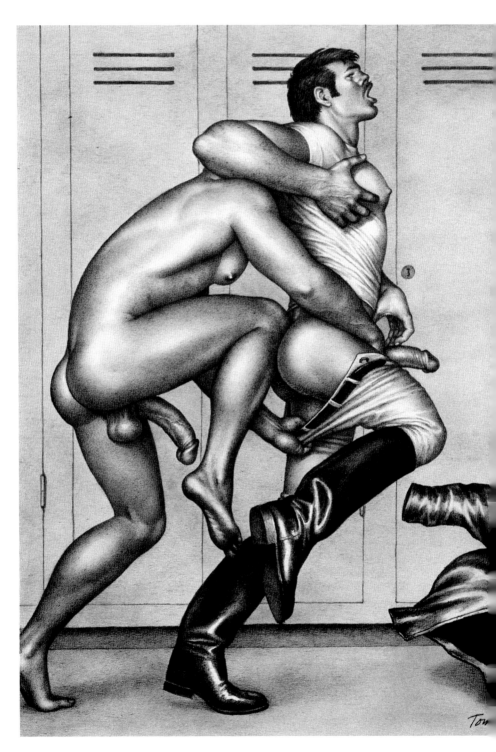

ABOVE AND OPPOSITE 1977, graphite on p

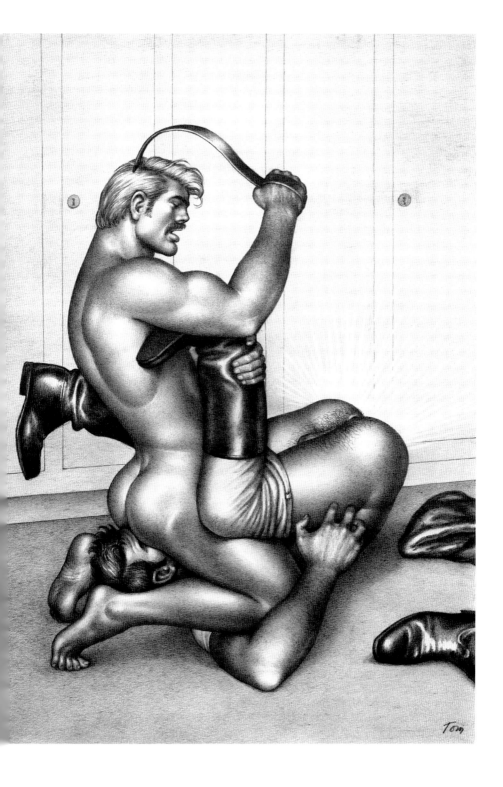

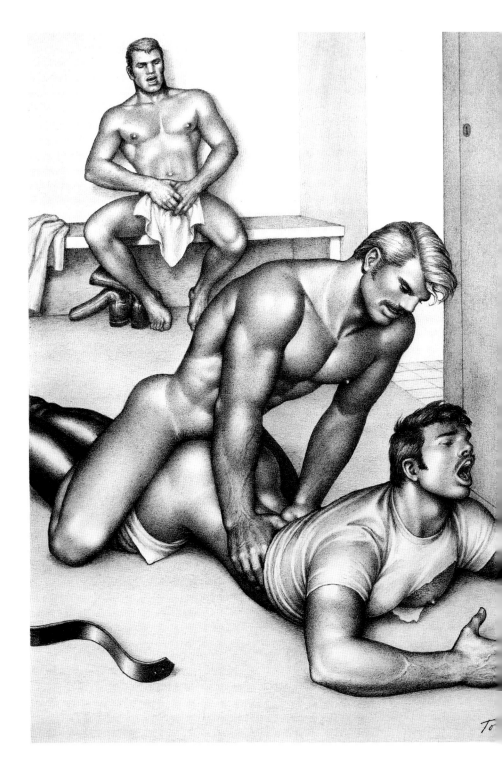

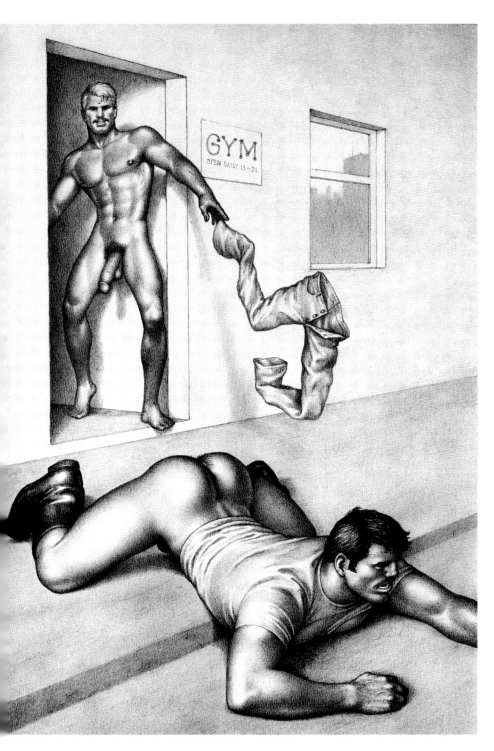

OSITE AND ABOVE 1977, graphite on paper

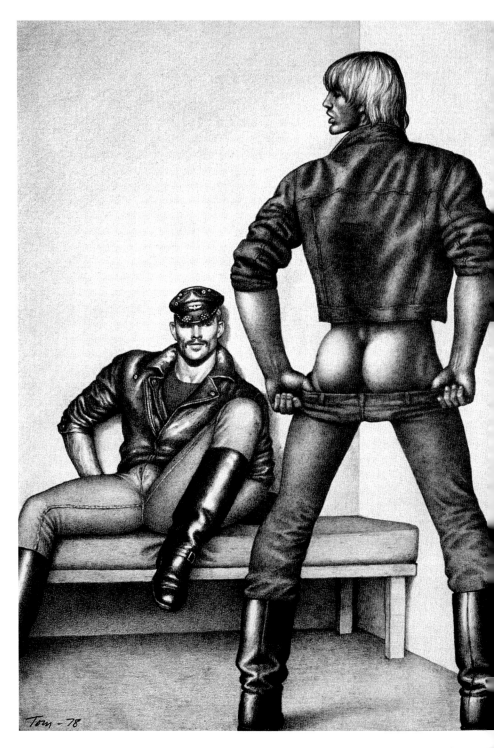

ABOVE AND OPPOSITE 1978, graphite on pa

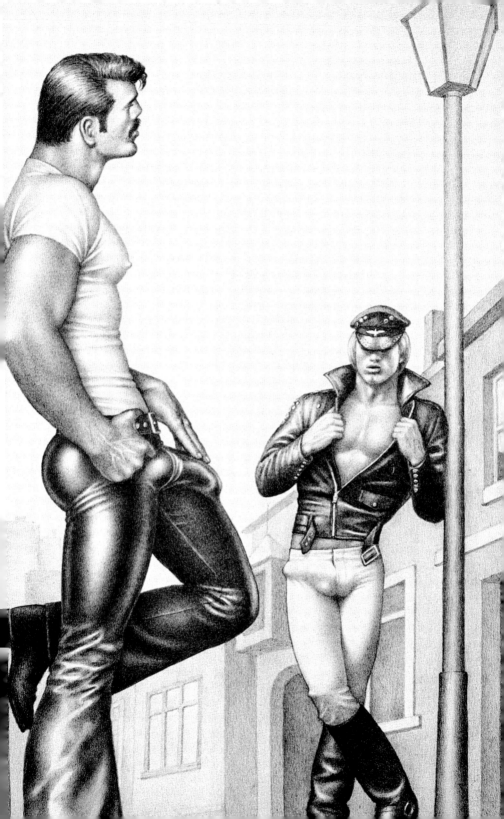

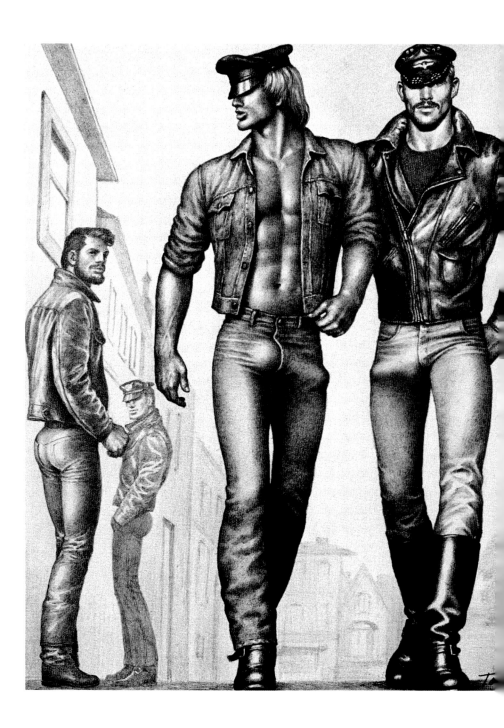

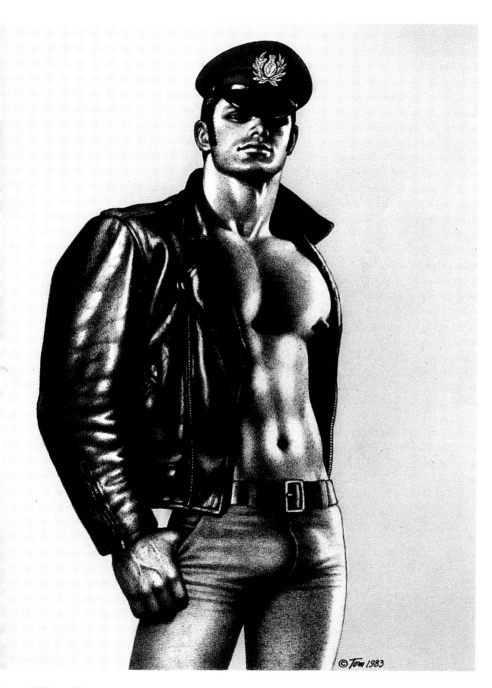

OPPOSITE 1978, graphite on paper
ABOVE 1983, graphite on paper

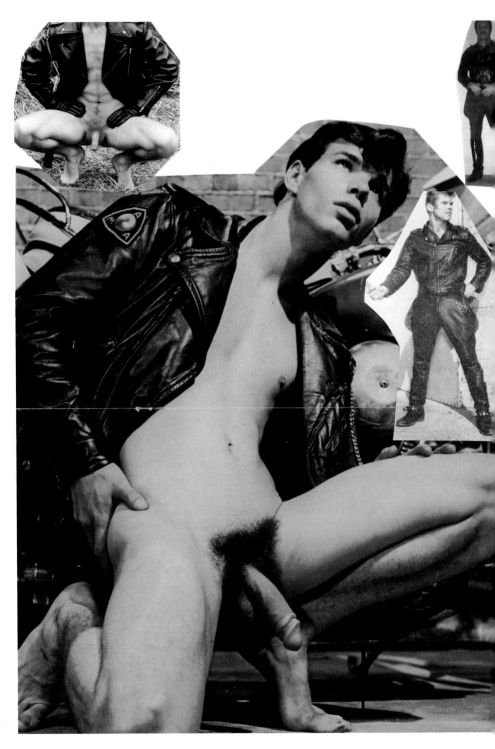

ABOVE Reference photo collage by T
OPPOSITE 1980, colored pencil on pa

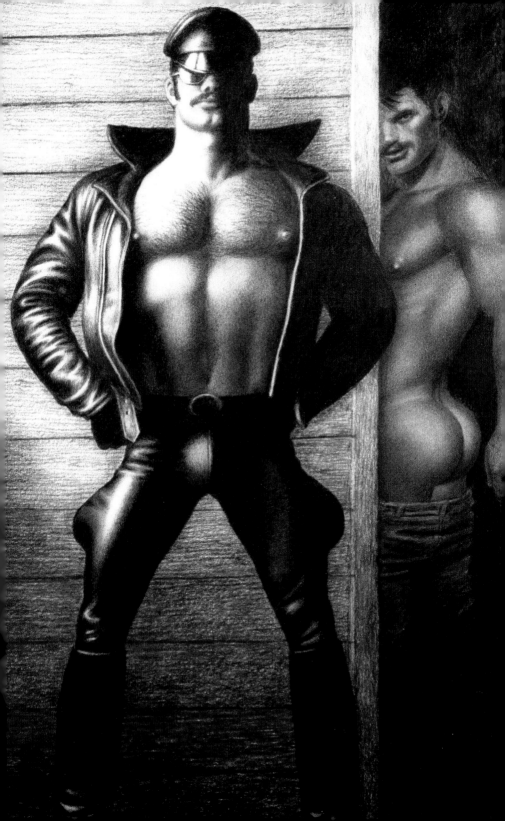

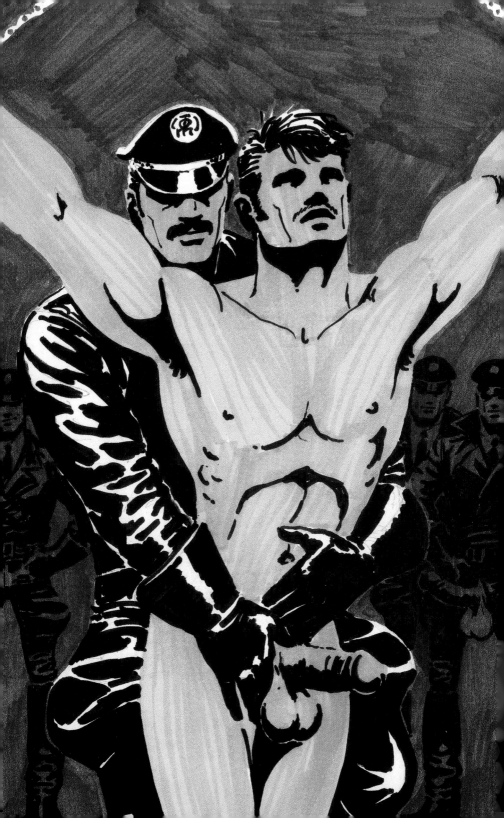

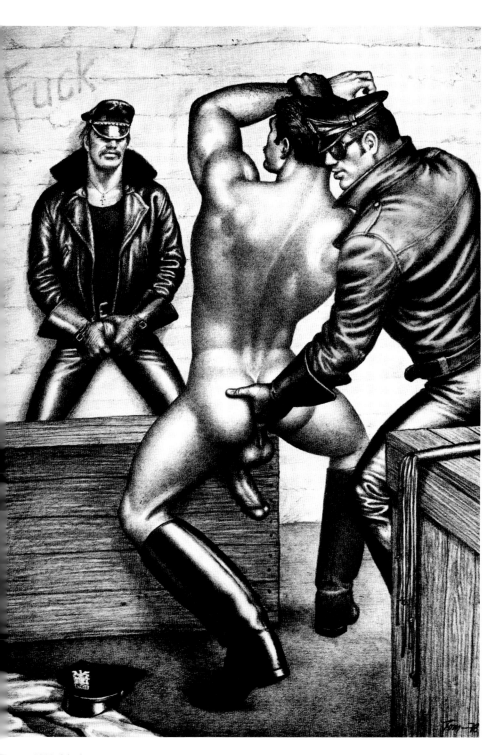

OPPOSITE 1983, felt tip pen on paper
ABOVE 1978, graphite on paper

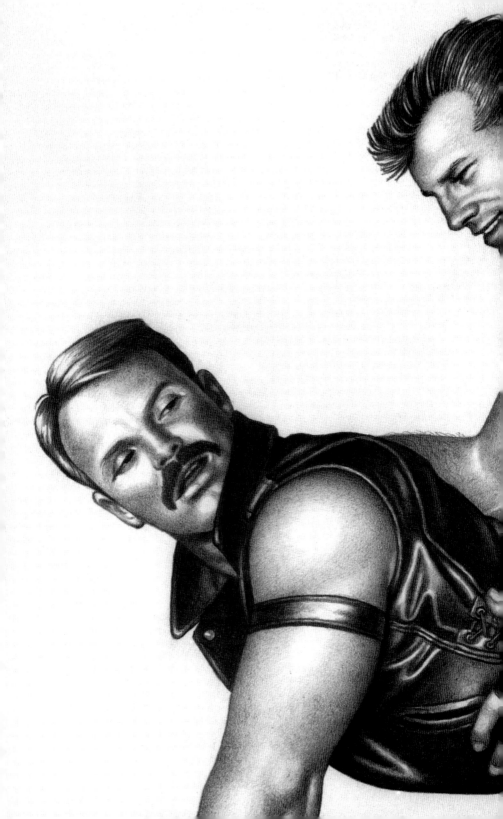

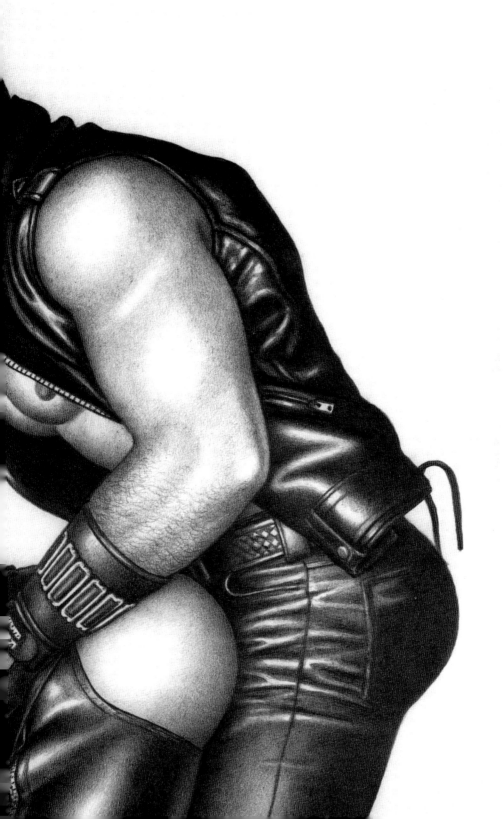

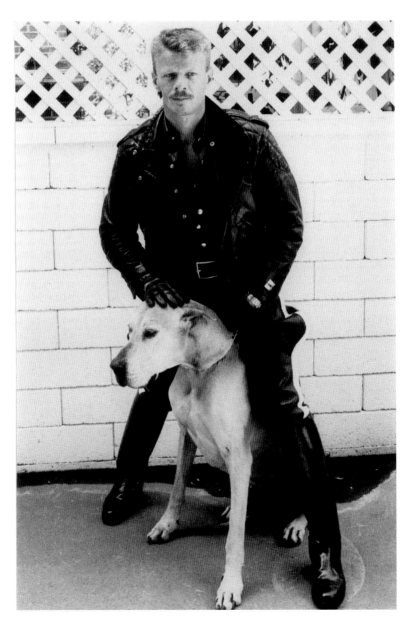

PAGES 250-251 1985, graphite on paper
ABOVE photo © Tom of Finland
OPPOSITE 1987, graphite on paper

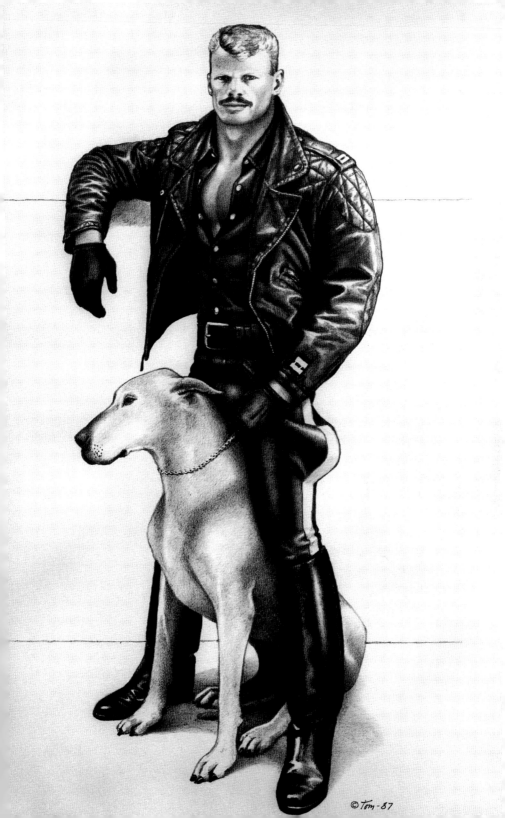

©Tom -87

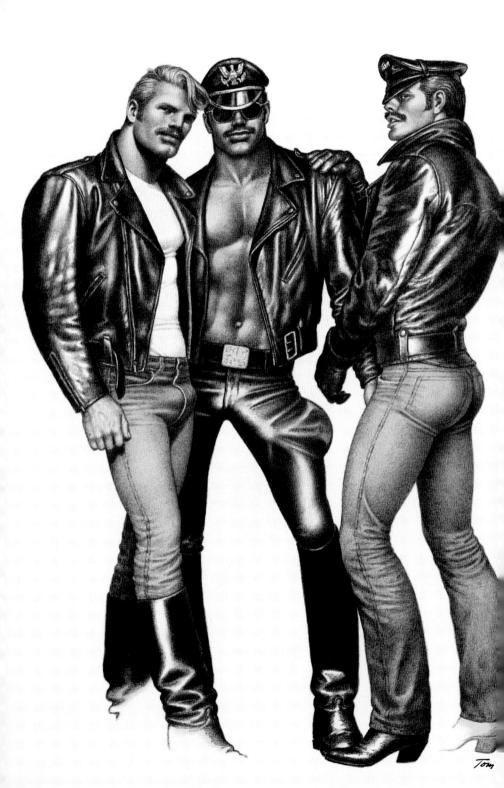

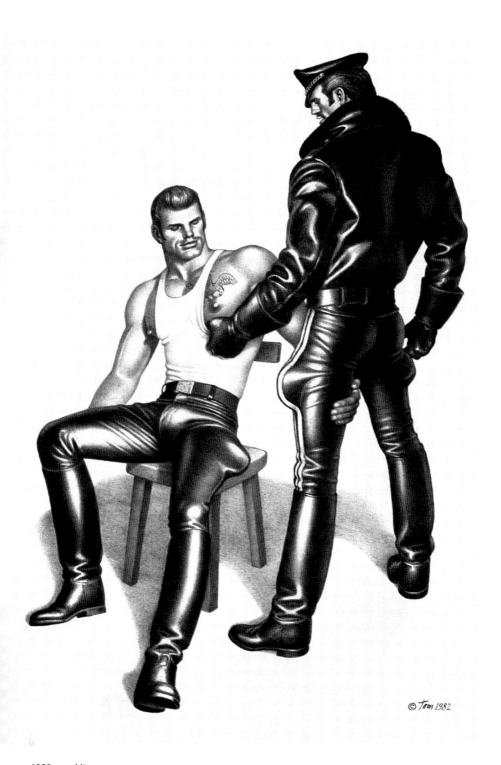

OSITE 1980, graphite on paper
VE 1982, graphite on paper

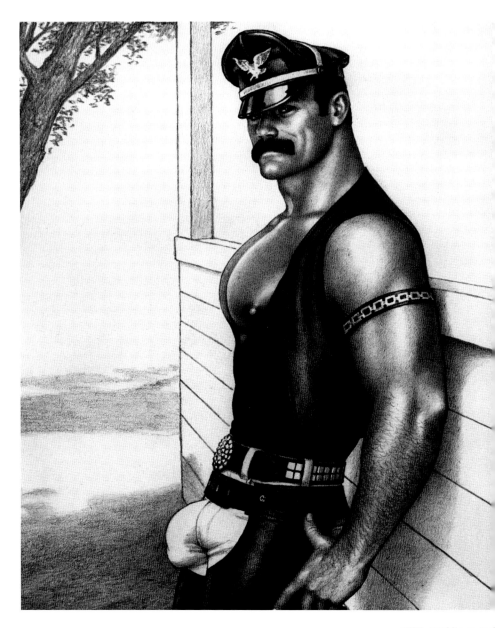

ABOVE 1987, graphite on pa
OPPOSITE 1986, graphite on pa

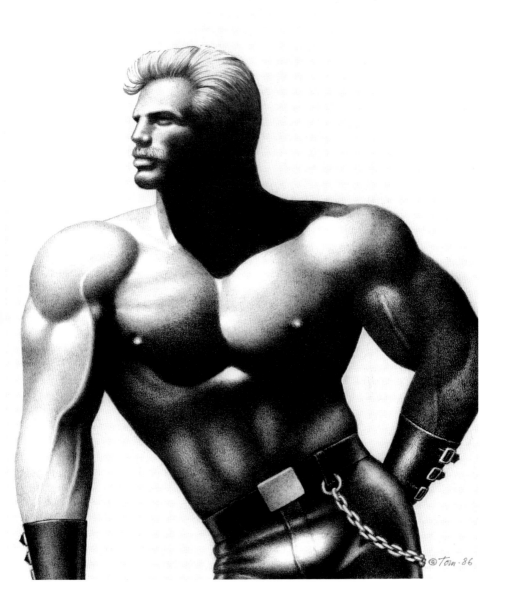

©Tom·86

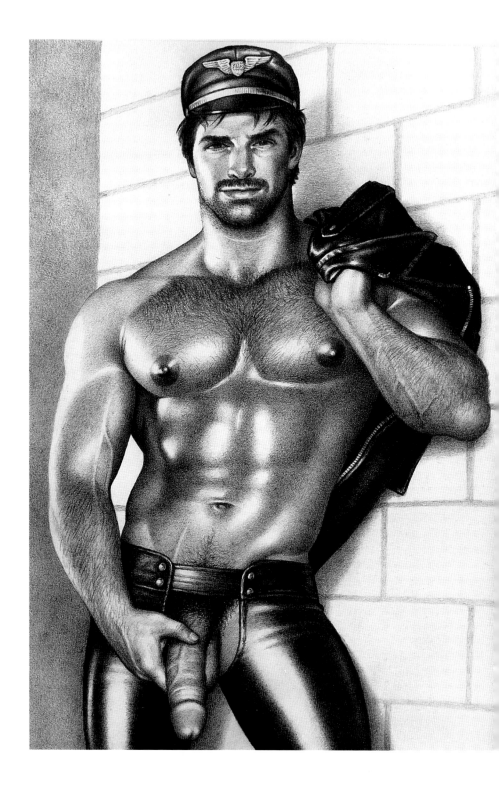

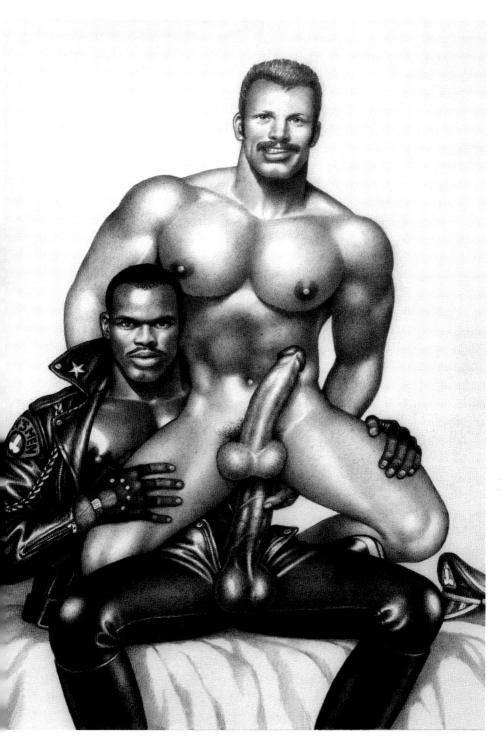

OPPOSITE 1981, graphite on paper
ABOVE 1986, graphite on paper

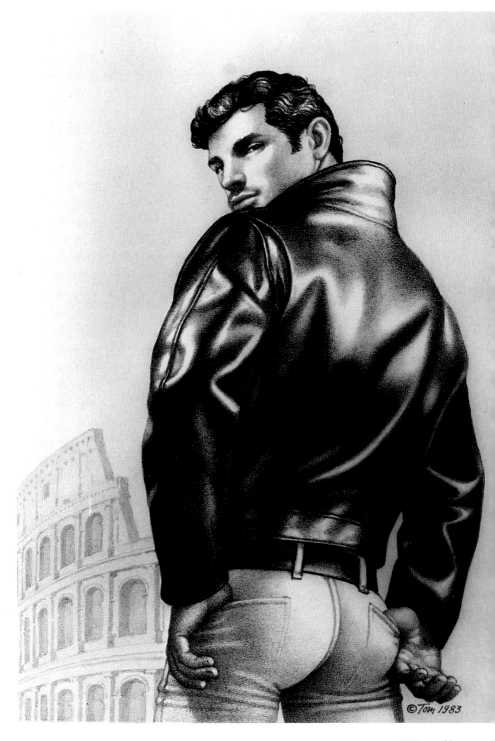

ABOVE 1983, graphite on pap[er]
OPPOSITE 1985, graphite on pap[er]

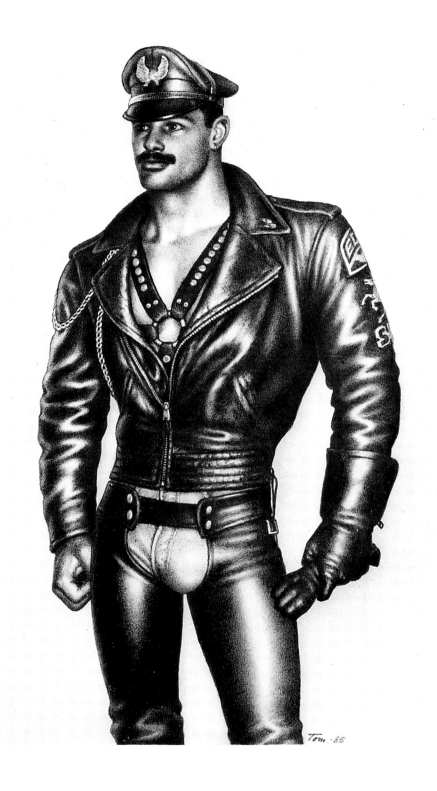

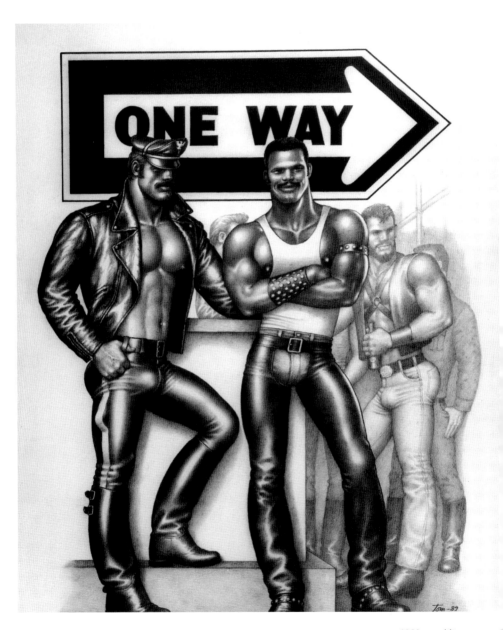

ABOVE 1989, graphite on paper
OPPOSITE 1983, graphite on paper
PAGE 264 1982, graphite on paper
PAGE 265 1984, graphite on paper

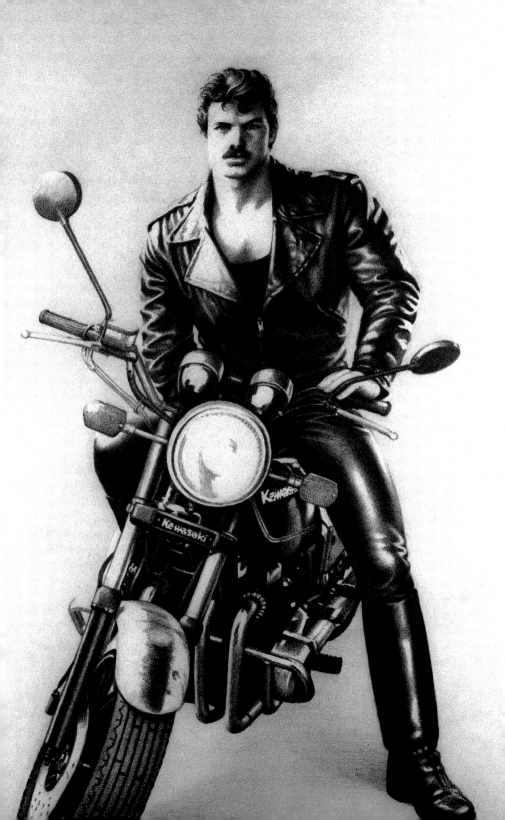

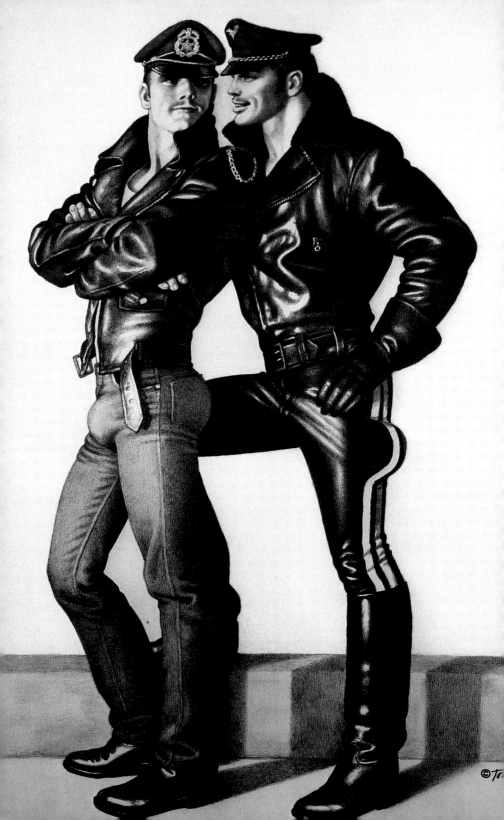

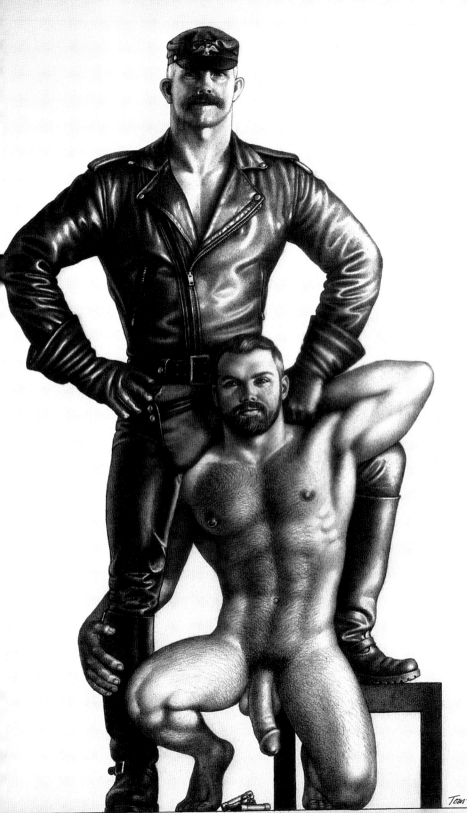

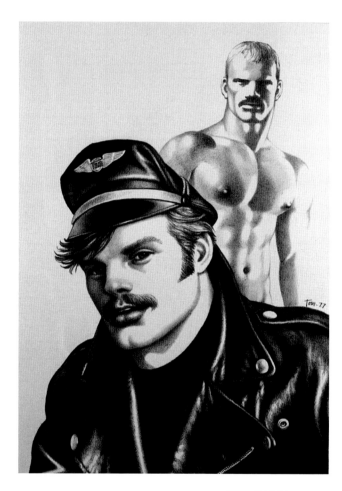

ABOVE 1977, graphite on paper
OPPOSITE AND PAGES 268-269 1984, graphite on paper

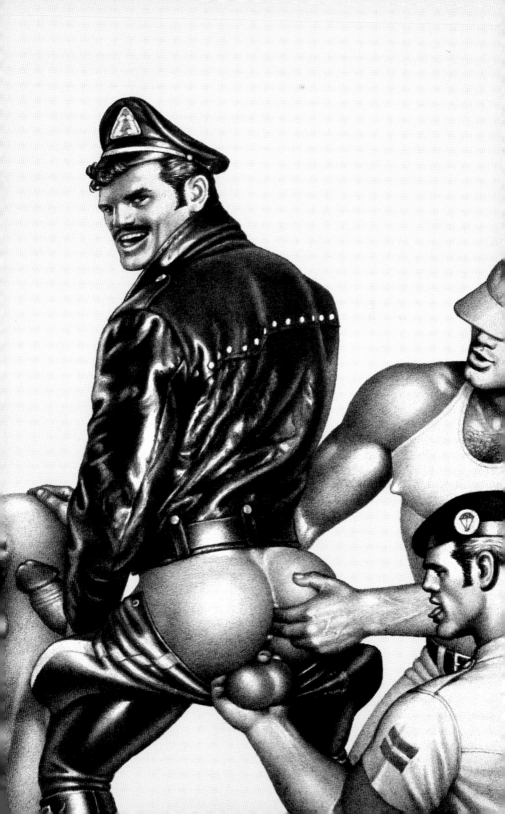

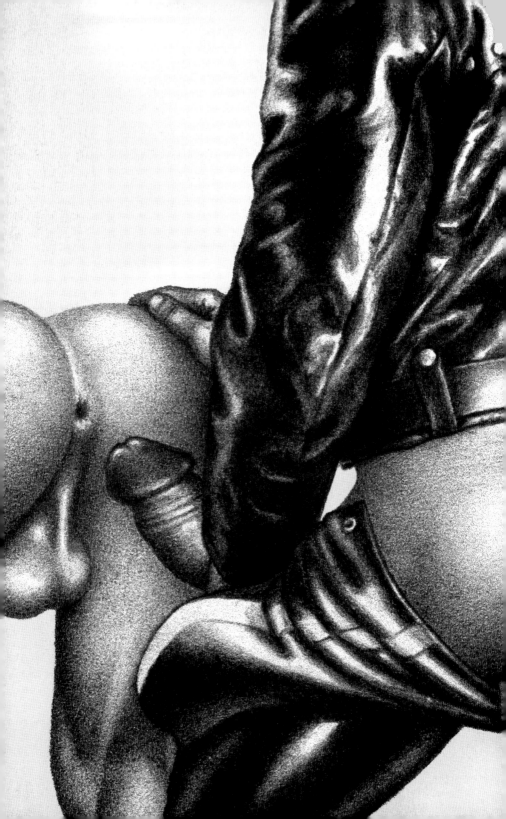

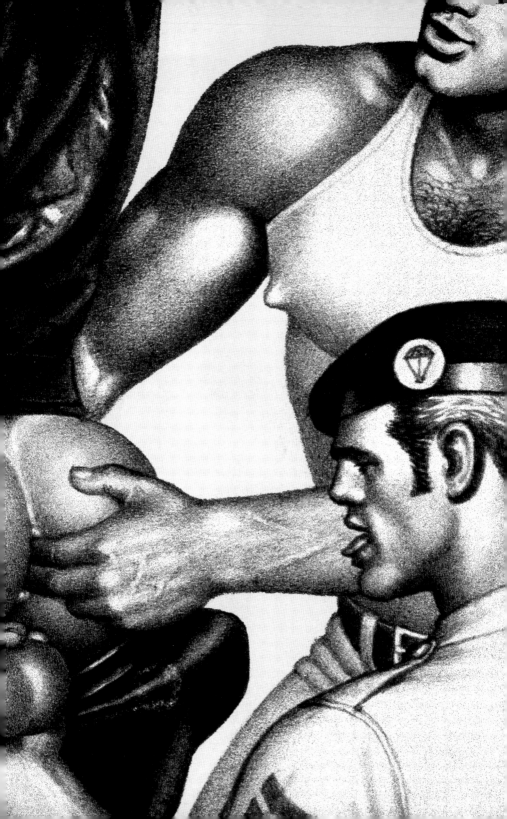

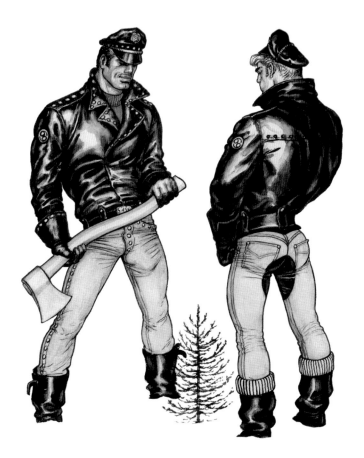

Protecting, Preserving, and Promoting Erotic Art

Tom of Finland Foundation was conceived by the artist Touko Laaksonen and his business partner Durk Dehner in 1984 as a nonprofit art institution to house and preserve the collective works of the artist. It has evolved into a support facility and library serving all artists working in the visual field of human sexuality.

Today the Foundation has over 500,000 visual records and over 3000 original works of art by Tom of Finland and hundreds of other artists from around the globe.

The Foundation is only able to continue its work of protecting, preserving, and promoting erotic art through the public's generous support, including donations and membership in Tom of Finland Foundation.

We invite you to visit us on the web at www.tomoffinlandfoundation.org
When in Southern California please visit our Museum House at 1421 Laveta Terrace, Los Angeles, CA 90026
Write us at Tom of Finland Foundation, P.O. BOX 26658, Los Angeles, CA 90026
Phone: 213 250-1685
Email: administration@tomoffinlandfoundation.org

ABOVE 1963, graphite on paper

To stay informed about upcoming TASCHEN titles, please request our magazine at www.taschen.com/magazine or write to TASCHEN, Hohenzollernring 53, D-50672 Cologne, Germany; contact@taschen.com. We will be happy to send you a free copy of our magazine, which is filled with information about all of our books.

Edited by Dian Hanson, Los Angeles
Editorial coordination by Jascha Kempe, Cologne
Design by Jessica Sappenfield, Los Angeles
Cover design by Marco Zivny, Los Angeles
Production by Jennifer Patrick, Los Angeles
German translation by Egbert Baqué, Berlin
French translation by Philippe Safavi, Paris

Printed in South Korea
ISBN 978-3-8365-3485-7

Acknowledgments

Private Collection of Durk Dehner: page 194; Courtesy of EroticArtCollection.com: pages 37, 258; Private Collection of Michael Fesco: pages 62-63, 195; Private Collection of Robert Fontanelli: pages 237, 240; Collection of The Leather Archive and Museum: pages 79, 80, 81, 82, 83, 121, 122, 123; Collection of the Leslie-Lohman Gay Arts Foundation: pages 162-163; Private Collection of Sean M.: pages 220, 233, 259; Private Collection of Volker Morlock: page 257; Private Collection of Tom Nicoll: pages 40, 41, 46, 47, 55, 64, 65, 66, 67, 68, 69, 70, 73, 74-75, 76, 77, 91, 120; Private Collection of Michael Reynolds: page 88; Courtesy of The Herb Ritts Foundation: page 239; Private Collection of Dr. Stefan Thürmer: pages 222-223; Tom of Finland Foundation Collection: pages 18, 19, 28, 29, 30, 31, 32-33, 34, 35, 42, 44, 45, 48-49, 50, 51, 52, 53, 54, 56, 57, 58, 59, 60, 61, 71, 78, 84, 85, 86, 87, 89, 90, 92, 93, 112, 113, 114-115, 116, 117, 118, 119, 124, 125, 126, 127, 128-129, 130, 131, 132, 133, 134, 135, 136, 137, 138, 139, 140, 141, 142, 143, 144, 145, 146, 147, 148, 149, 150, 151, 152, 153, 160, 165, 167, 170, 171, 193, 198, 199, 200, 201, 202, 203, 208, 209, 210, 211, 212, 213, 218, 219, 221, 224, 225, 228, 229, 230, 232, 234-235, 236, 246, 248; Private Collection of William Traucht: page 157; Private Collection of Jon Voss: pages 166, 169; Private Collection: pages 226-227.

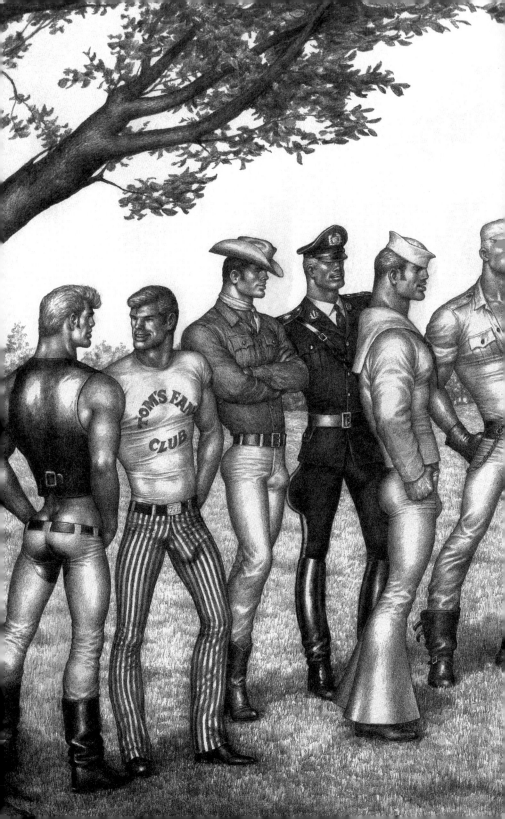